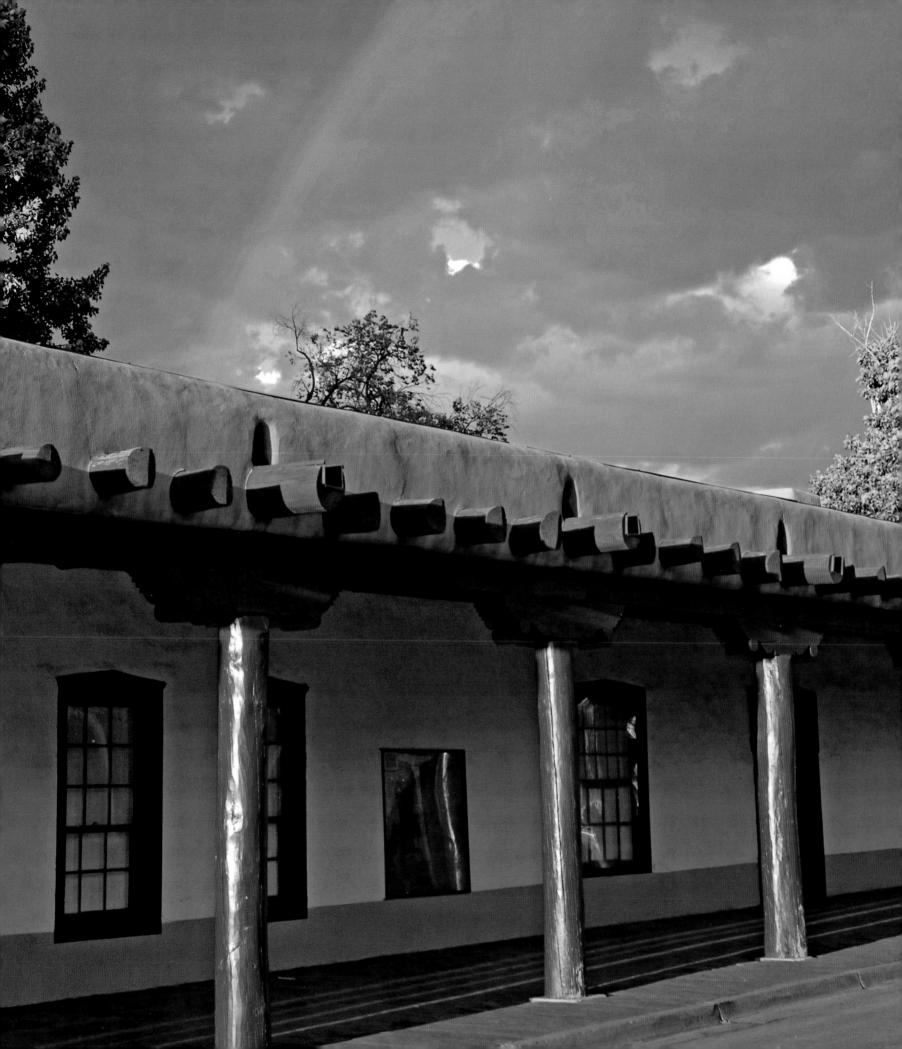

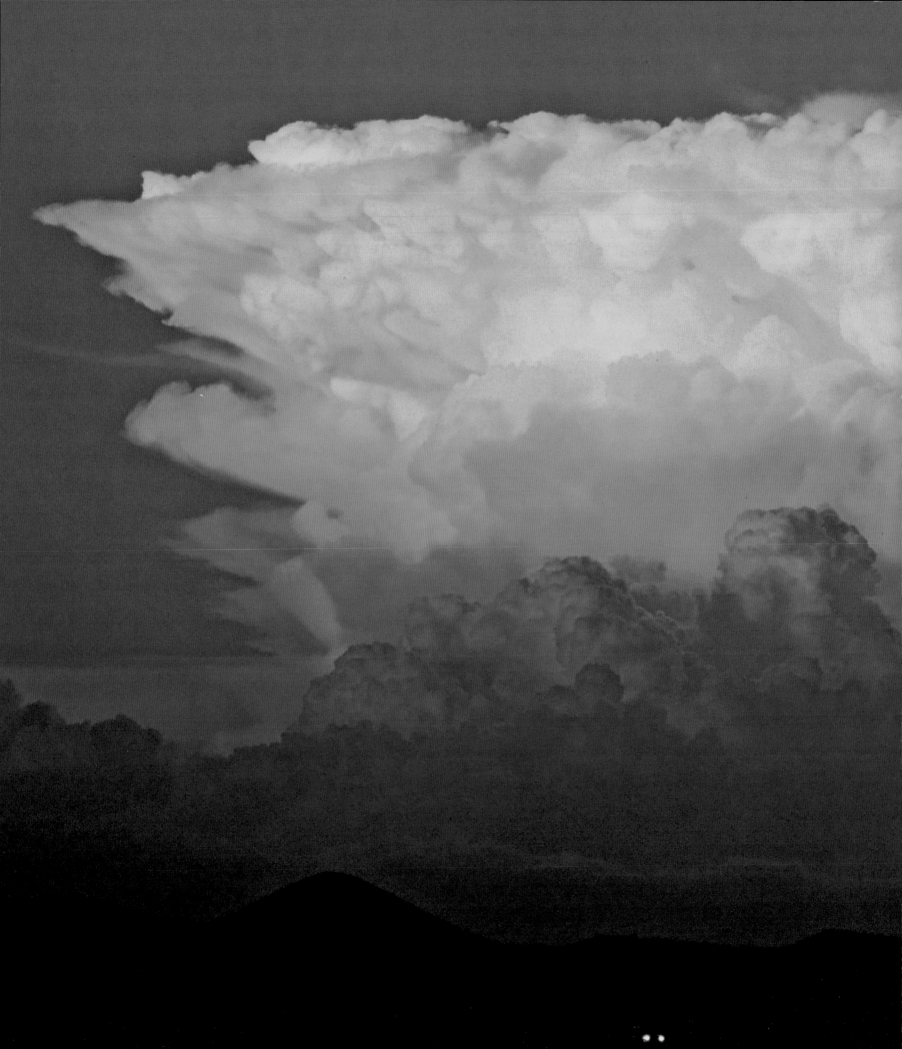

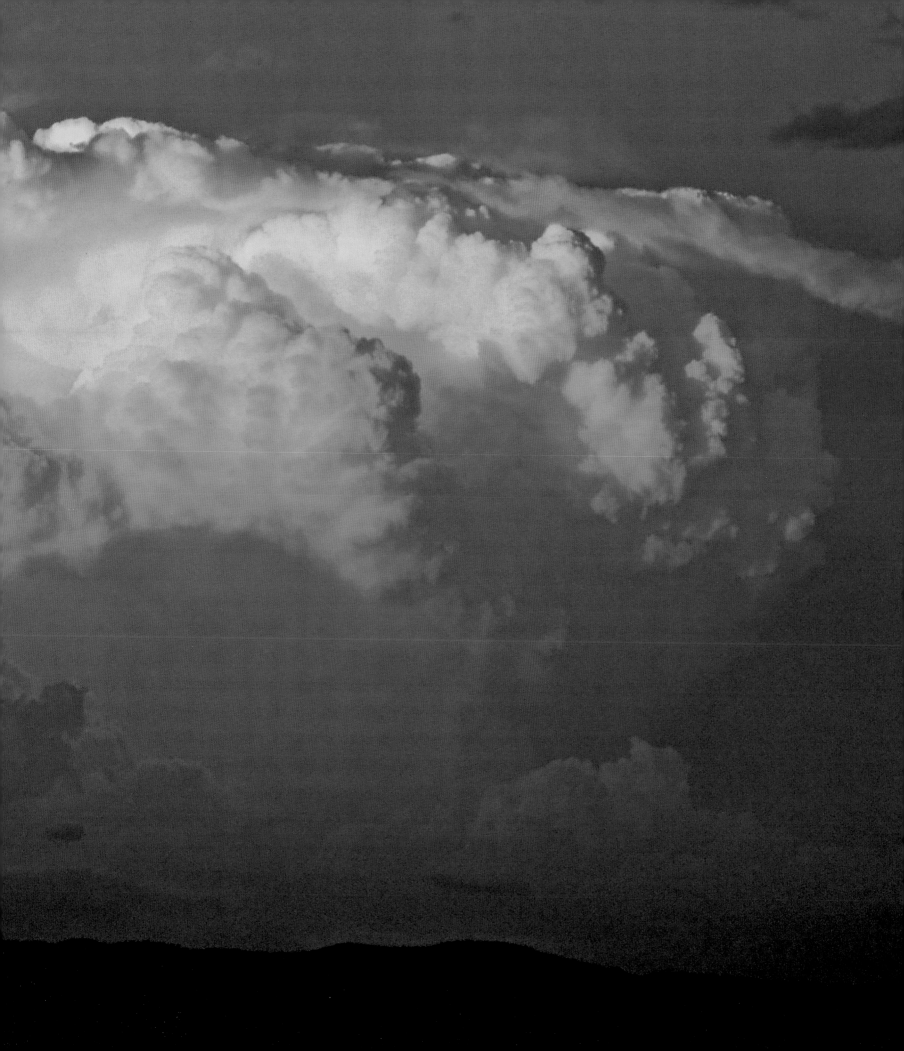

SANTA FE

GENE PEACH

WITH AN INTRODUCTION BY CHRISTINE MATHER

Museum of New Mexico Press
Santa Fe

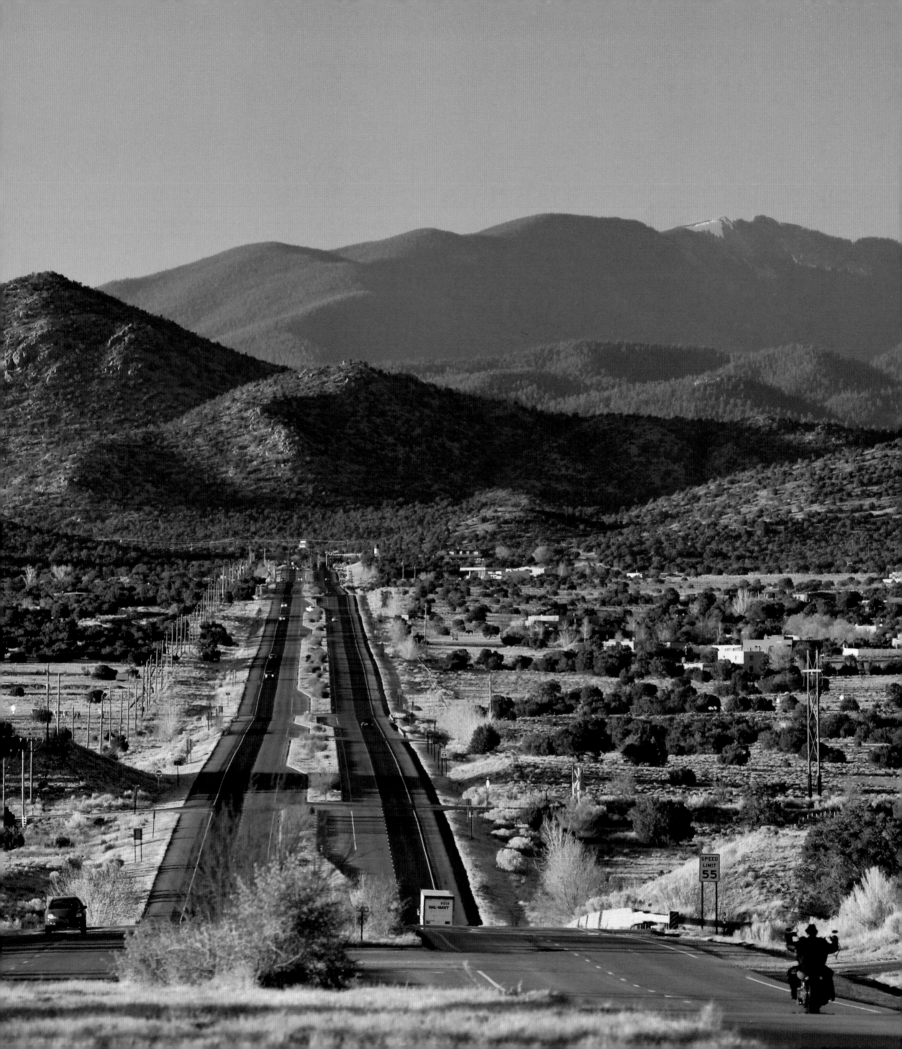

PREFACE

This book is dedicated to the city and people of Santa Fe.
—GENE PEACH

SANTA FE has been my home since 1989. I visited here while on a cross-country trip two years earlier and, like many before me, was hooked.

I grew up on the horizontal prairie of rural Indiana but lived from my late teens in Boston's cramped cityscape. Trips to the New England countryside offered me little relief. Wherever I went, I felt enclosed by endless walls of trees and hills, rarely seeing farther than one mile in any direction, and everything green. I adjusted to my East Coast claustrophobia but never felt at home.

So, I was a goner from almost the moment I crested La Bajada Hill and saw for the first time this sweeping expanse of high plateaus and mountains. It was love at first sight. I'll never forget watching my first moonrise here. It was early evening and the sky was an impossibly clear and deep blue. I never felt the moon so close or been more excited about a cloudless sky. Almost as impressive to me as the light and land was the town itself, with her earthy colors, natural shapes, and everything sized to a human-scale and steeped in history. I love how old adobe homes can look like they emerged from the land and have existed forever.

My first years living here were absorbed in chasing New Mexico's magical light, photographing architecture, landscape, and the always-amazing sky. On summer evenings, I would drive to a favorite spot not far from my home to shoot Technicolor rainbows in the east, and as they faded, spin around to capture magnificent sunsets spreading across the western sky. Spectacular lightning storms often followed. There are times when Northern New Mexico can feel like heaven on earth.

My photos appeared in many tourism ads and visitors guides, but the longer here, the less I saw Santa Fe with a tourist's eyes. I lost interest in the popular myth and yearned for a deeper connection to New Mexico.

A turning point came when shooting working ranch families for what would become my book *Making a Hand: Growing Up Cowboy in New Mexico*, published by the Museum of New Mexico Press in 2005. It was a personal project that became an all-consuming obsession stemming from my childhood on a farm. I explored every corner of New Mexico and befriended many great cowboys, some of them National Cowboy Hall of Fame inductees.

It was during this time that I began seeing Santa Fe in a different light and started looking more closely at its deep-rooted locals and less at the artists, hipsters, and drifting transplants like myself. I became a student of Southwest history and very gradually began thinking of myself as a New Mexican. I realized I had finally found an endlessly captivating place I want to call my home and never leave.

Santa Fe is a many-layered community that grows richer with time. Every other place I've been appears dour and one-dimensional by comparison. Its three cultures—Indian, Hispanic, Anglo—are at the very heart of why this is a fascinating area. Big cities may have a more diverse mix of nationalities. But Santa Fe's three cultures are American and have been here for generations, sometimes centuries, coexisting side-by-side and also blending. As a result, this small town celebrates an almost endless variety of cultural activities, many which are unique to this town. During summer months, there is something special happening here every weekend!

The plaza is the historical heart of Santa Fe, and few, if any, U.S. communities have anything like it. Many locals dismiss it as existing for tourists only, but I think that unfair. I can't name a town center anywhere that hosts a greater number of community events. Half the photos in this book were taken on or very near the plaza. It more than fulfills the purpose it was designed for four hundred years ago.

Mention the name Santa Fe and everyone has an opinion. Fans champion her spellbinding beauty, unique architecture, great food, ideal weather, and diverse culture. Critics grouse about a "fauxdobe" Disneyland crawling with New Age flakes and bad artists. Santa Fe is tagged with many nicknames, often derogatory: Santa Fake, Fanta Se, Santa Fantasy . . . Indeed, it takes one a long time to begin sorting fact from faux in this unusual place, but I think the fantasies are imported and not homegrown. Most fall away over time.

My goal in creating this book is to honor Santa Fe as a beauty with substance and soul. I hope to inspire a greater appreciation for her cultural vitality and unbroken connection with the past. I think the longer one is here and paying attention, the more interesting Santa Fe becomes. One's everyday adventures here can be greater than any fantasy.

This is the book I dreamed about doing from the moment I first crested La Bajada Hill. I want to acknowledge several people for helping with its creation. First to thank is the Museum of New Mexico Press staff. Mary Wachs has taken a big creative role in helping shape this project. David Skolkin has created a book design more stunning than I could have ever hoped for. Thanks to Rick Palmer of Garcia Street Books for helping spark the idea for this book; and to Deborah Villa, the *Santa Fe New Mexican* magazine's senior editor whose assignments account for many of the photo opportunities reflected here. And I thank Sharon Morris, without whom I may never have discovered Santa Fe.

INTRODUCTION

Christine Mather

SANTA FE exists in the imagination of the world as a special crossroads, a sought-after destination, a place with a powerful mystique. It has had this reputation for hundreds of years. But, in a way, it never fails to disappoint. Countless visitors of all types, over hundreds of years, are flummoxed by the small proportions, the brown sameness of it all, underwhelmed by the modest plaza or frustrated by how quickly the town gives way to more of the untamed that surrounds it. This may be because it has an outsized reputation for a small city.

But for a local, this disappointment delivered at the initial impact of seeing the low and humble, the unexpected modesty of the place set amidst a much grander scene—this we value. It is as if the city would not dream of competing with the mountains, the foothills, the run-up to the place through miles and miles of high desert, deep canyons, a lone rift valley, a sparse and spare river, a smattering of stubby trees and the great big dome of a blue sky. If this is not enough for you—this hand of creation upon the land—then the pokey little city populated by a seriously festive citizenry might come as a disappointment, or then again it might come as a comforting relief and respite from the knock-your-socks-off grandeur of nature.

In any case, it takes some getting used to. In fact, there is not much about Santa Fe that doesn't require a new set of eyes, a different attitude, a relaxation of the norm. This is not the America of elsewhere, it is very much its own place. If you live in Santa Fe all the time or have always been here, well, then, you must leave to appreciate how poorly it conforms.

How did all this contrariness come into being? Santa Fe seems to have been born to be different. It has never even come close to achieving any type of conventional success. For the first conquerors, those desperately seeking loot to pay off the very expensive underwriting of their explorations, it was a dead loss. To the citizenry that followed, it became home—what they knew and loved—even though it was not such an easy life. The settling-in process has not been without its dramas—major dramas—including revolts, murders, displacements, captives, raids, starvation, disease, to name a few. Perhaps these spiked the stubborn contrariness of the place—almost as if to say it will go on despite all this kerfuffle. It is not easy but then what is? Soldiering on for centuries, making do, living on the edge, being totally isolated—well frankly, Santa Feans thrive on this kind of adversity. Economic downturn? Bring it on. New Mexicans were so used to being self sufficient that even the Great Depression seemed like life as they knew it. Stumbling into this alternative universe of extreme independence, over-the-top contrariness, endemic differentness, might come as a bit of shock, and so it has for many centuries by all comers. This is not to say it is a harsh and difficult place, it is just not quite like any other and justifiably so.

Santa Fe wears this uniqueness well; it embraces it. Almost anything that goes on here seems special to it, and nowhere is this more pronounced than in how it appears. The visual nature of Santa Fe, from the outdoors in, is so special, so constant, so all consuming that over the last hundred years it has become a work and playground for artists. If you walk these streets—regardless of the weather, the time of year, the time of day—you can expect to be filled with an intense sense of well being brought on by the mingling of nature and man in a delightful and serendipitous way. Lilacs come on stronger, funky gates and dirt roads are a charm here whereas elsewhere they might be a hazard, and the light and air cannot be compared. Plus, this haphazard beauty that springs from every detail seems to be random, uncontrived, unselfconscious like a precious little child or darling baby duck. Santa Fe has a certain obliviousness to itself that is both infuriating and seductive—and the camera has always been its friend.

Besides the everyday physical appearance, there is also the attraction of a certain type of play that has come to define the city. Santa Feans tend to like their leisure activities to be especially homegrown and rooted in time-honored traditions, mixed with a predilection for a certain amount of eccentric wackiness and invention. As a result, a solemn religious festival such as the Santa Fe Fiesta, at some point, took on the burning of a giant puppet, Zozobra. There is no way to easily explain exactly what these things are or why they exist, nor another community that has come close to duplicating this bizarre formula, although they do try. The willing embrace of all things creative and exotic has brought to Santa Fe a calendar of events that is unmatched— activities that make the warm months a marathon and the cold ones a respite punctuated with a solemn religious holiday that also includes some very un-solemn festivities, again. Throughout this blessed partying and fiesta-ing, there is little acknowledgment of the churning demands of popular culture that are so influential elsewhere. Naturally, this self-sufficiency is the target for both takeover and resentment. So, Santa Fe has had more than a few poor imitations of its stellar creations, as well as nasty slams about their authenticity, as if all this and more is some form of giant fake— an annoying attack inspired by envy that haunts the place.

Santa Fe begets and attracts its very own breed of people who love to step out into its beauty, engage in its creations, add to its outsized reputation, and capture its flowing visual energy. And there is always room for one more paean to this unmistakable world, room for one more attempt to hold its transient but abiding essence in the moment. Santa Fe is the most willing subject.

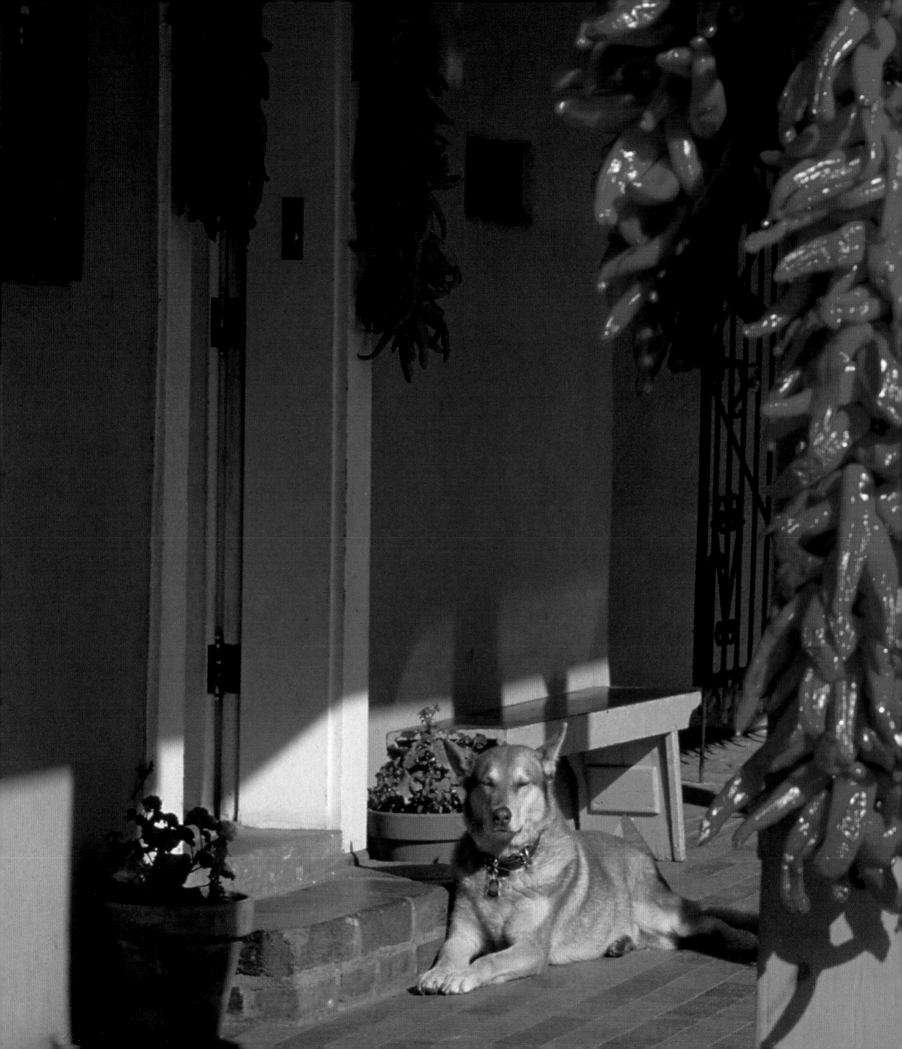

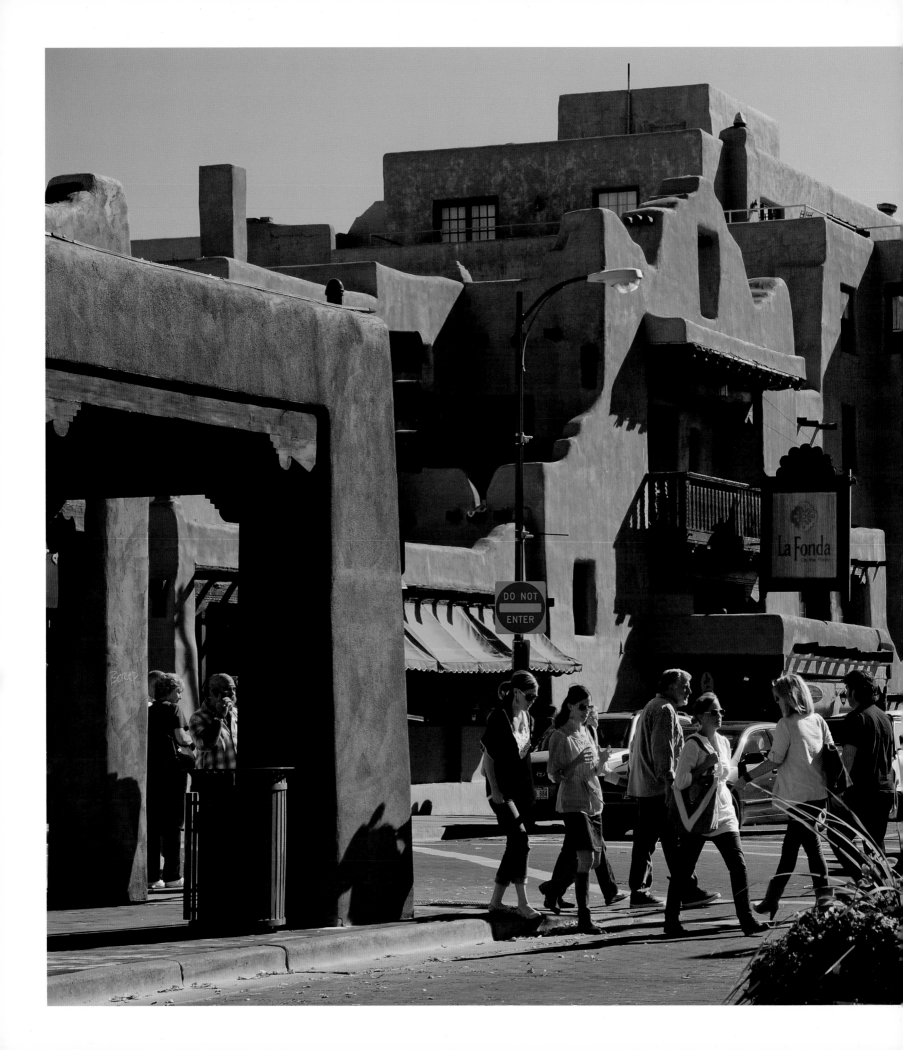

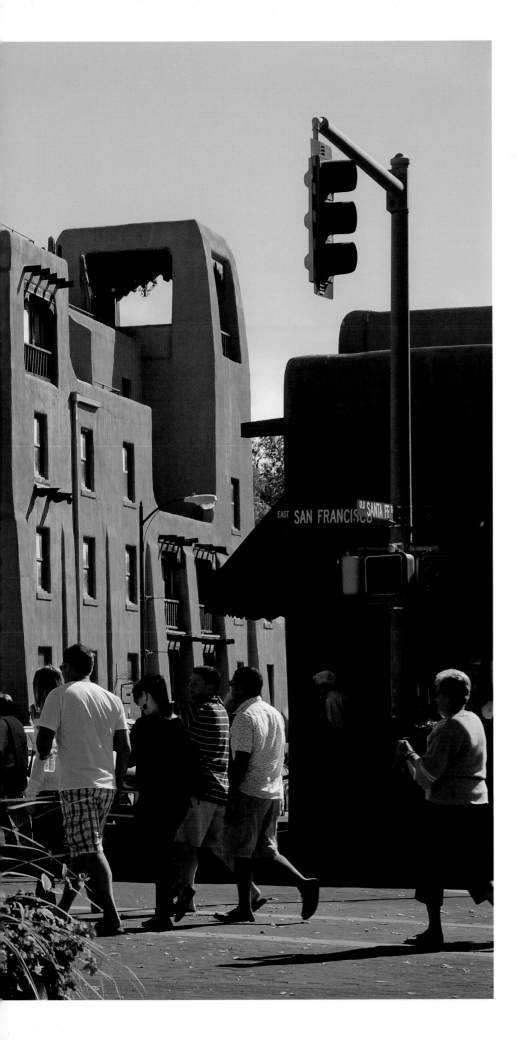

The site of LA FONDA on the Plaza, Santa Fe's oldest and best-known hotel, has been the location for inns since Spanish settlement. Located at the end of the Santa Fe Trail, the current La Fonda was built in 1922 and was a famous Harvey House during the railroad tourist era.

PREVIOUS SPREAD
MISTY soaks up sunlight in front of The Rainbow Man gallery on the Prince Plaza portal. A back room of the gallery was the check-in office for arriving Manhattan Project scientists during World War II.

FOLLOWING SPREAD
THE INN AT LORETTO is a modern example of Santa Fe's Pueblo Revival architecture. The large hotel was built in 1975 to resemble Taos Pueblo. It quickly became a Santa Fe landmark.

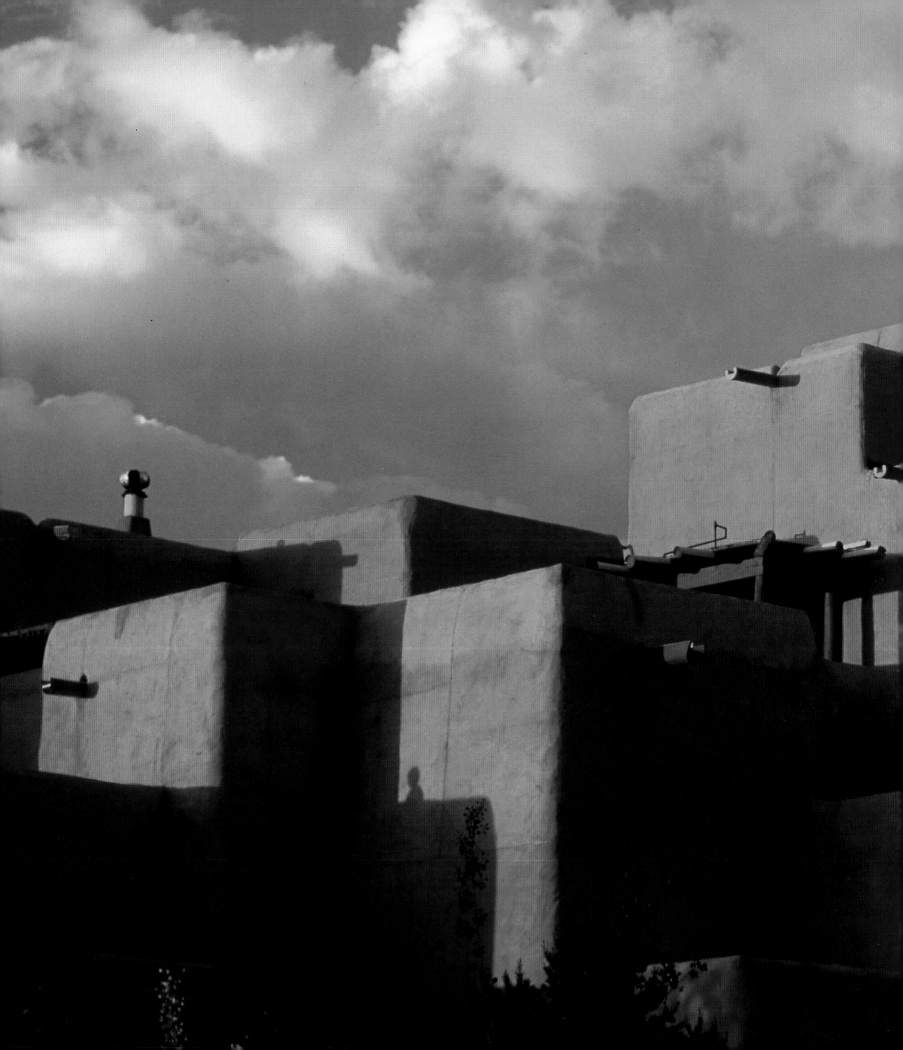

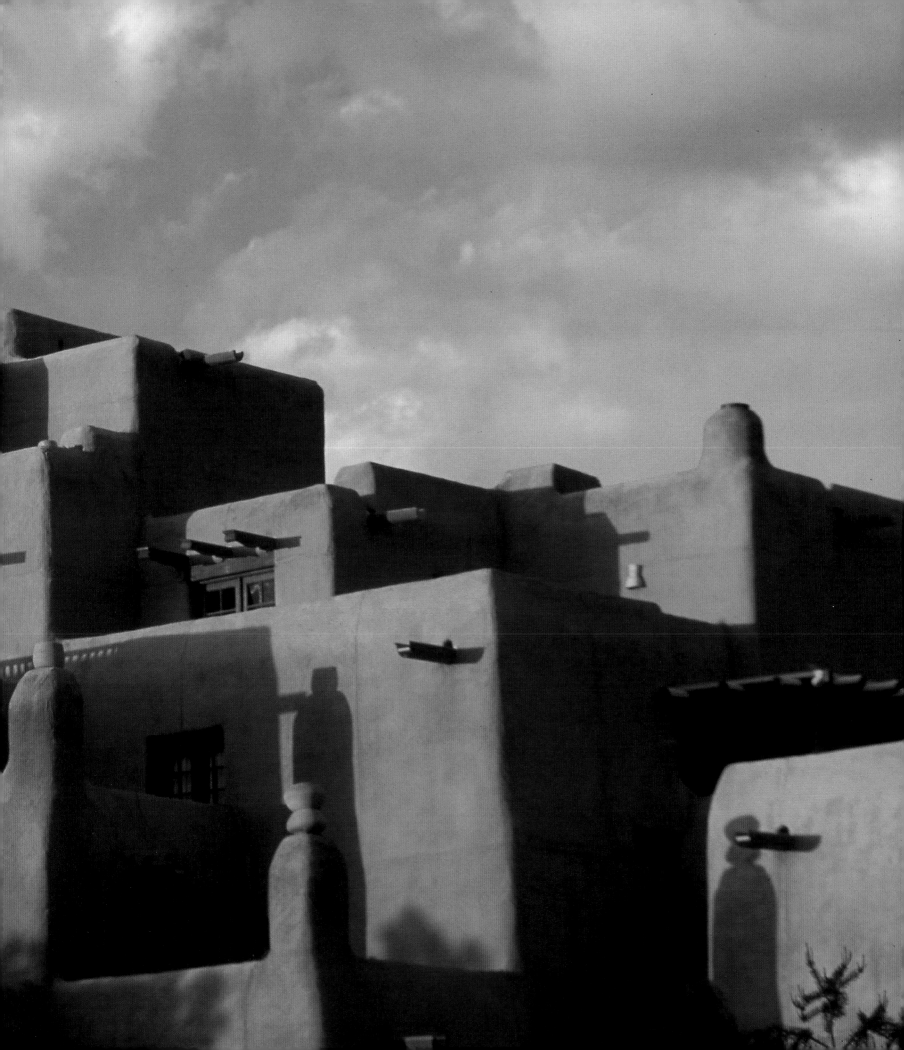

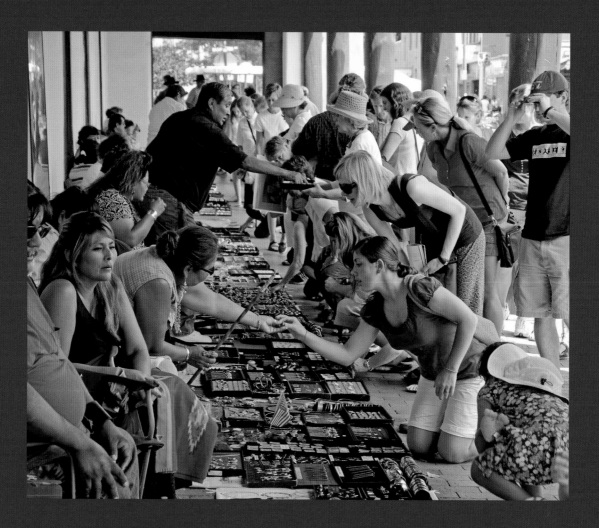

INDIAN ARTISTS have sold their work under the
Palace of the Governors portal for generations. Today,
the Native American Artisans Program regulates the
vendors and ensures that all wares are authentic and
handmade by New Mexico tribal members.

SUMMER

The first moment I saw the brilliant, proud morning shine high up over the deserts of Santa Fe, something stood still in my soul, and I started to attend.

—D. H. Lawrence

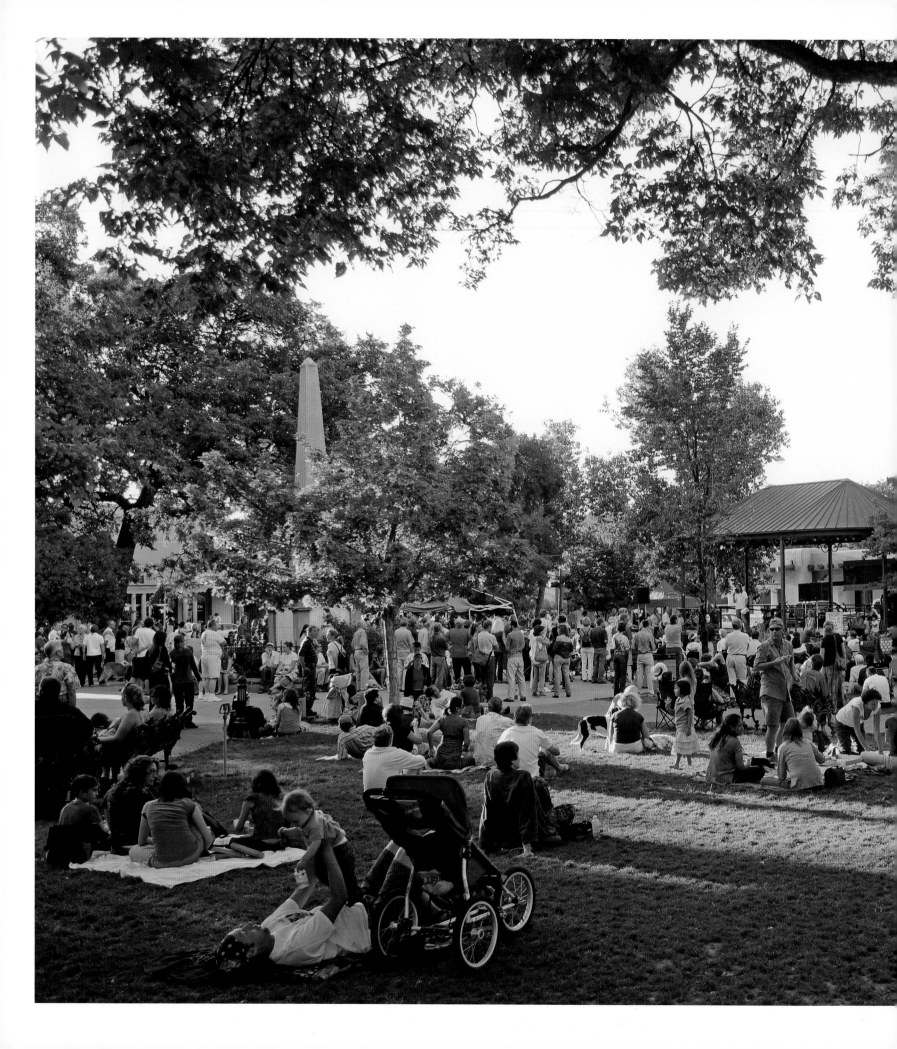

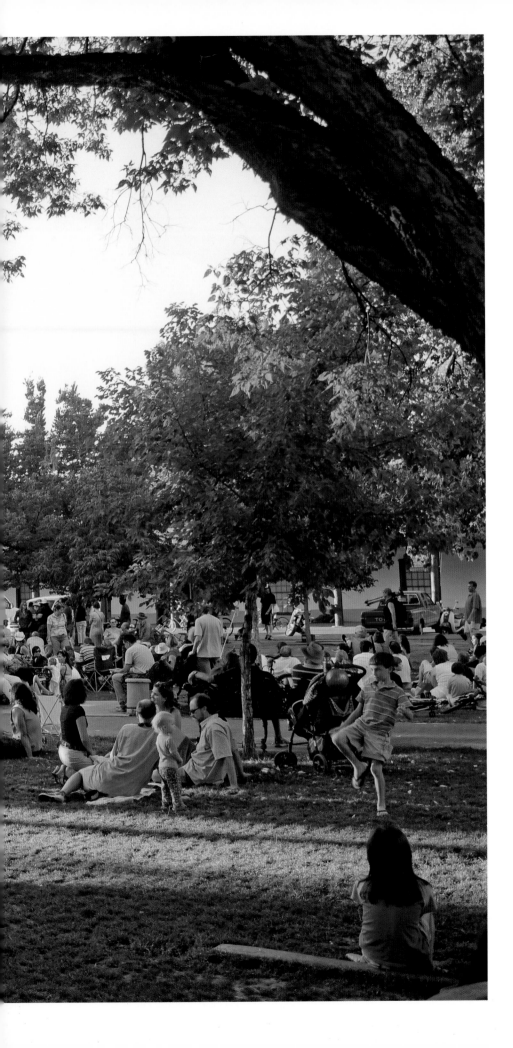

SANTA FE BANDSTAND
concerts invigorate the plaza
with music and dance on
summer evenings.

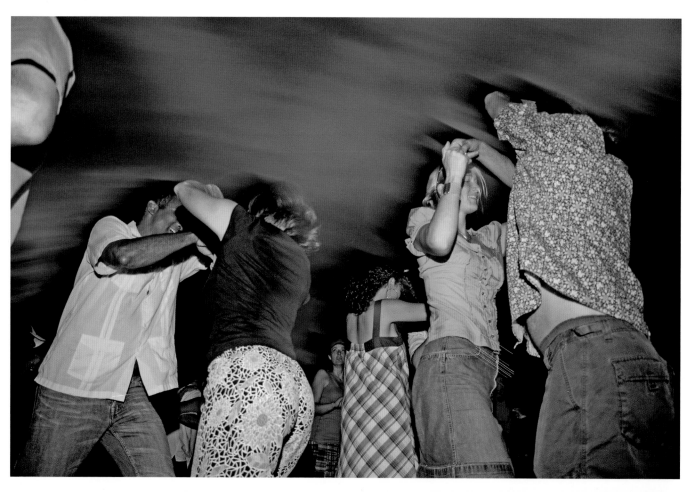
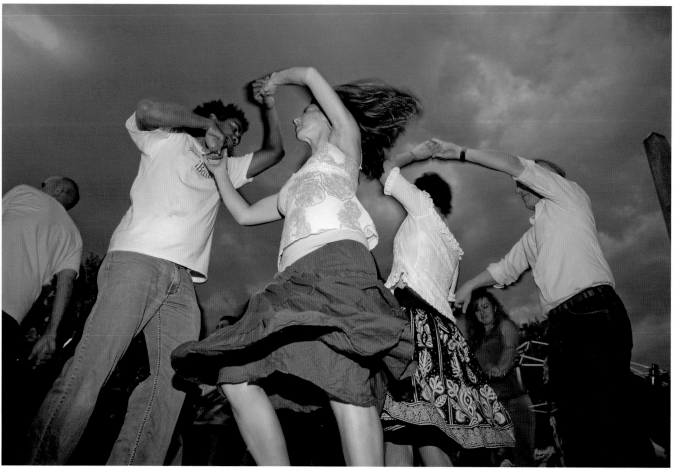

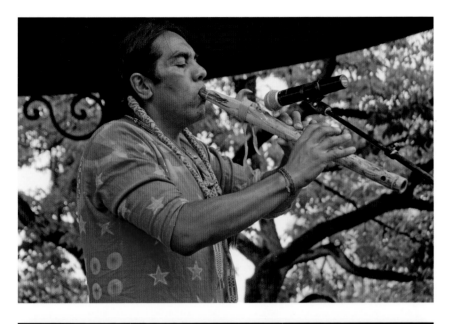

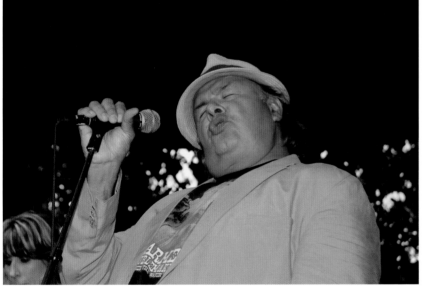

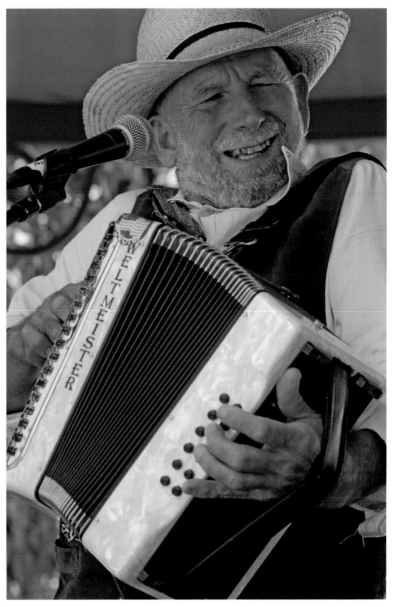

FROM TOP, CLOCKWISE

Grammy Award-winning ROBERT MIRABAL (Taos Pueblo)
plays to a big plaza audience. The free concert series, created by David
Lescht in 2002, is the centerpiece of summertime on the plaza.

Multi-instrumentalist MICHAEL COMBS plays an
encyclopedic range of American and Hispano folk music.

Artist and actor GARY FARMER (First Nations)
belts out the blues with his band The Troublemakers.

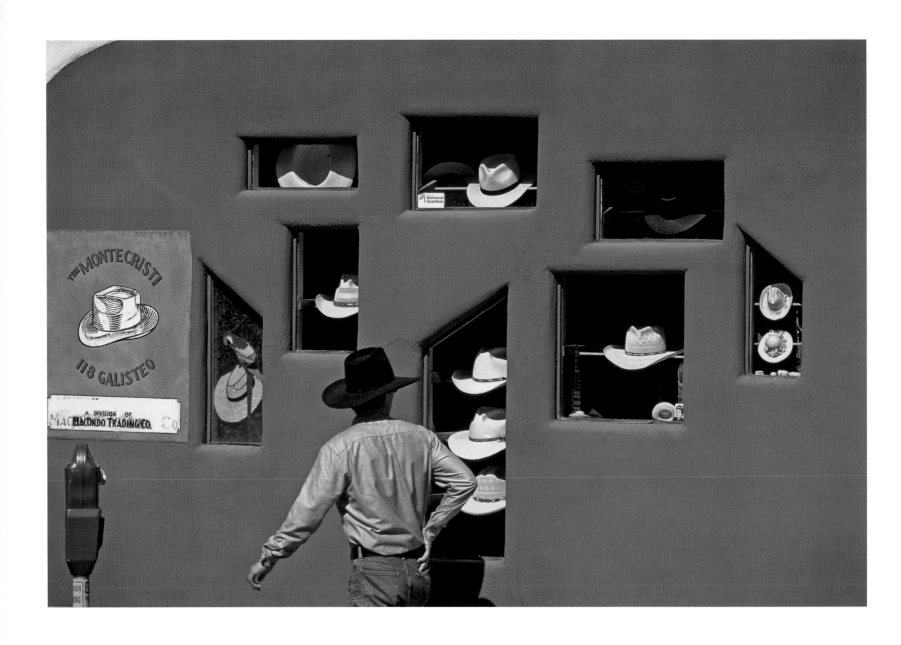

MONTECRISTI CUSTOM HAT WORKS
is one of many plaza area shops
catering to a high-end clientele.

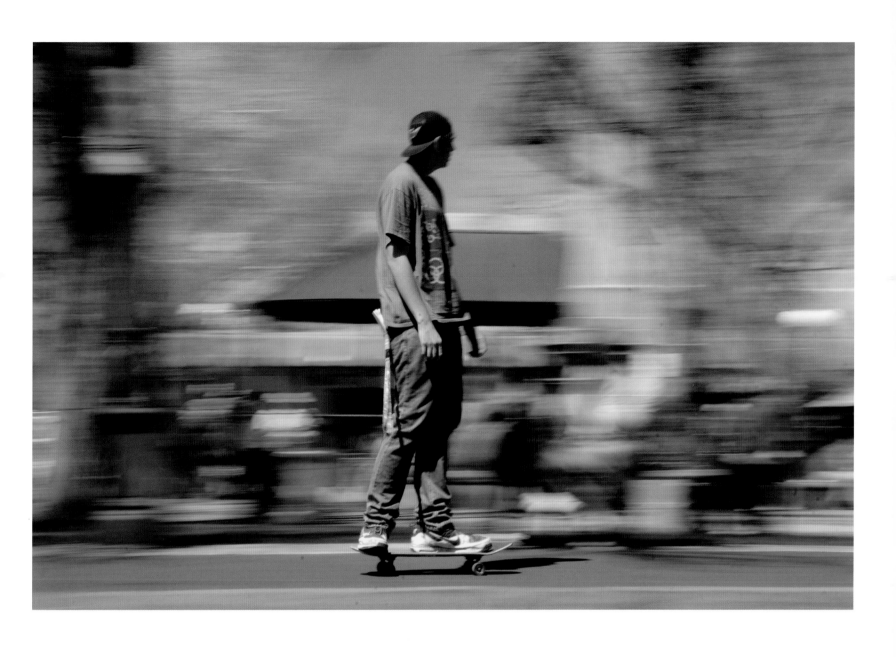

A young SKATEBOARDER
sails through the plaza
on a summer day.

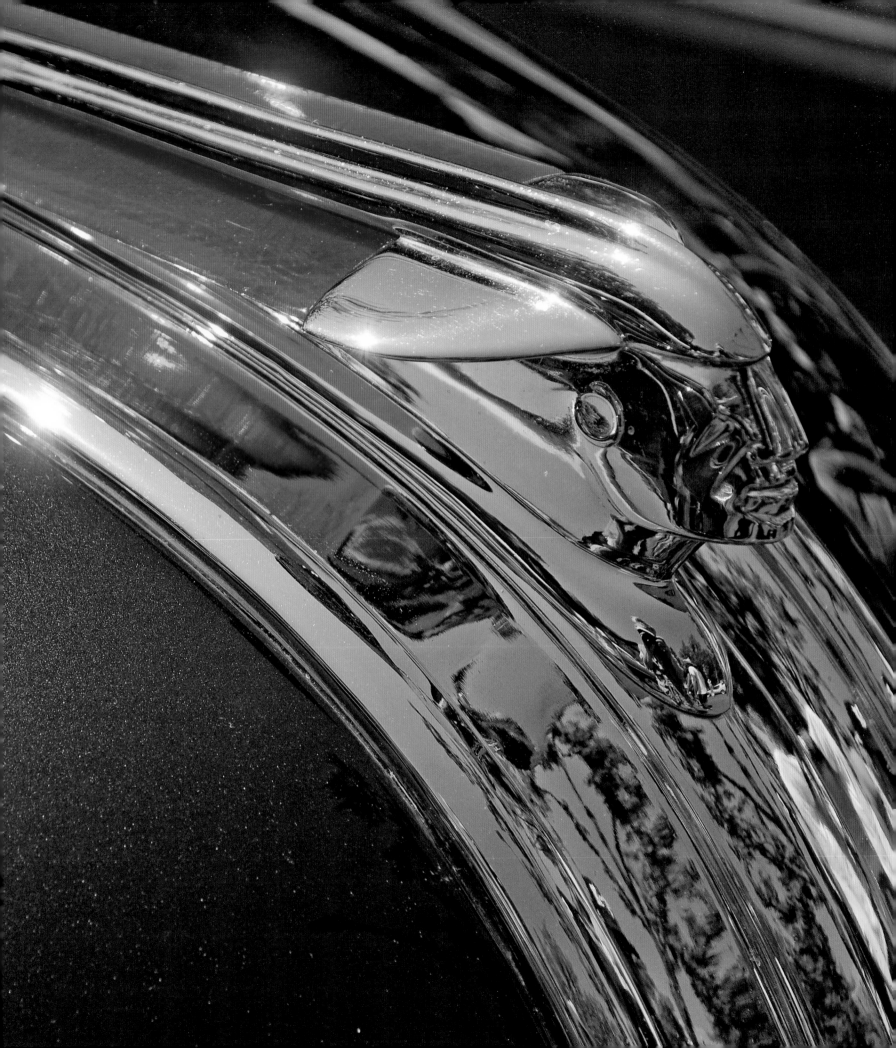

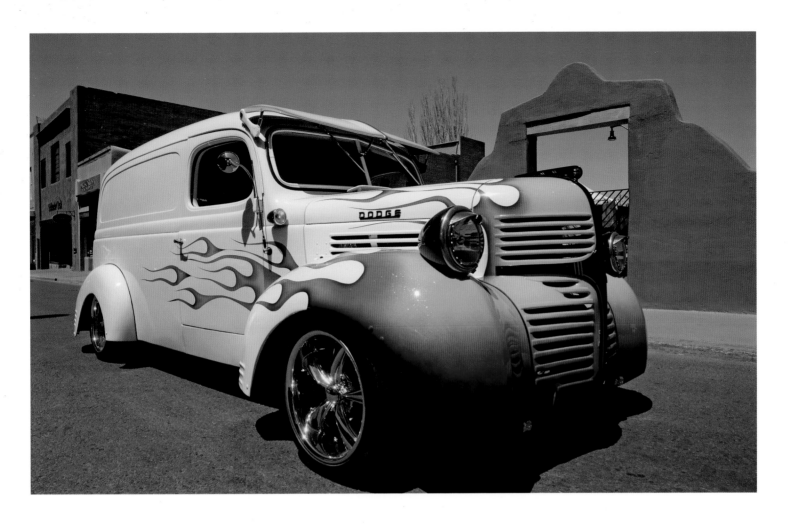

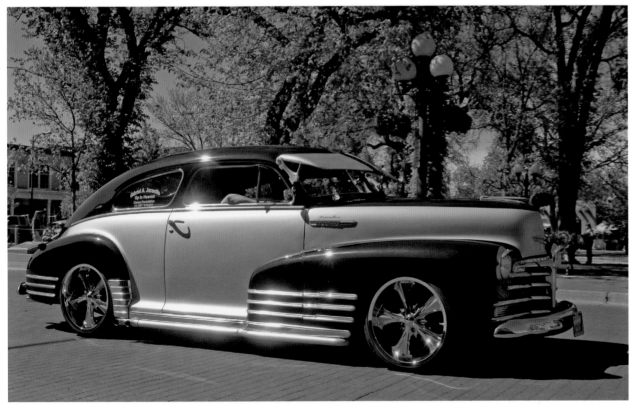

A custom 1946 Dodge delivery van approaches the plaza from West San Francisco Street. CRUISING THE PLAZA in style is a time-honored local tradition that may be as old as the town itself.

A '48 Chevy Fleetline "LOWRIDER BOMB" cruises the plaza like a royal flagship. Sonnie Jaramillo maintains and drives the car as a family shrine and memorial for his son Gabriel, who died of cancer at the age of twenty-three. The car appears often at cancer fund-raising events.

OPPOSITE PAGE
The antique HOOD ORNAMENT of a 1948 Pontiac Streamliner shines like a religious icon at one of many classic car shows on the plaza.

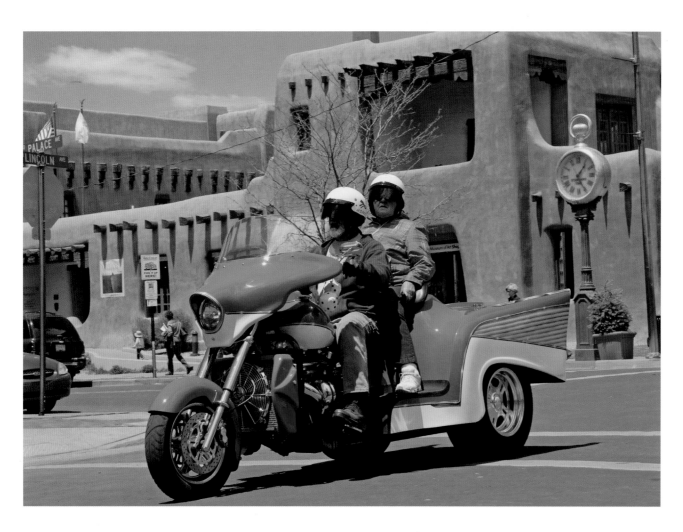

A BOSS HOSS '57 Chevy trike motorcycle. Bikes, trikes, and an endless variety of other wheeled vehicles cruise the plaza on sunny weekends.

BELOW
JOAQUIN MONTOYA rides like a king as Sara Henley powers their custom V8 trike motorcycle along West San Francisco Street. A variety of V8 trikes are everyday visitors to the plaza.

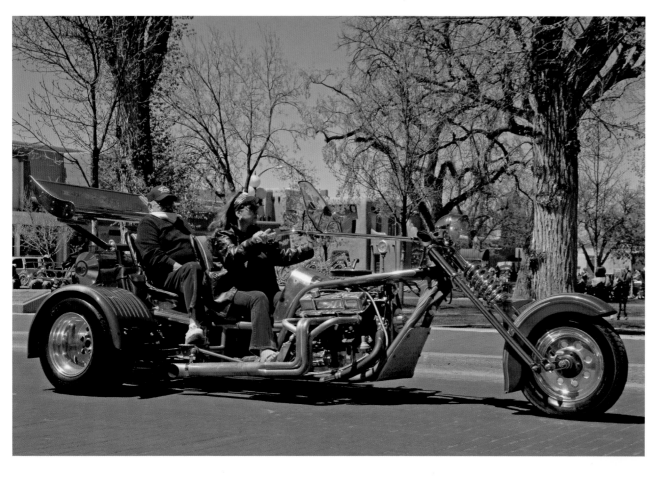

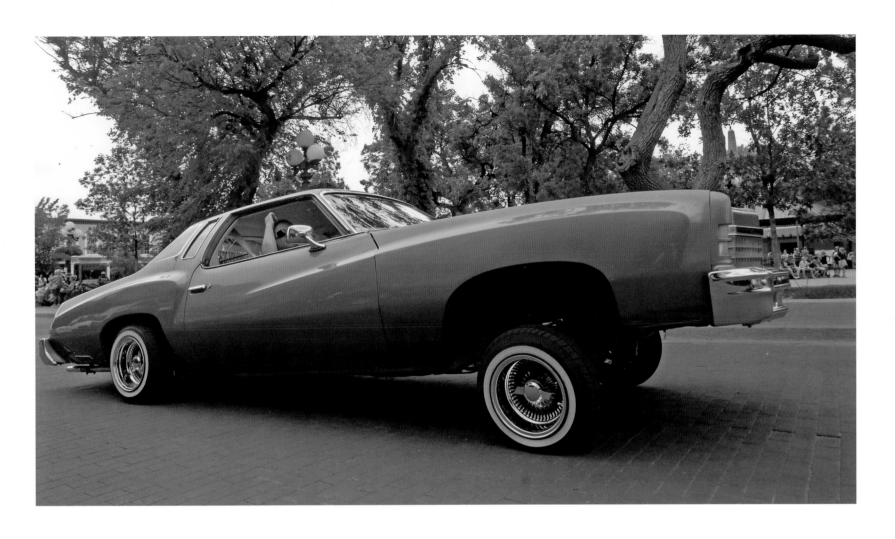

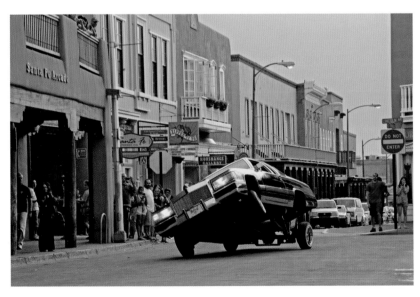

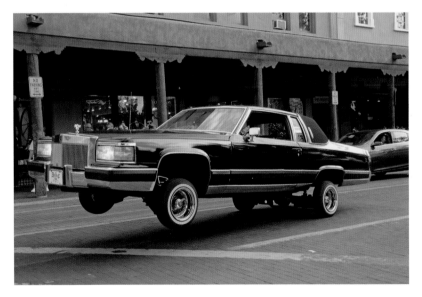

FROM TOP, CLOCKWISE

A '74 CHEVROLET MONTE CARLO.

Lincoln Town Car. LOCAL LOWRIDERS slowed plaza-area traffic to a crawl on weekends, until discouraged by law enforcement in the late 1980s. Their plaza performances today are special occasions.

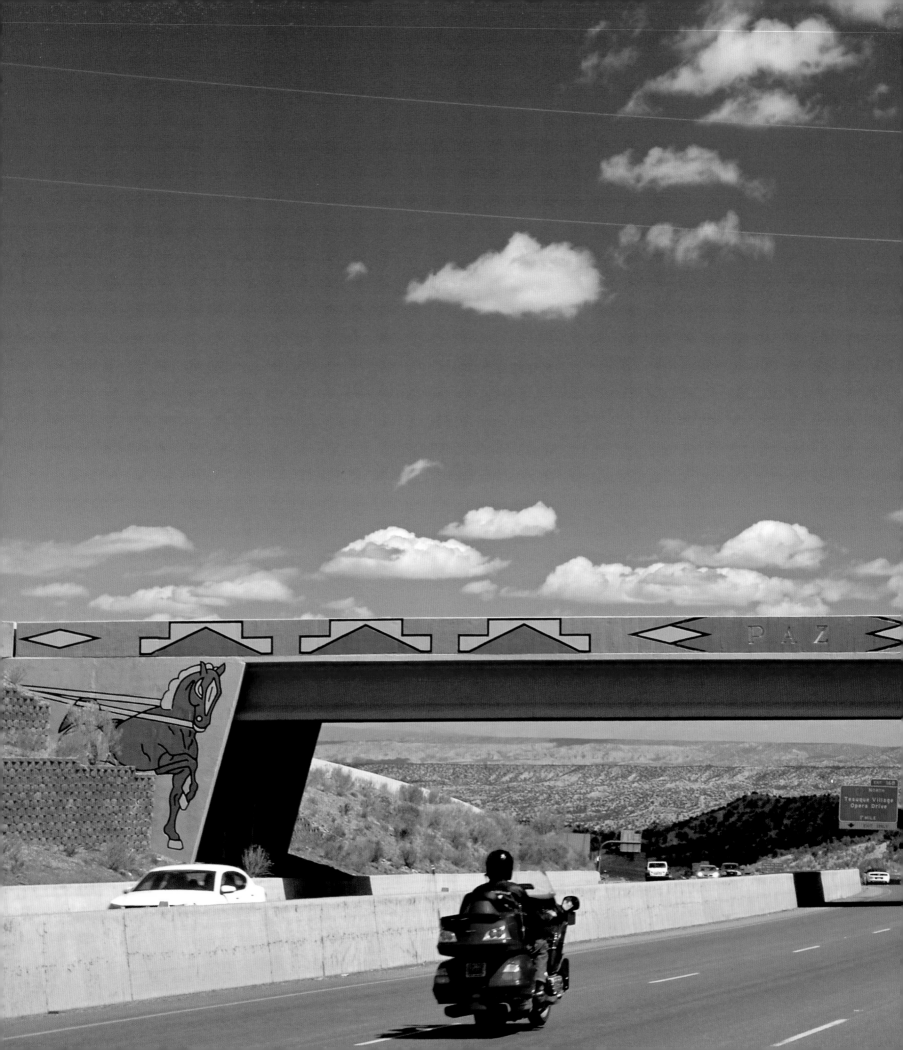

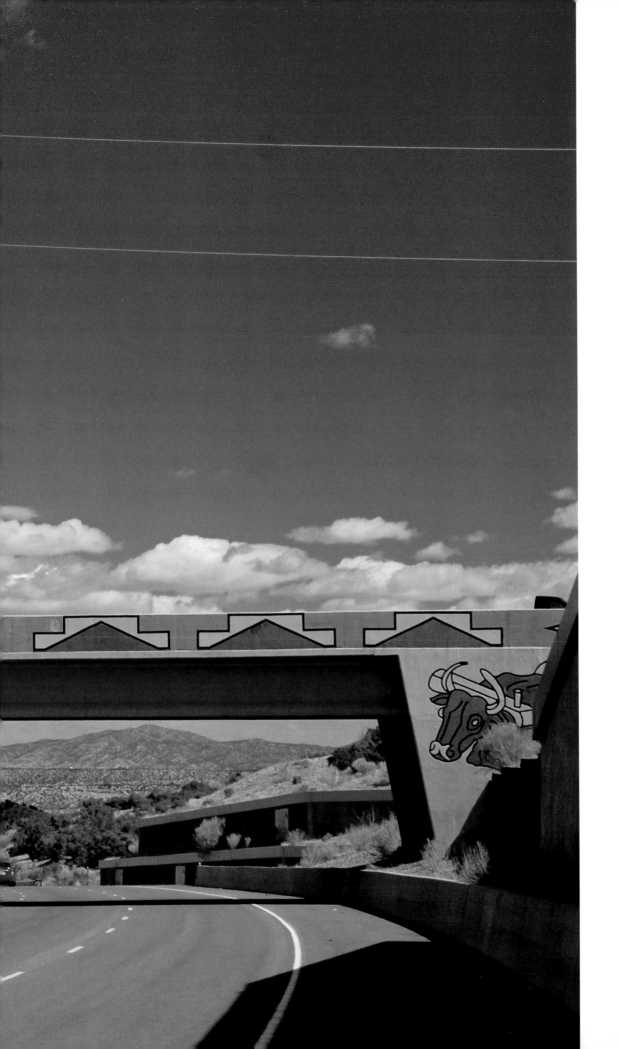

Tile mural designs by FEDERICO VIGIL decorate an overpass spanning U.S. 84/285, Santa Fe's gateway to all destinations north. The highway through the Pojoaque Corridor also features mural designs by Tesuque Pueblo's Anthony Dorame and Pojoaque Pueblo's George Rivera.

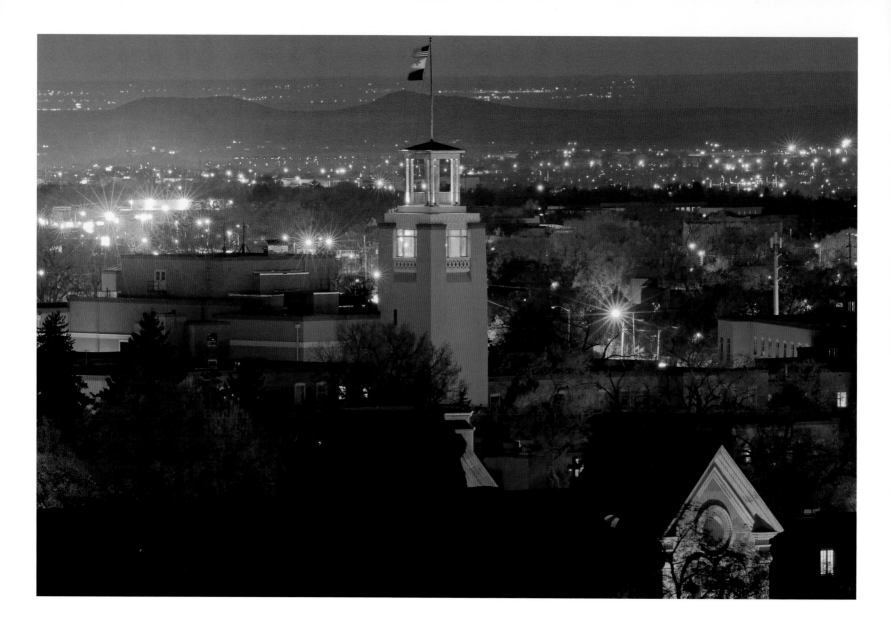

Santa Fe's skyline is punctuated by the tower
of the BATAAN MEMORIAL BUILDING, one
of the tallest structures in the city.

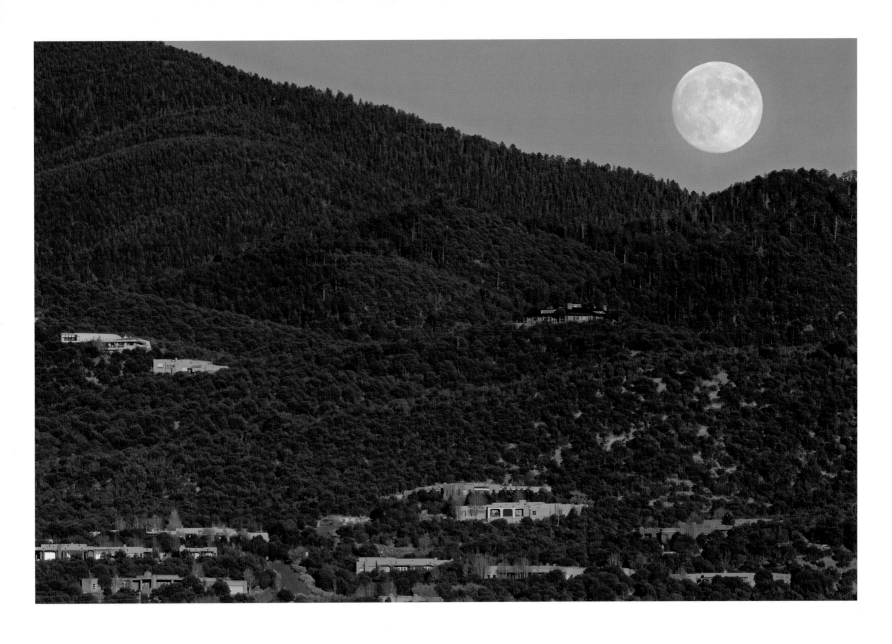

The foothills of the SANGRE DE CRISTO
MOUNTAINS rise east of town.

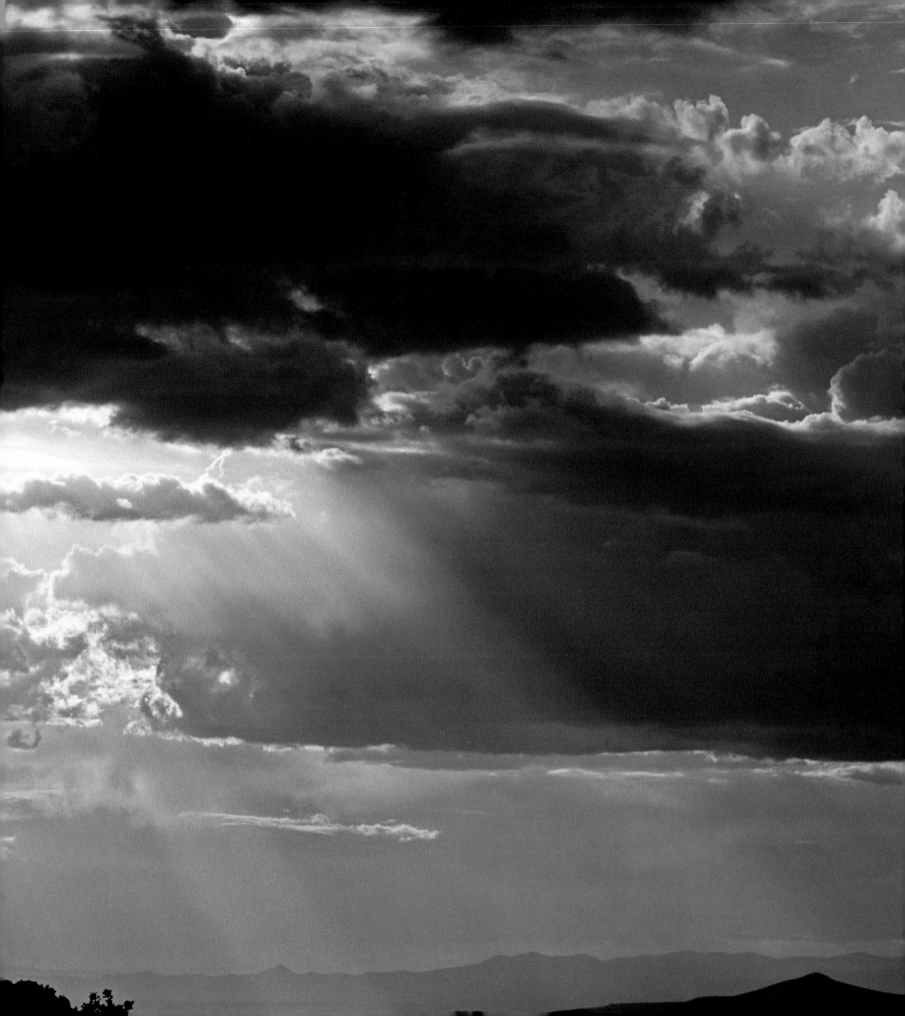

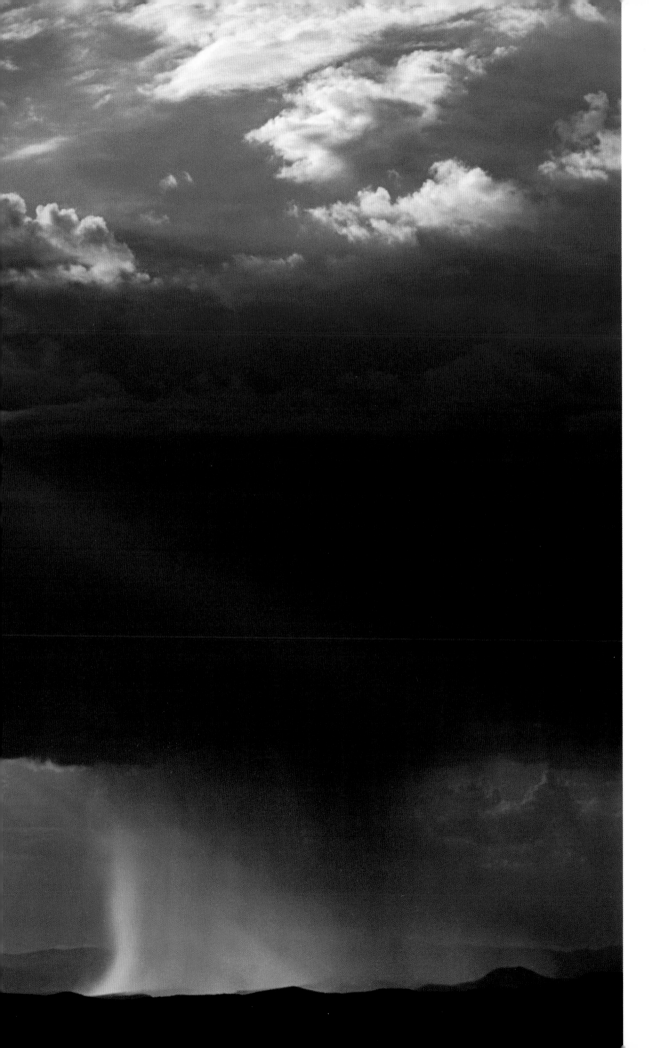

WALKING RAIN strolls the vast
openness west of town.

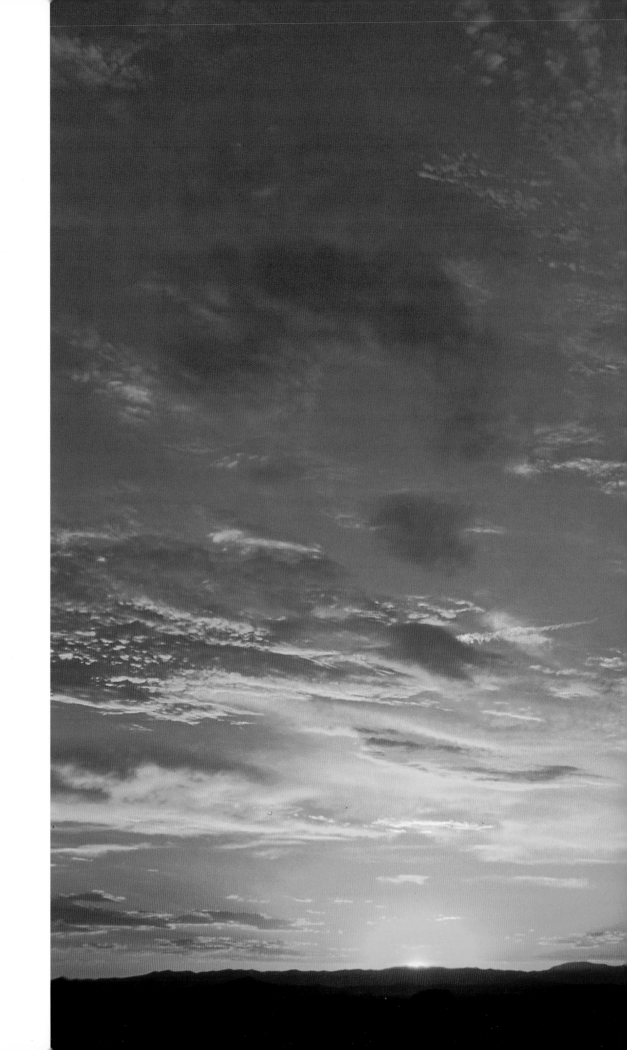

HIGH AND DRY at an altitude of 7,000 feet, Santa Fe is famous for its spectacular skies and sunsets.

FOLLOWING SPREAD
TREMENDOUS LIGHTNING STORMS are an almost daily occurrence during New Mexico's July and August monsoon season.

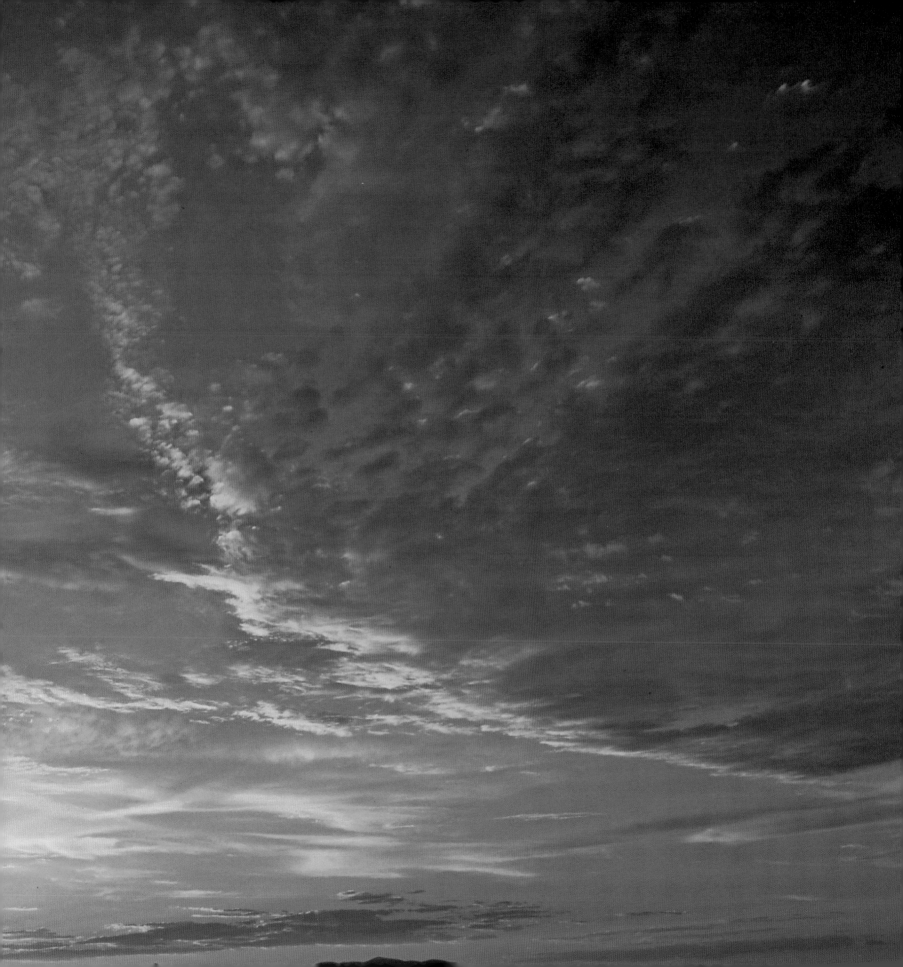

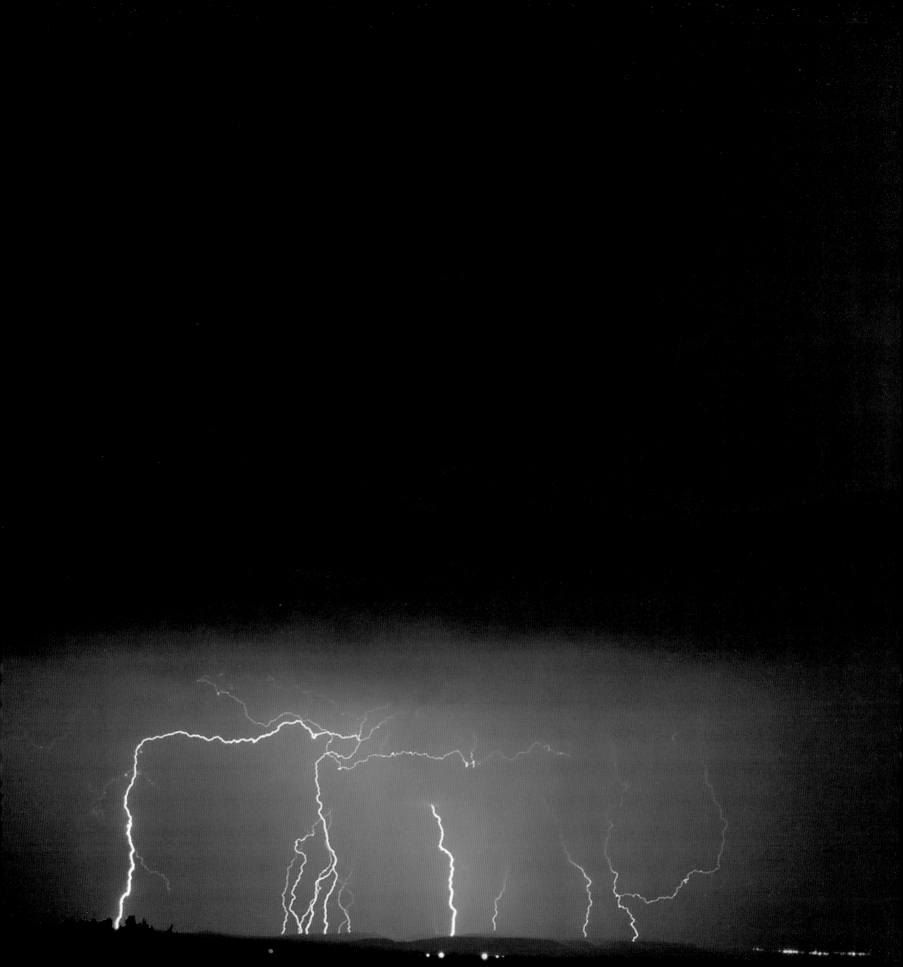

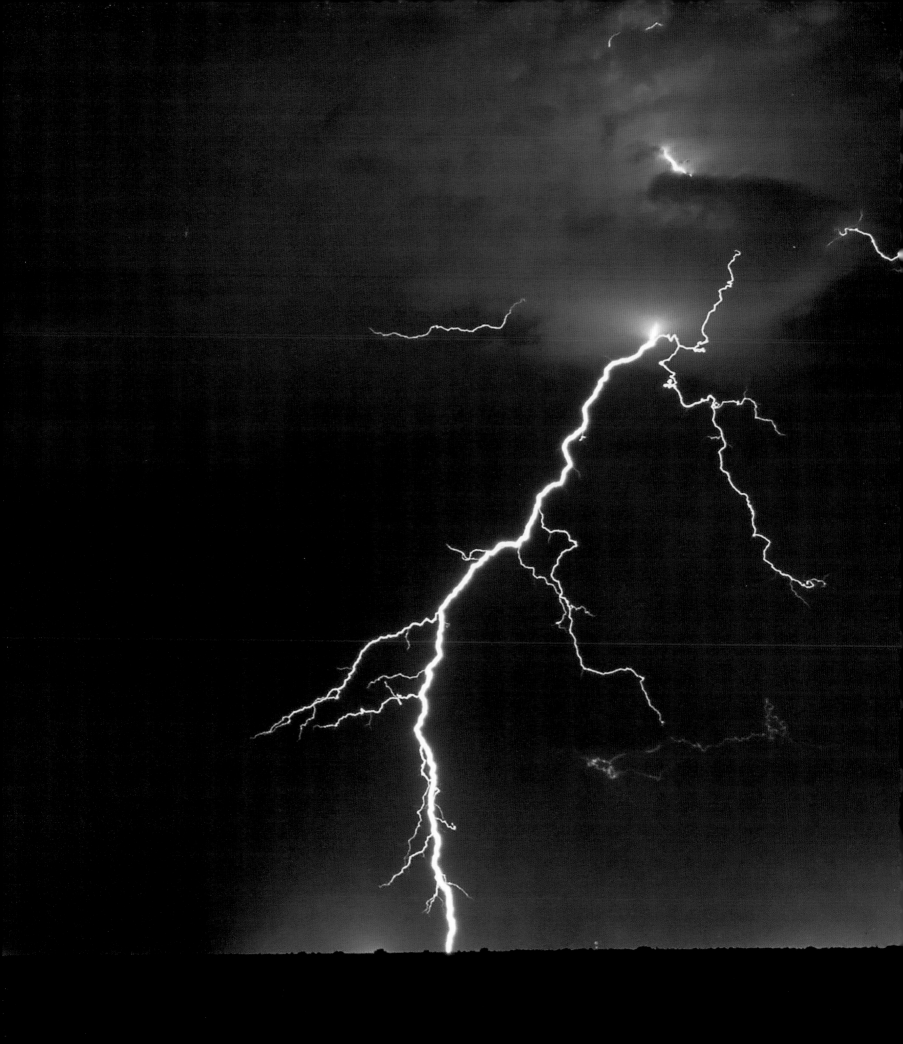

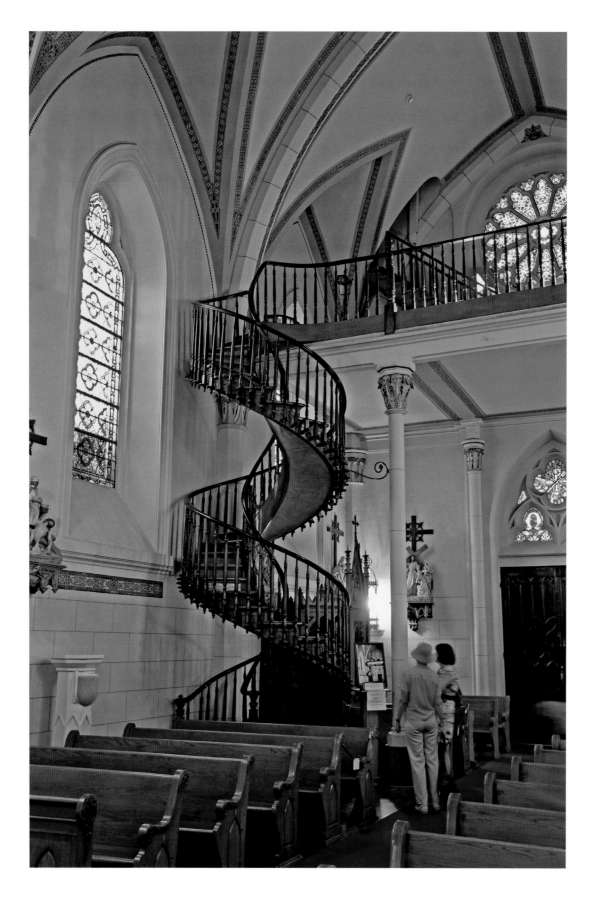

The MIRACULOUS STAIRCASE of the gothic-revival Loretto Chapel, which reveals no visible means of support, is one of Santa Fe's most popular tourist and wedding destinations.

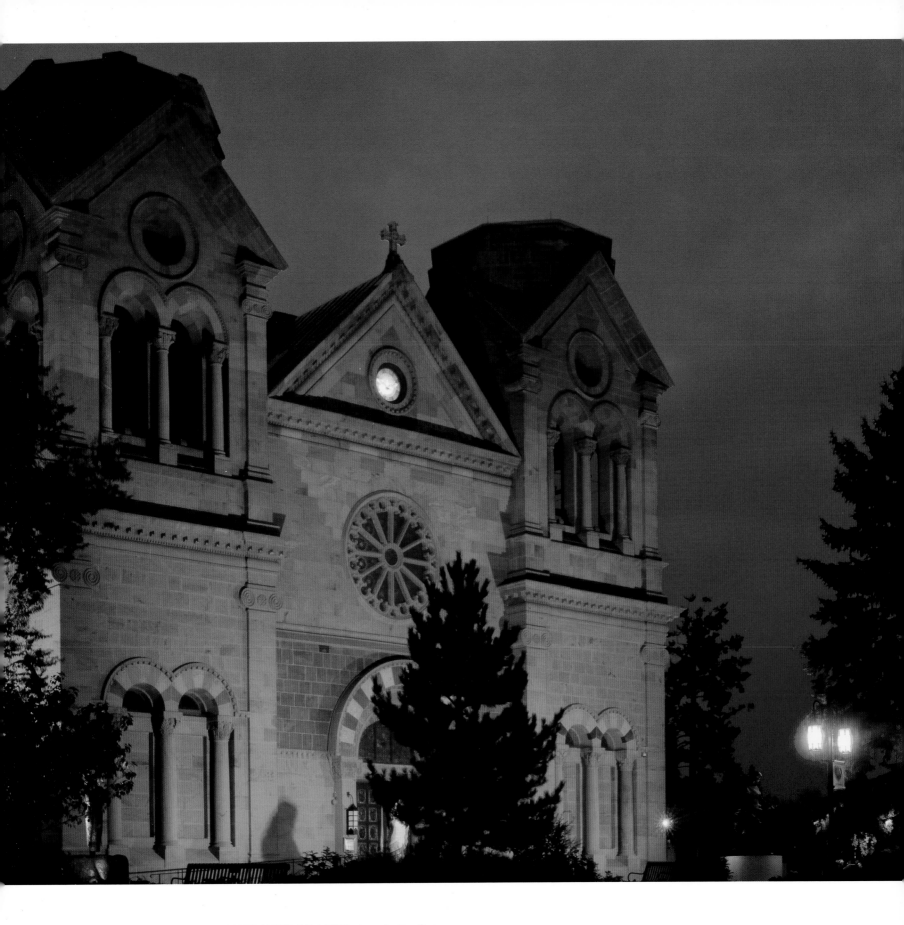

THE CATHEDRAL BASILICA OF SAINT FRANCIS OF ASSISI glows in the first
light of daybreak. Archbishop Jean Baptiste Lamy built the Romanesque
Revival-style cathedral between 1869 and 1886 as a clean break from the
town's Spanish influence. It is the third church building to occupy this
commanding site at the heart of downtown.

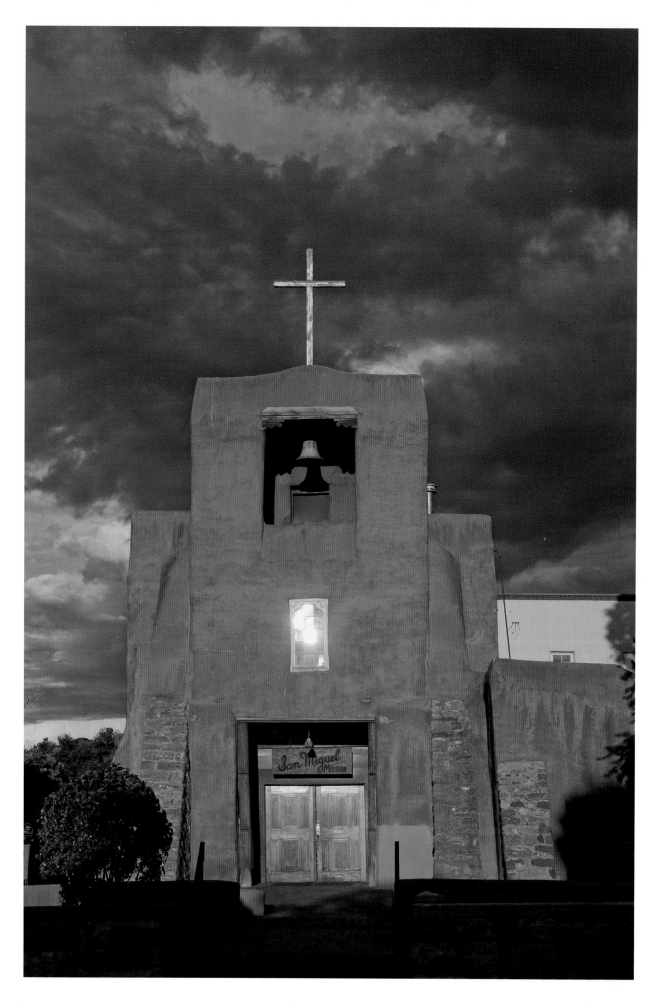

Built in the early 1600s, the SAN MIGUEL MISSION is recognized as the oldest church building in the United States. Santa Fe was founded as the "Royal Town of the Holy Faith of Saint Francis of Assisi" and is a community rich in religion and spirituality.

OPPOSITE
The MORADA DE LA CONQUISTADORA on Calvary Hill is a Penitente meetinghouse reconstructed at El Rancho de las Golondrinas living history museum.

The PENITENTE MORADA AT ABIQUIU echoes the deeply spiritual nature of rural New Mexico. Los Hermanos Penitentes is a unique lay brotherhood of Hispanic Catholics formed in the isolation and harshness of rural Northern New Mexico in the 1700s. The Penitente Brotherhood remains active today.

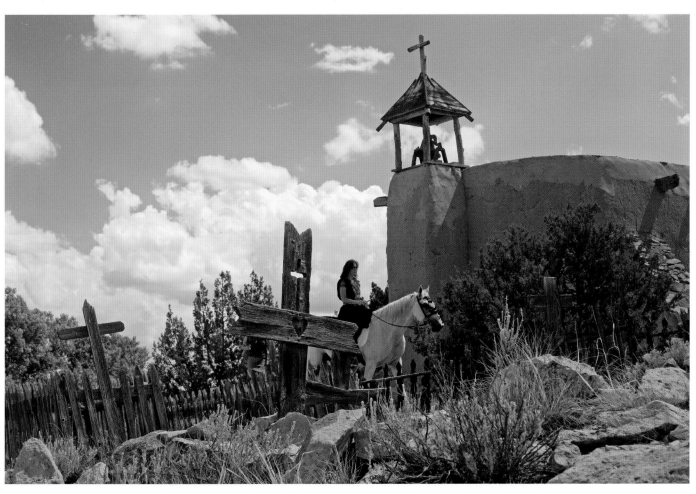

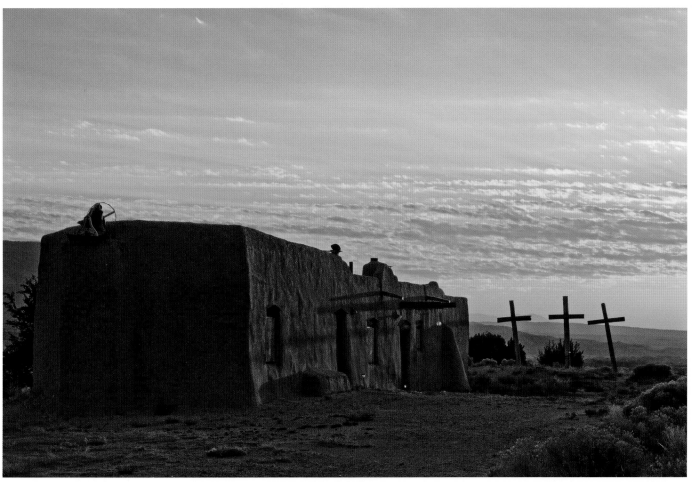

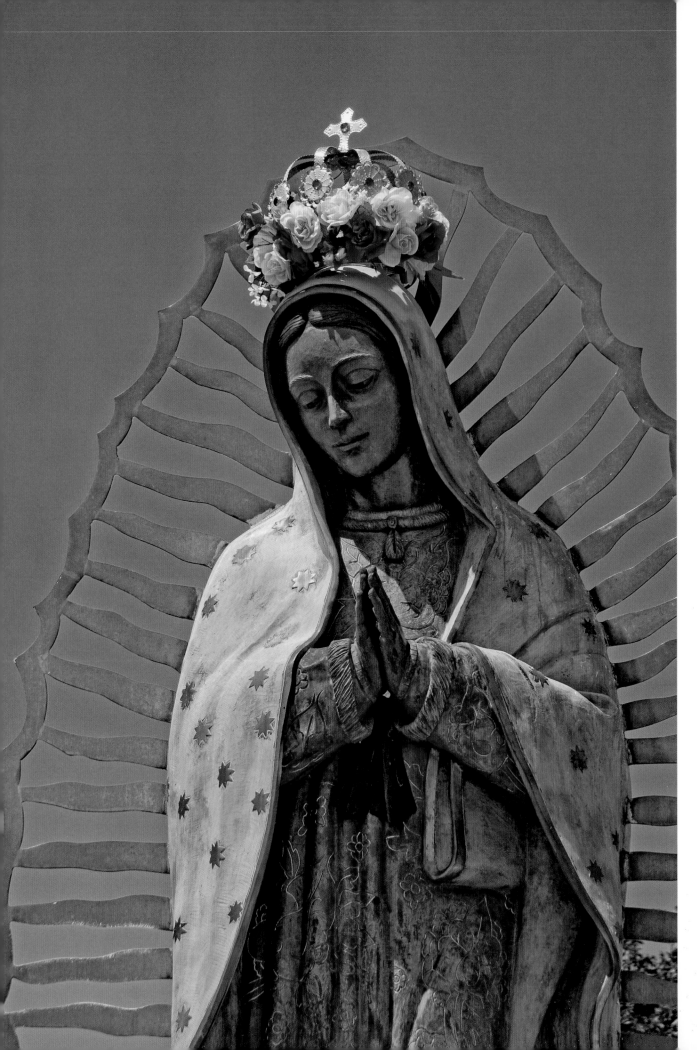

The Virgin of Guadalupe, or OUR LADY OF GUADALUPE, has been a New Mexico devotion since the Spanish reconquest of 1692. Her 12-foot bronze statue traveled the historic Camino Real to its home at El Santuario de Nuestra Señora Guadalupe.

Shrine and church ruin, ABIQUIU.

INTERNATIONAL FOLK ART MARKET

The world comes to Santa Fe in July for the International Folk Art Market, the largest event of its kind for authentic folk art and a force for economic and cultural sustainability for folk artists. It is Santa Fe's newest and most exotic arts market and among the most popular.

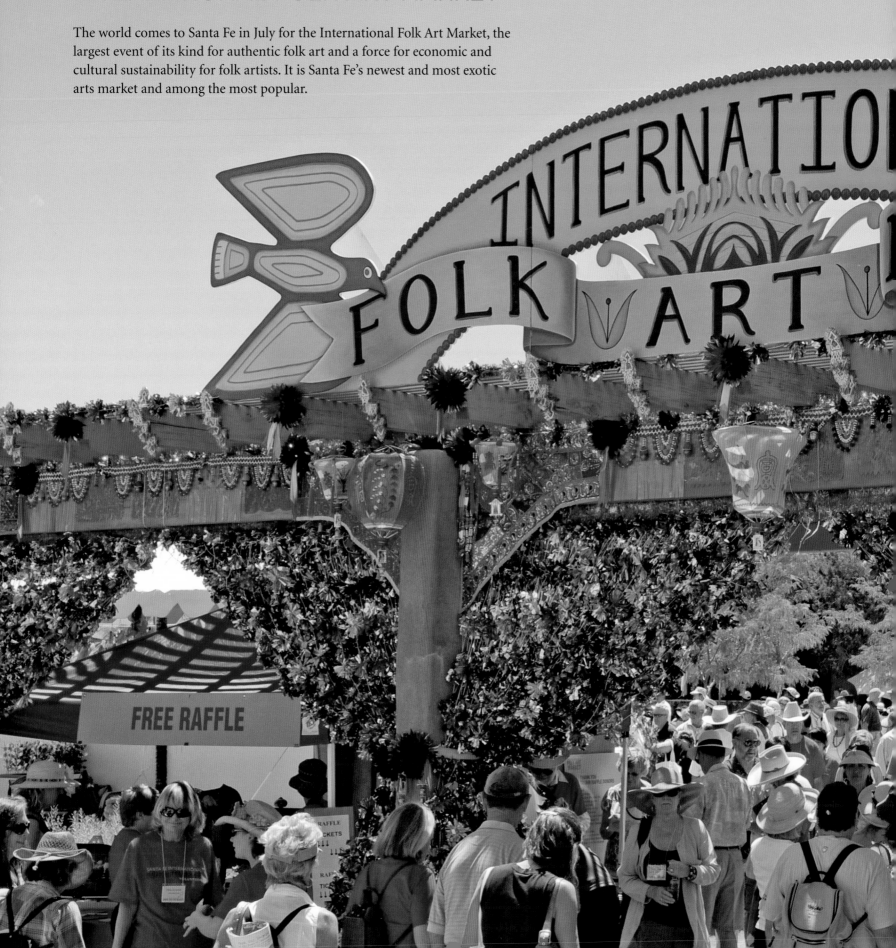

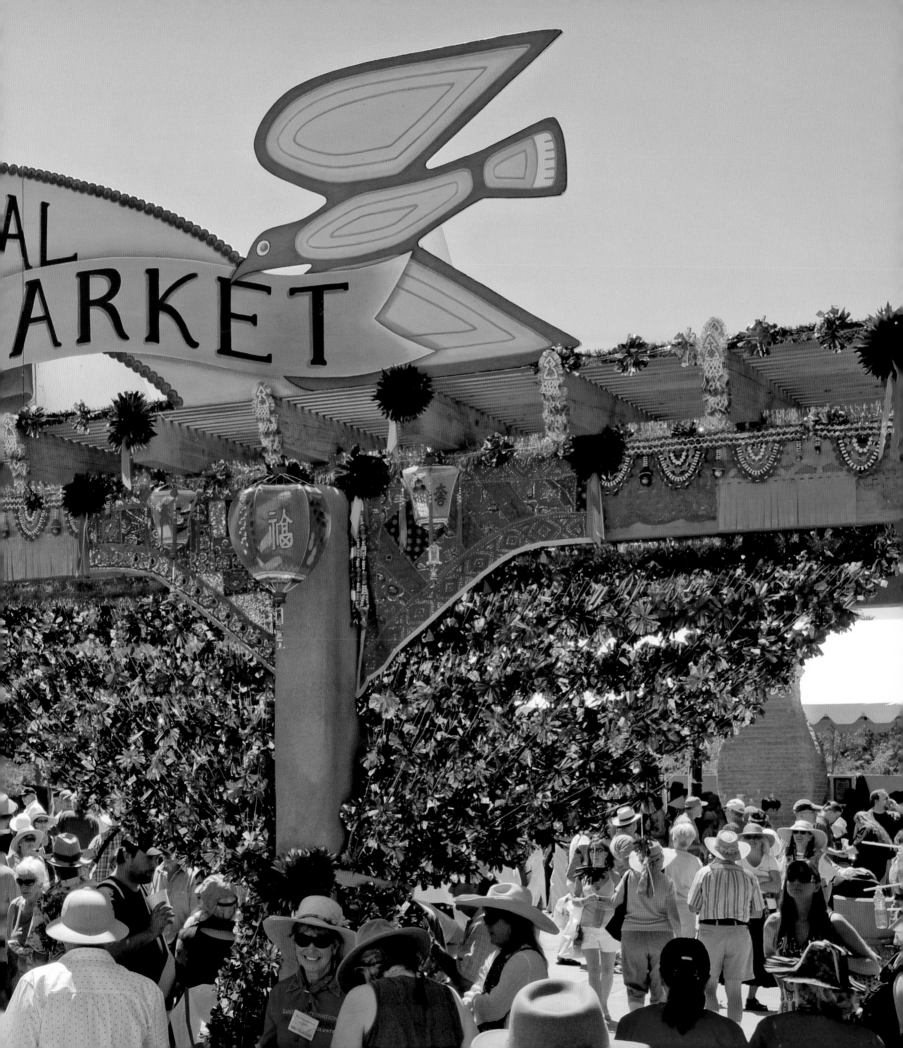

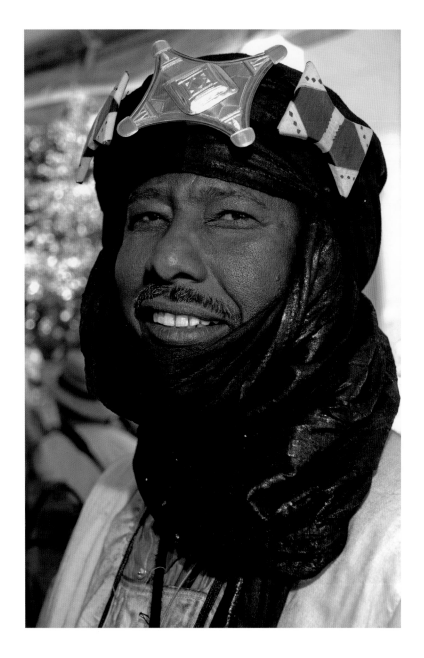

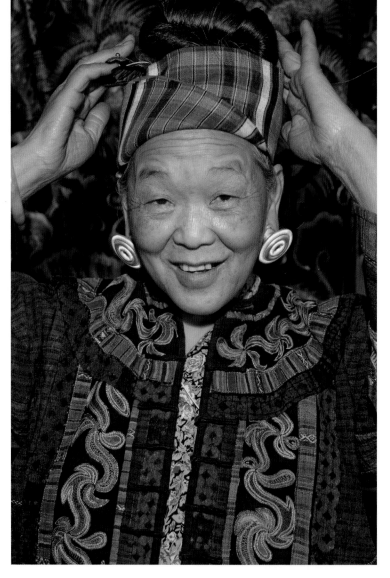

MOUSSA ALBAKA is a traditional Tuareg silversmith from Niger.

PAN YUZHEN of Minority People Textile Folk Artists Cooperative of southwest China creates fine embroidered textiles and clothing.

PREVIOUS SPREAD
Thousands of visitors pass through MILNER PLAZA on Museum Hill during the three-day International Folk Art Market.

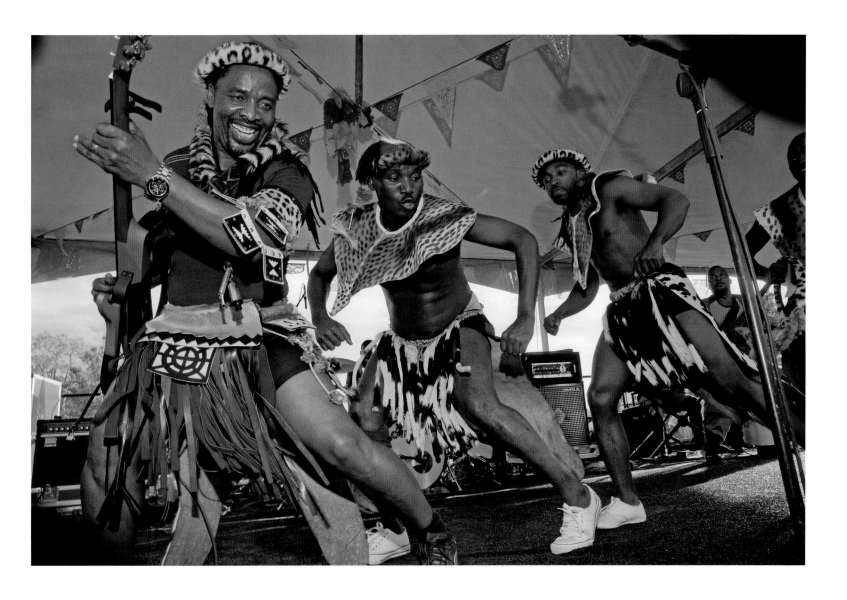

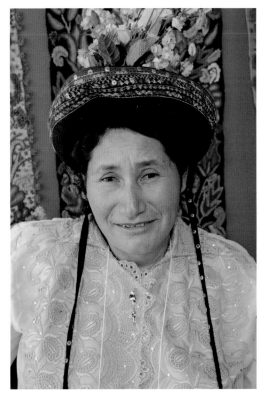

The world famous MASKANDI ZULU GROUP Ihashi Elimhlophe of South Africa ignites the crowd at the market's Thursday free opening events at the Railyard.

LUZMILA HUARANCCA GUTIÉRREZ of Peru creates traditional Wari hand-embroidered weavings.

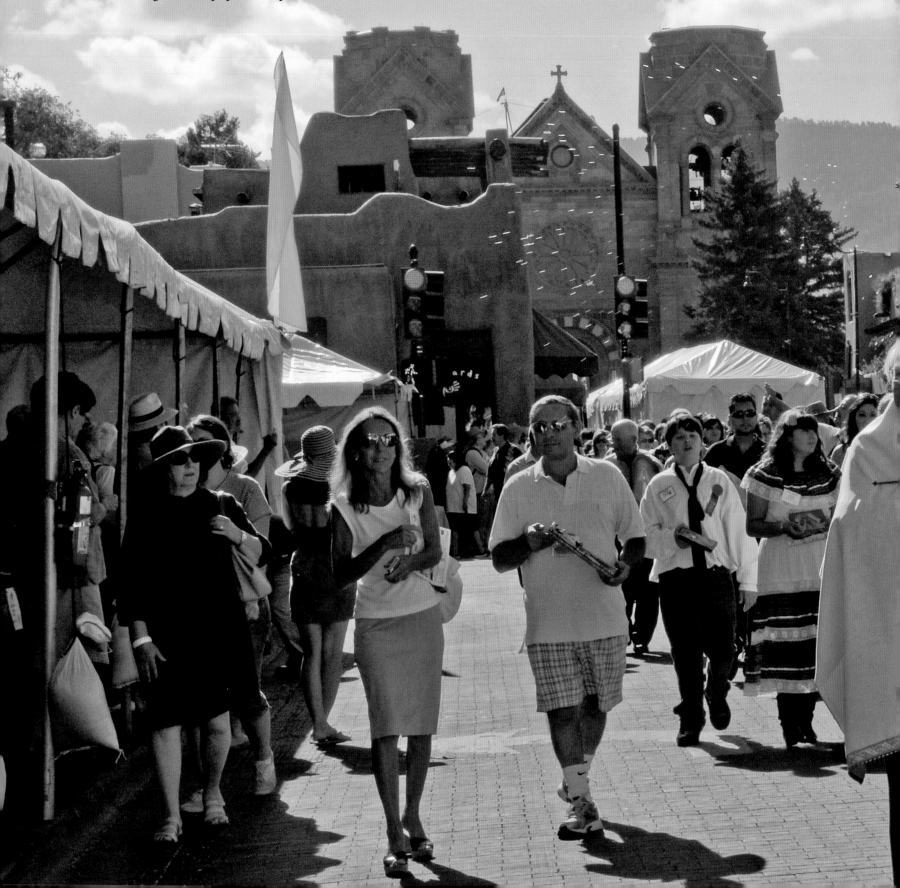

SPANISH MARKET

The rich Hispanic culture is celebrated annually in July at Traditional Spanish Market and Contemporary Hispanic Market, the largest markets dedicated to traditional religious and popular Hispanic arts in the United States.

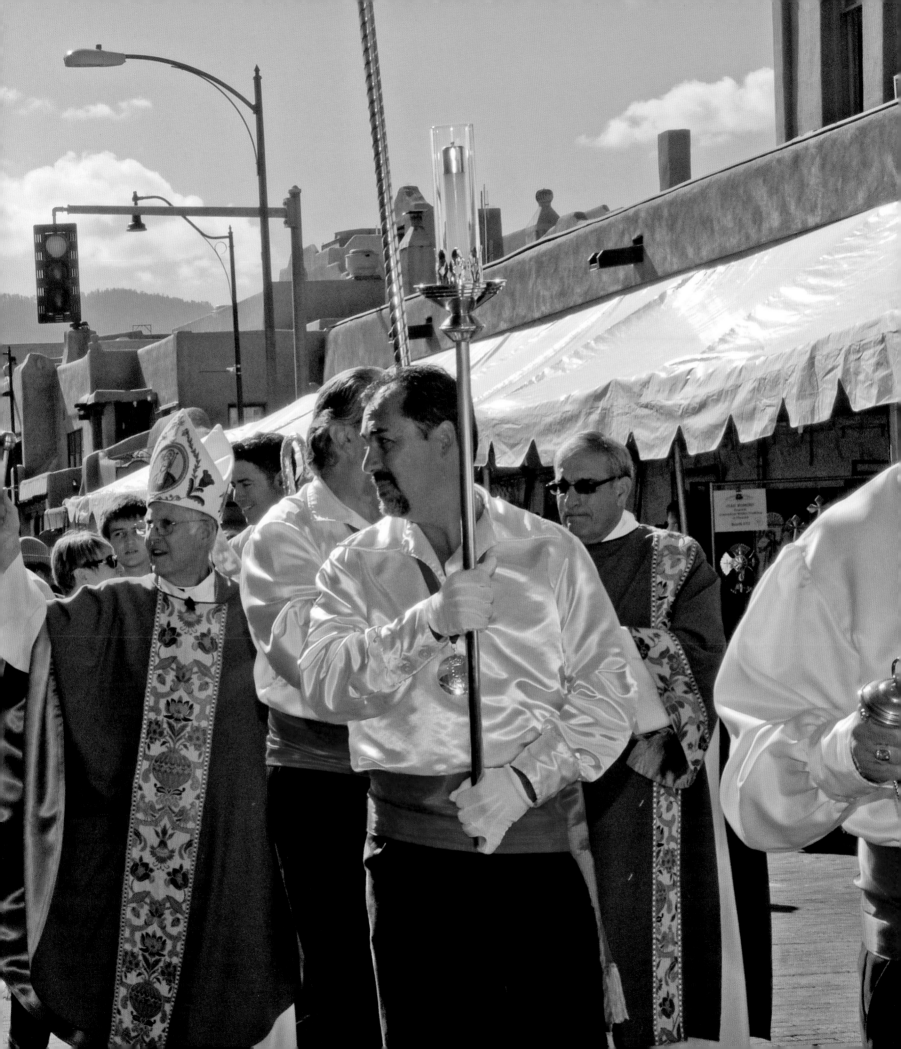

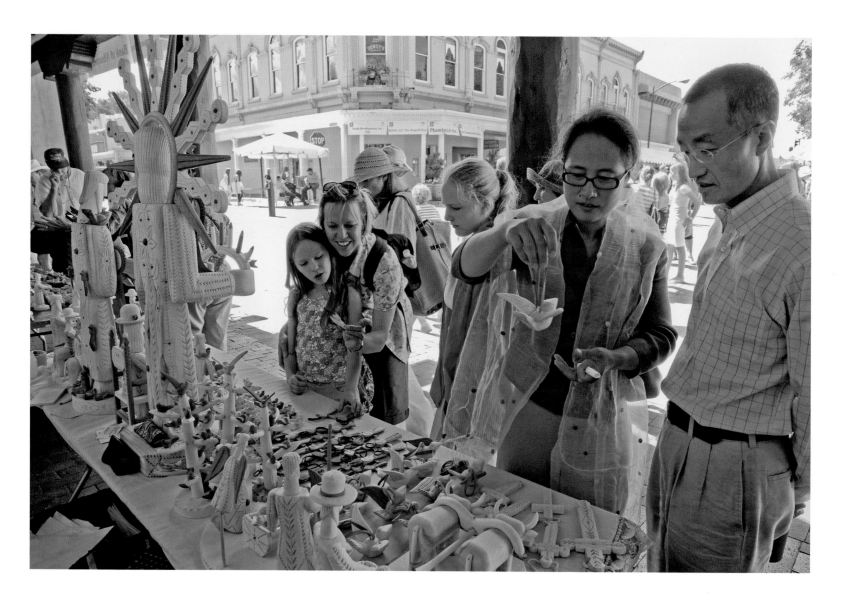

Shoppers admire unpainted carvings made by GLORIA LOPEZ CORDOVA.

PREVIOUS SPREAD
ARCHBISHOP MICHAEL SHEEHAN blesses Traditional Spanish Market booths with holy water during the artists procession.

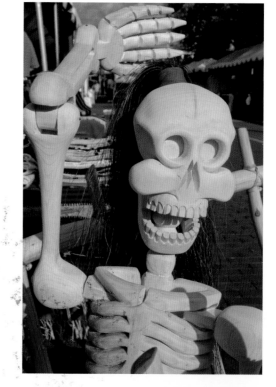

ROBERTO BARELA'S unpainted *bulto* skeleton waves to market shoppers.

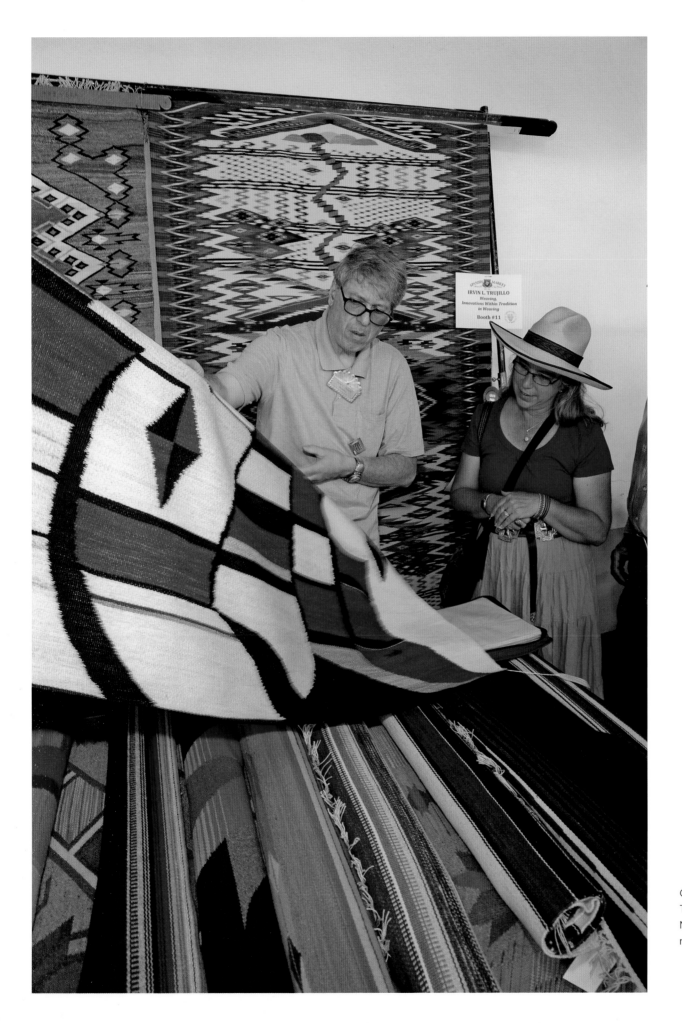

Chimayó weaver IRVIN TRUJILLO has received Spanish Market's Best of Show award numerous times.

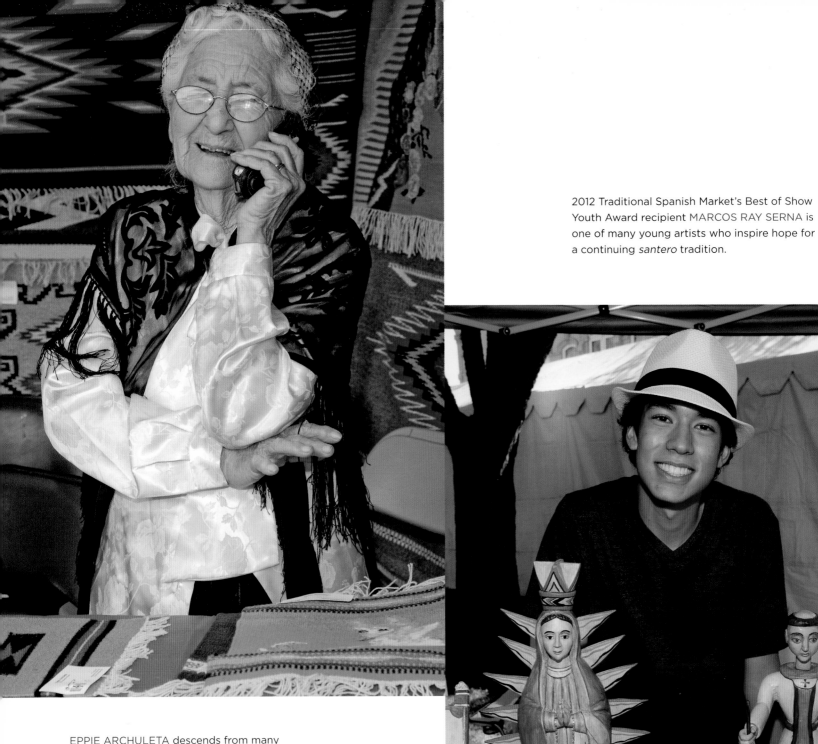

2012 Traditional Spanish Market's Best of Show Youth Award recipient MARCOS RAY SERNA is one of many young artists who inspire hope for a continuing *santero* tradition.

EPPIE ARCHULETA descends from many generations of traditional northern New Mexico weavers and has received an NEA National Heritage Fellowship.

Painter ROBB RAEL is a Contemporary Market favorite and one of Santa Fe's rising young folk artists.

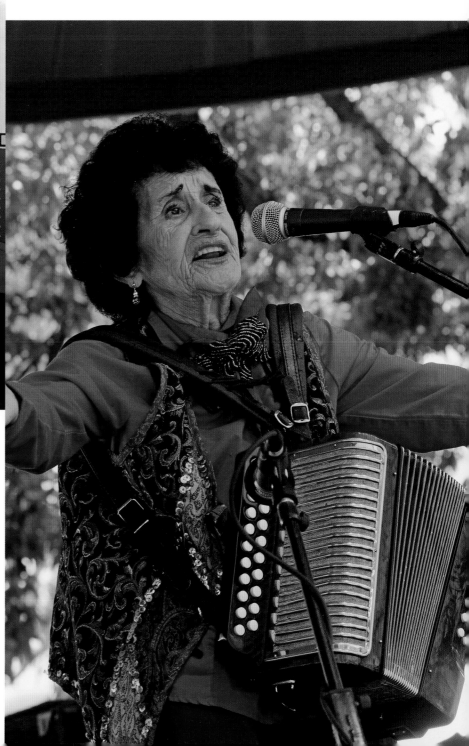

ANTONIA APODACA and her Trio Jalapeño are repeat favorites at Spanish Market.

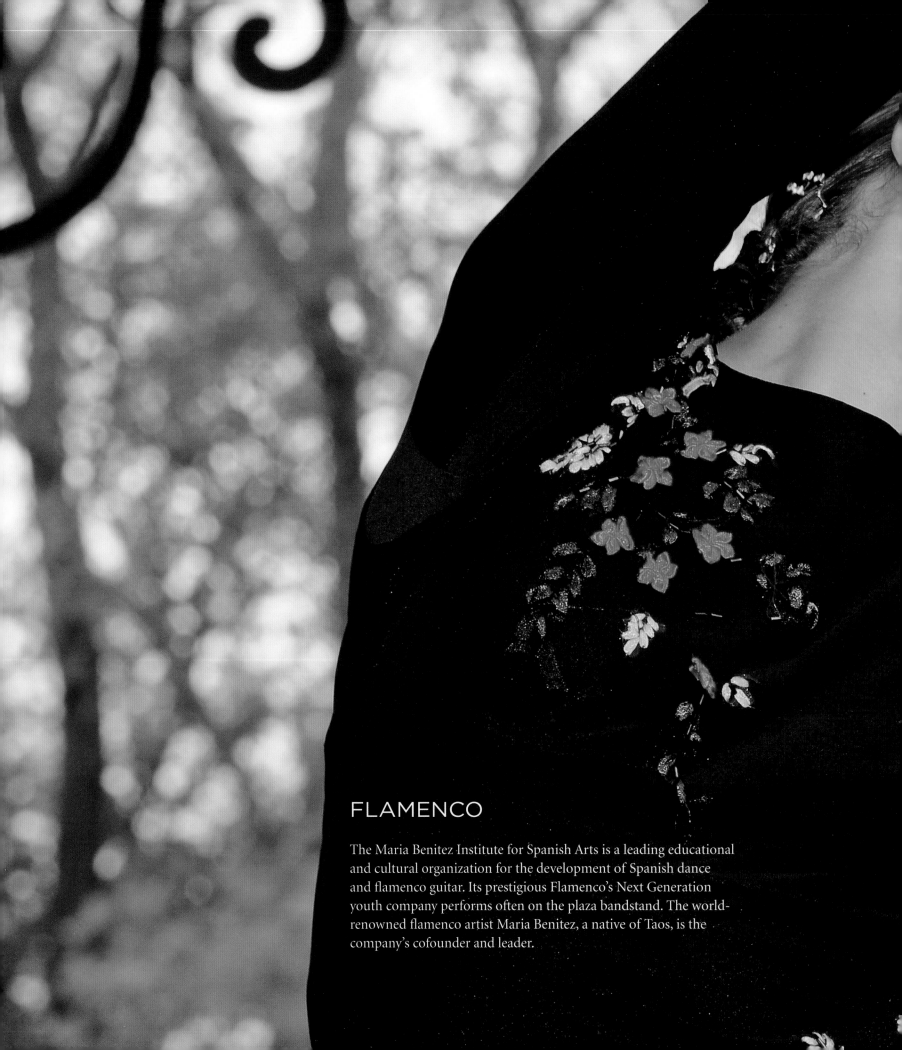

FLAMENCO

The Maria Benitez Institute for Spanish Arts is a leading educational and cultural organization for the development of Spanish dance and flamenco guitar. Its prestigious Flamenco's Next Generation youth company performs often on the plaza bandstand. The world-renowned flamenco artist Maria Benitez, a native of Taos, is the company's cofounder and leader.

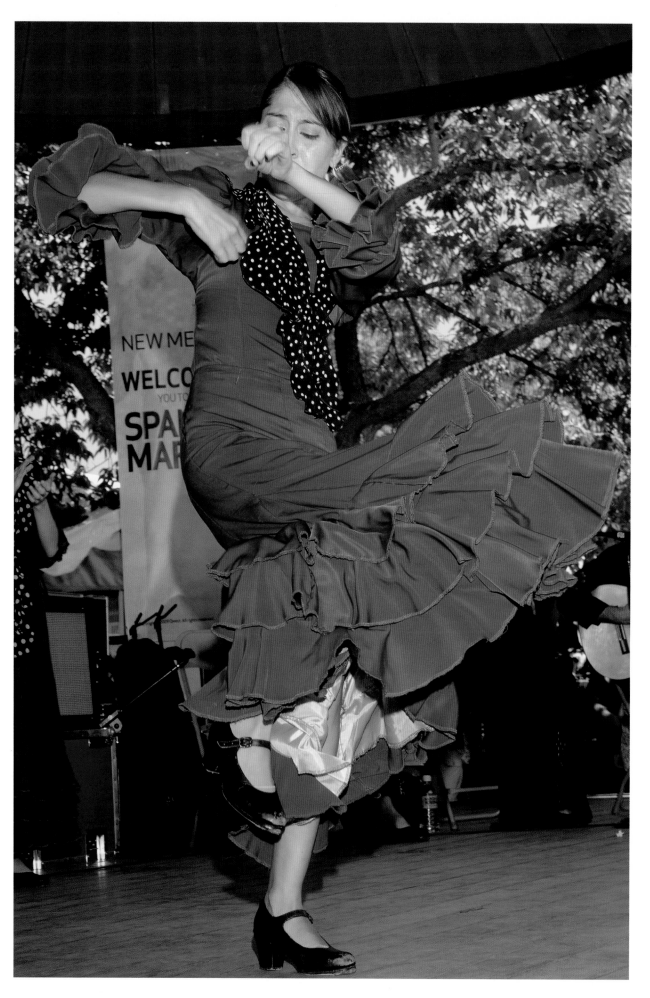

PREVIOUS SPREAD
EMMY GRIMM strikes a graceful pose. Many graduates of Flamenco's Next Generation are now professional dancers and teachers.

LEFT
MIKAYLA GARCIA expresses flamenco's fierceness and passion.

OPPOSITE PAGE
FLAMENCO'S NEXT GENERATION is an annual highlight at Spanish Market.

JANIRA CORDOVA, JAYLENA LUJAN, and SIMONE JARAMILLO dance to the music of flamenco guitar legend Chuscales.

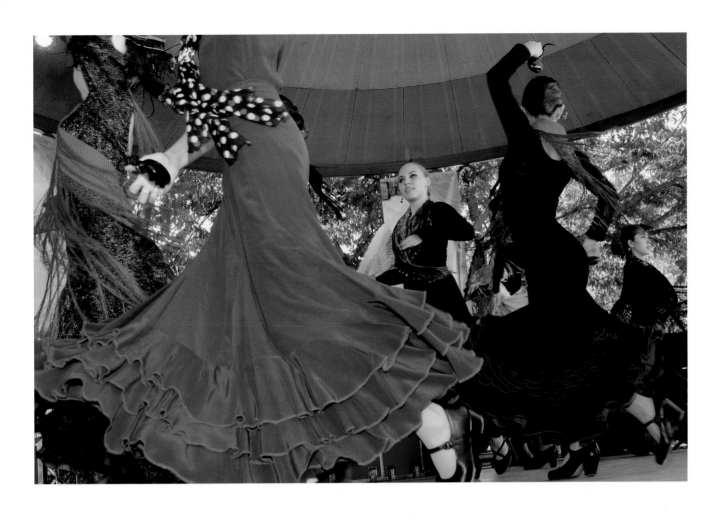

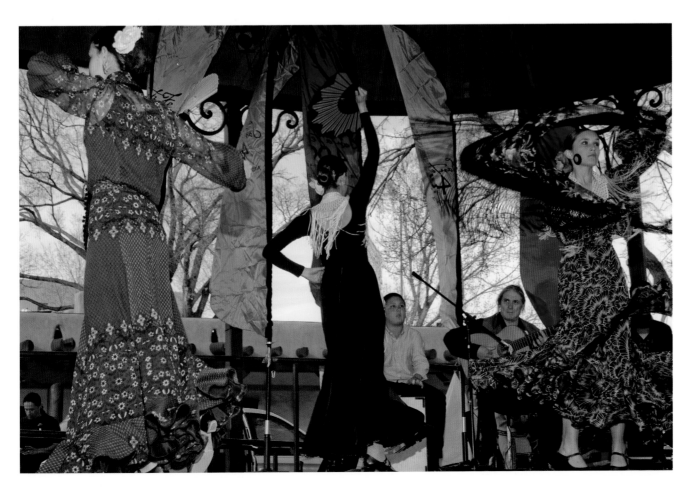

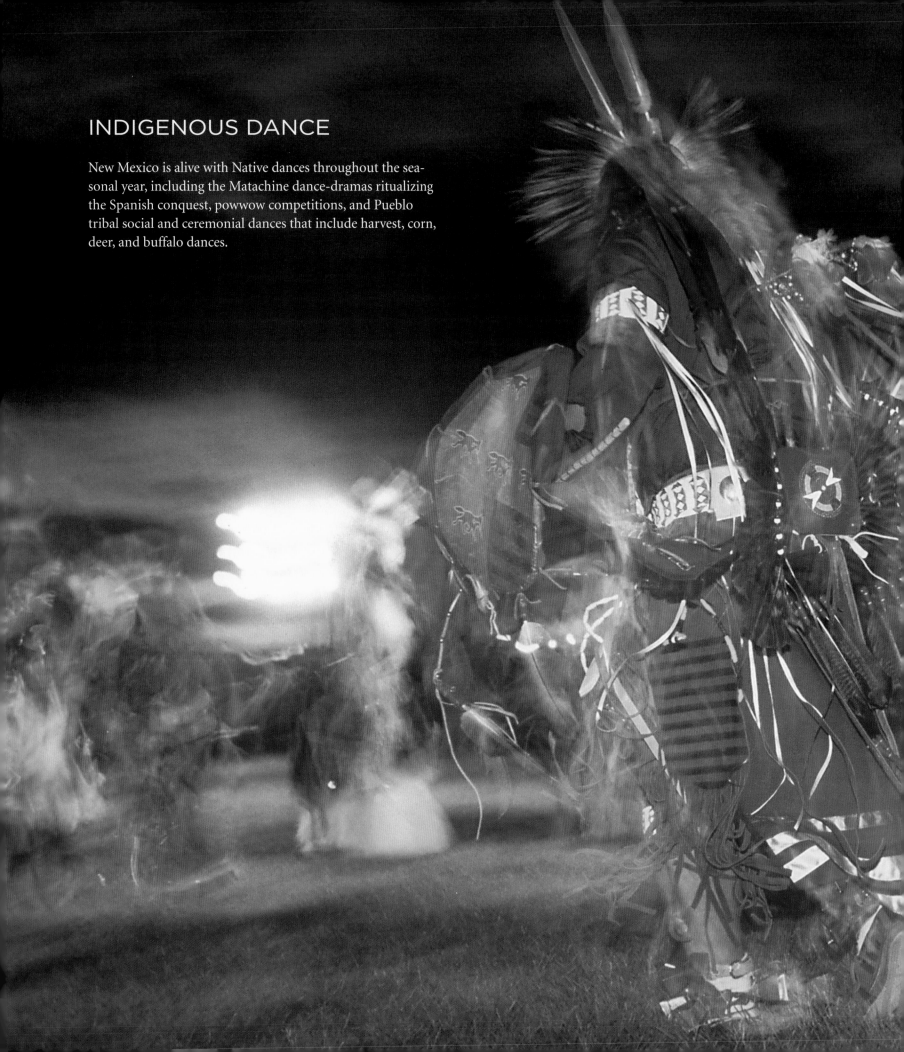

INDIGENOUS DANCE

New Mexico is alive with Native dances throughout the seasonal year, including the Matachine dance-dramas ritualizing the Spanish conquest, powwow competitions, and Pueblo tribal social and ceremonial dances that include harvest, corn, deer, and buffalo dances.

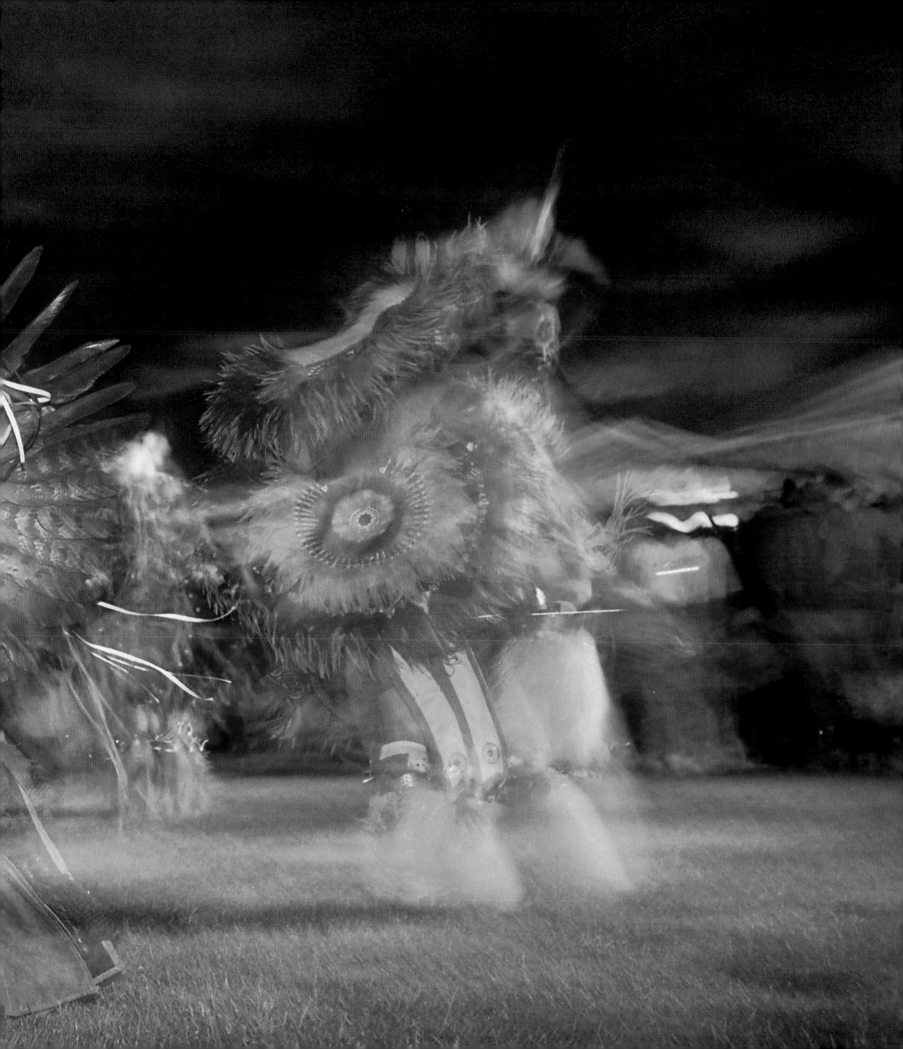

The Matachines Dance is a centuries-old folk play commemorating the blending of Spanish and Native peoples in the New World. In Northern New Mexico it is performed by both Hispano and Pueblo Indian groups. Its characters include El Monarca (Moctezuma), La Malinche (the young Indian mistress of Hernán Cortés), El Toro (the bull), eight or ten *soldados* (soldiers), and usually two *abuelos* (grandfathers) who function as clowns, directing the dancers and interacting with the audience.

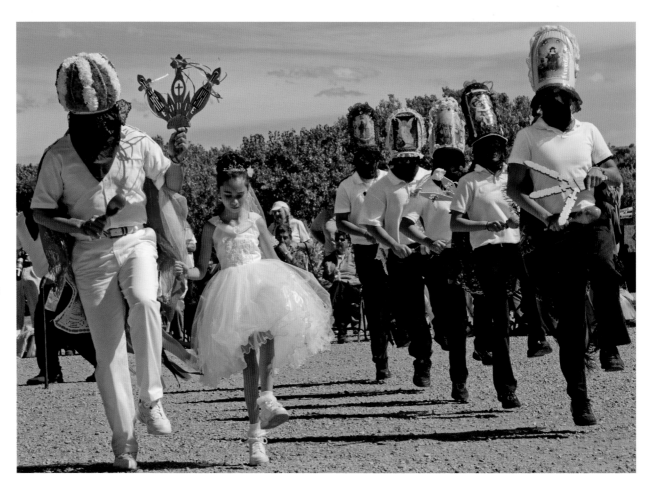

LOS MATACHINES DE SAN LORENZO of Bernalillo performs at El Rancho de las Golondrinas. La Malinche wears a first-communion dress and is the only female character in the dance.

LEFT
LOS MATACHINES DE EL RANCHO dances during Spanish Market. The dancers wear miter-style hats and wave *palmas* with their left hands. Dance regalia vary widely from group to group.

RIGHT
Spectators pin tokens of appreciation to a young EL TORO with Los Matachines de El Rancho. El Toro, the character of mischief, is symbolically castrated and tamed near the end of the dance.

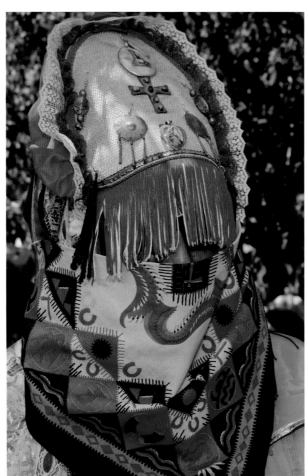

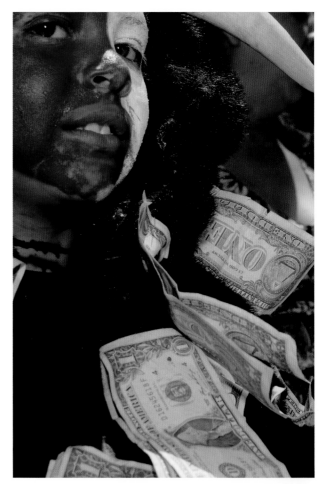

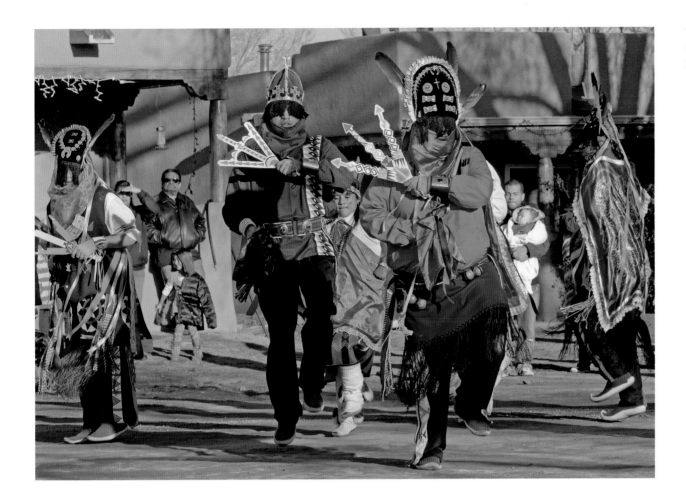

THE MATACHINES DANCE
is performed at Santa Clara
Pueblo on Christmas Day.

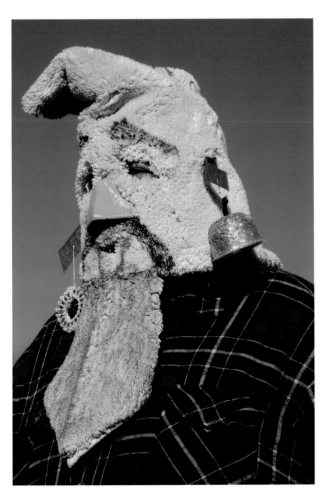

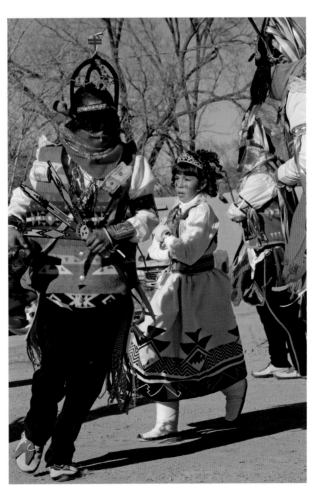

An ABUELO directs an
Okhay Owingeh (San Juan
Pueblo) Matachines Dance on
Christmas Day.

LA MALINCHE stays in
step with the Monarch at a
Matachines Dance at Okhay
Owingeh.

PREVIOUS SPREAD
POWWOWS, such as this at
Santa Fe Downs, are modern
intertribal social gatherings
celebrating American Indian
heritage with spectacular
regalia, dance competitions,
drumming, and singing.

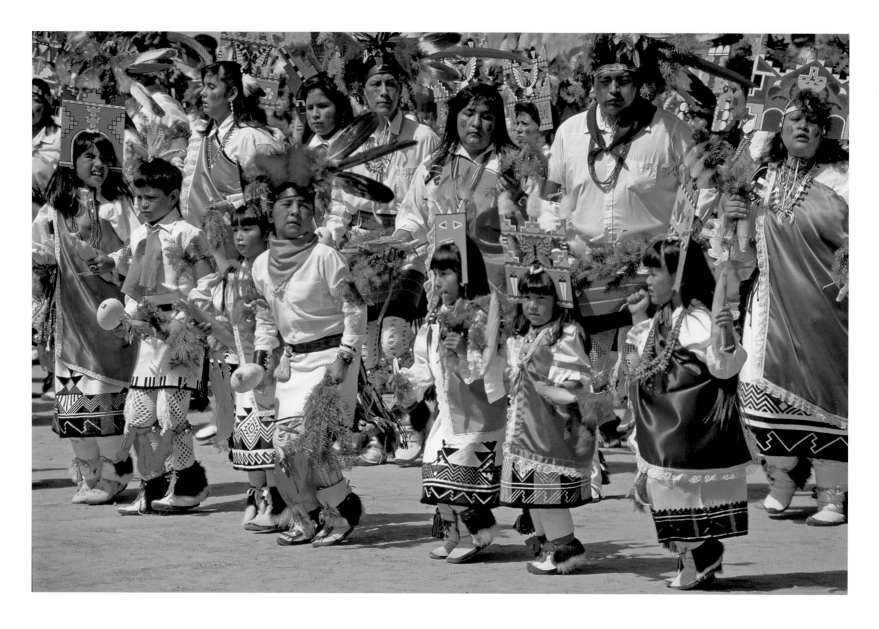

New Mexico's nineteen Pueblo Indian communities conduct ceremonial dances throughout the year, including many that are open to the public.

ABOVE
Santa Clara Pueblo performs its SACRED CORN DANCE, a centuries-old tribal ceremony. Everyone is welcome at many Pueblo feast days and dances, but the events are religious in nature and not public performances. (Photo permits for Pueblo ceremonial events are increasingly rare. These photos were taken with permission in 1991.)

OPPOSITE
PASQUALA ENOS (age ten) participates in the Santa Clara Pueblo Corn Dance.

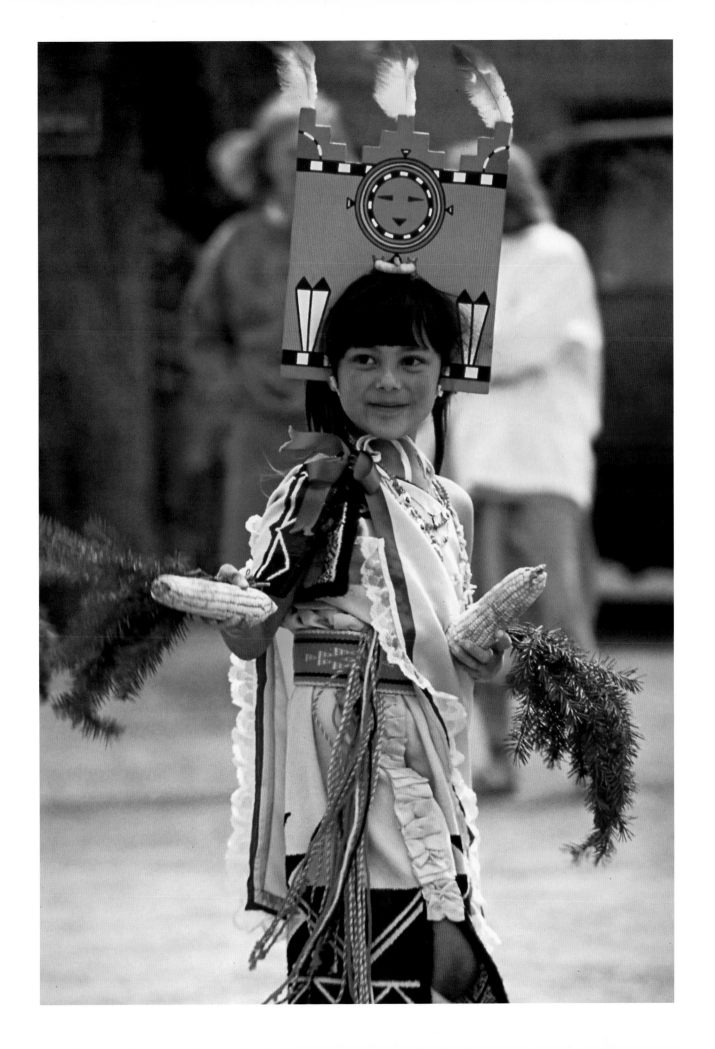

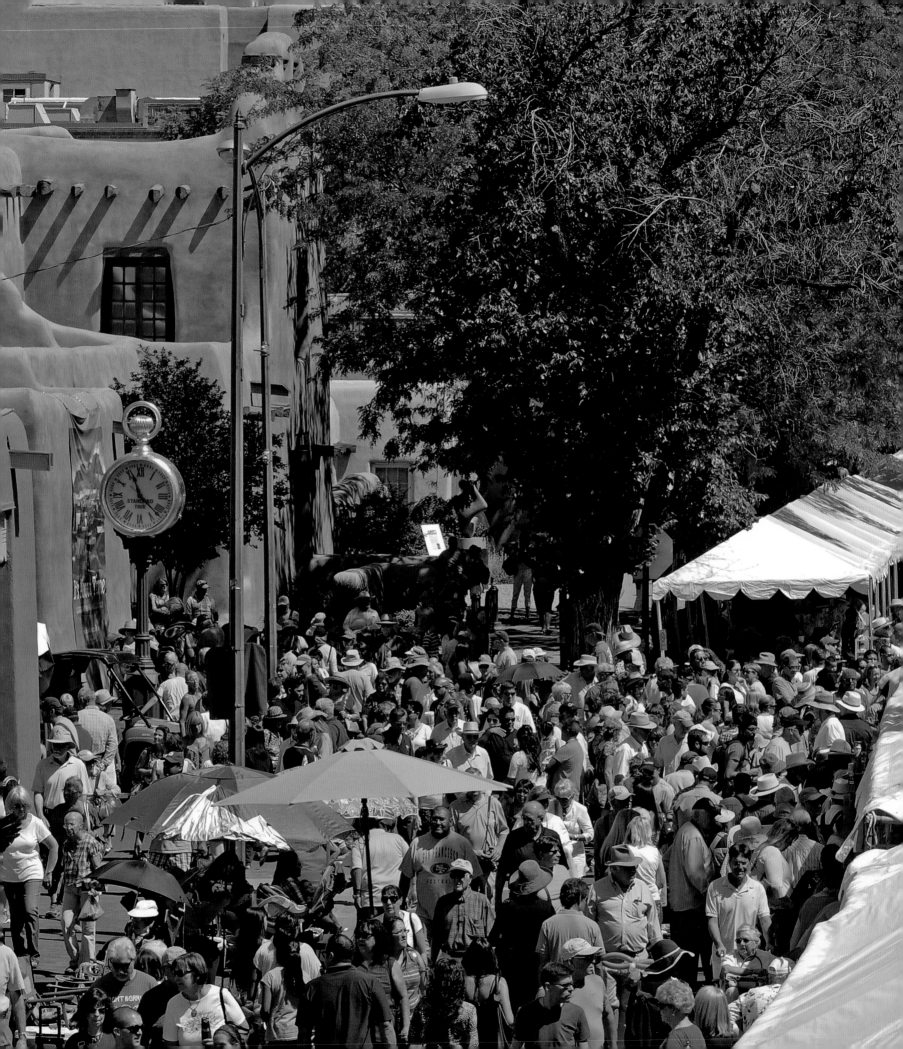

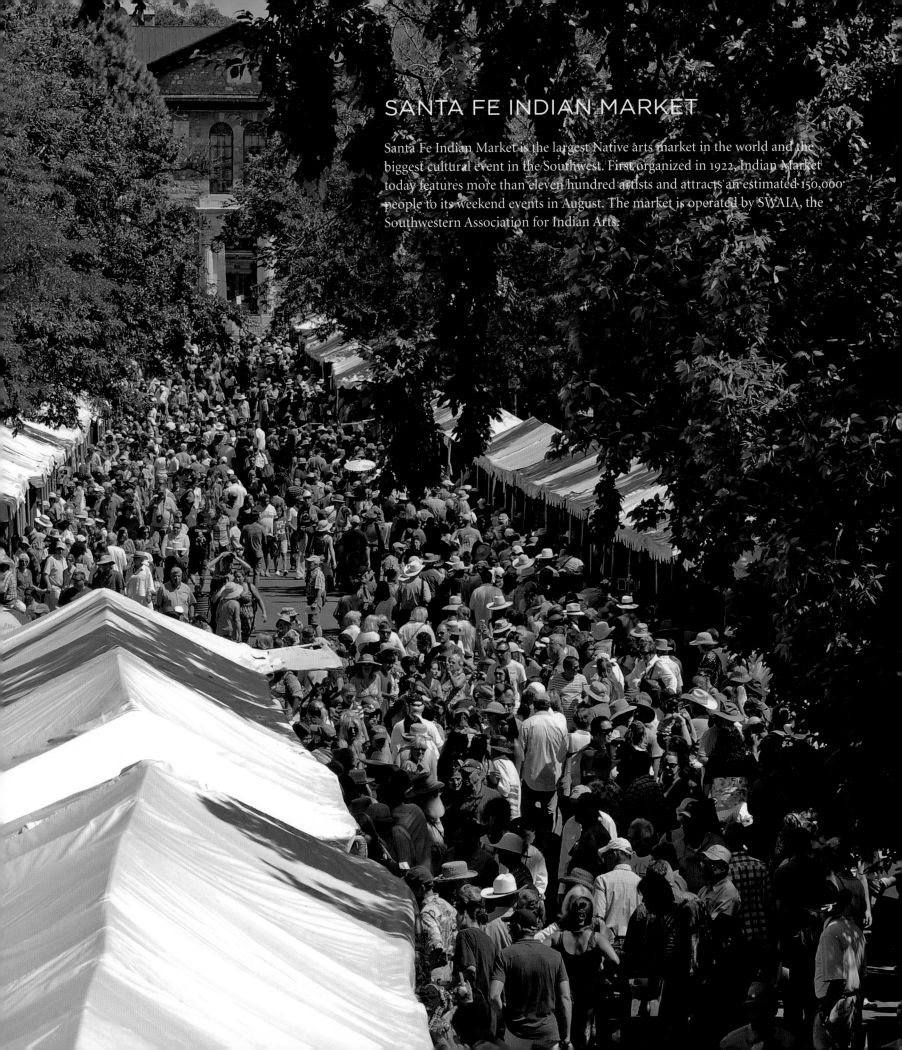

SANTA FE INDIAN MARKET

Santa Fe Indian Market is the largest Native arts market in the world and the biggest cultural event in the Southwest. First organized in 1922, Indian Market today features more than eleven hundred artists and attracts an estimated 150,000 people to its weekend events in August. The market is operated by SWAIA, the Southwestern Association for Indian Arts.

Acoma potter ROBERT PATRICIO discusses his award-winning traditional pottery with a collector.

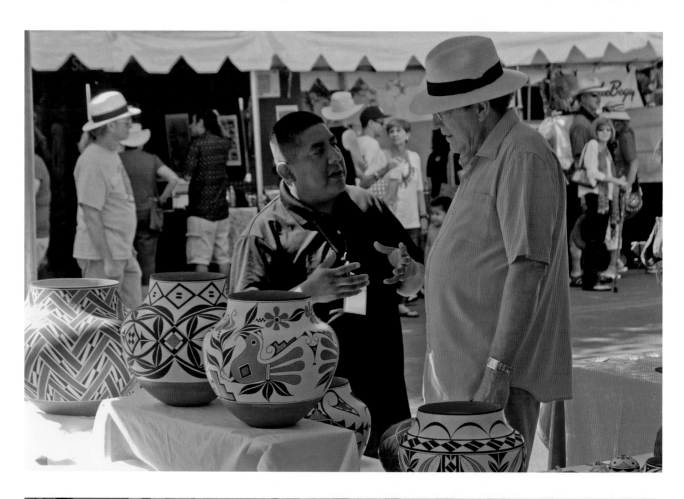

Passersby scrutinize the contemporary designs of Cochiti Pueblo's VIRGIL ORTIZ.

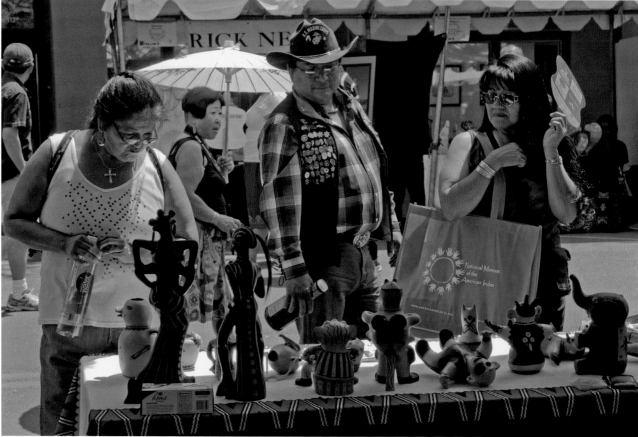

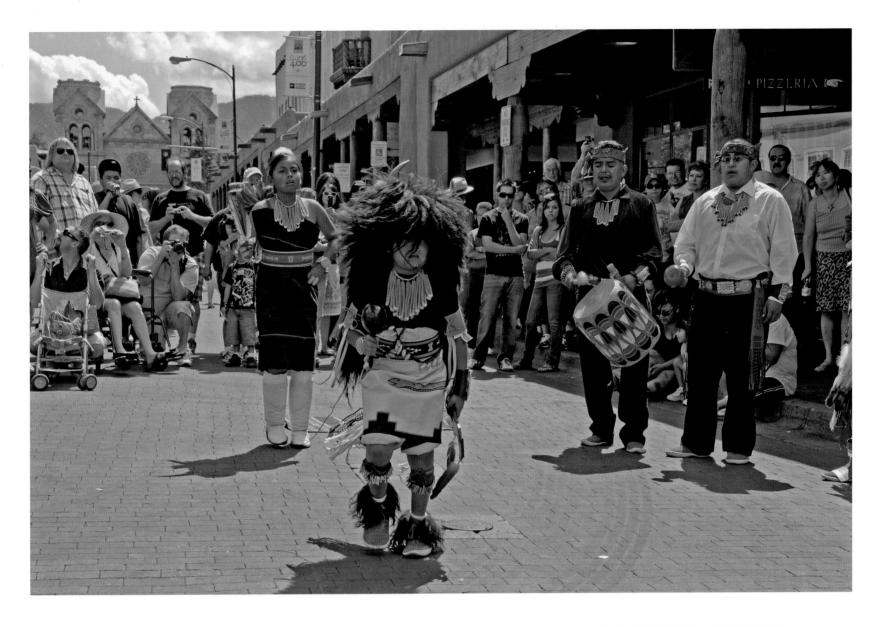

ABOVE
Zuni Pueblo's Ojo Caliente Dancers perform
BUFFALO DANCE around the plaza.

RIGHT
The grand-prize-winning pottery of LISA
HOLT AND HARLAN REANO OF KEWA
PUEBLO (Santo Domingo) signals the
emerging presence of a younger generation
of artists.

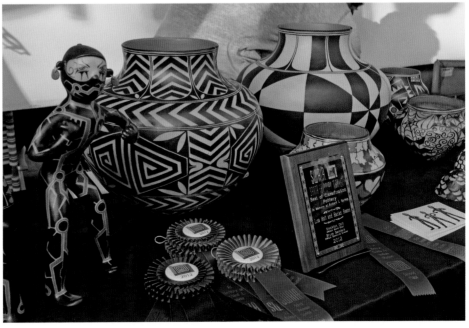

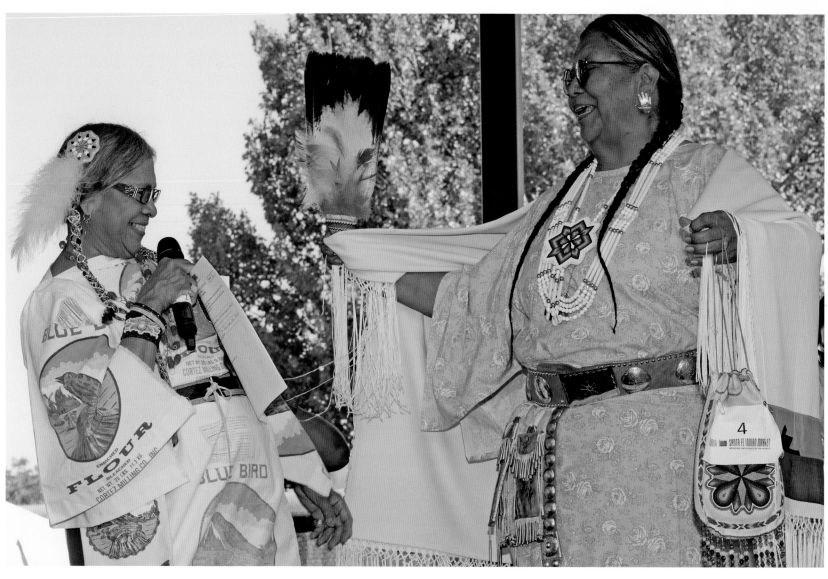

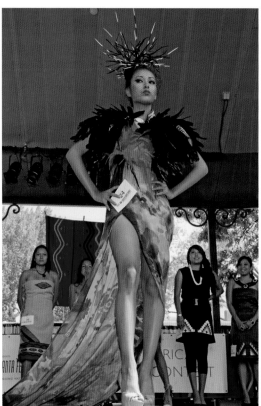

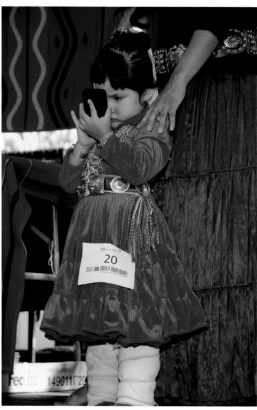

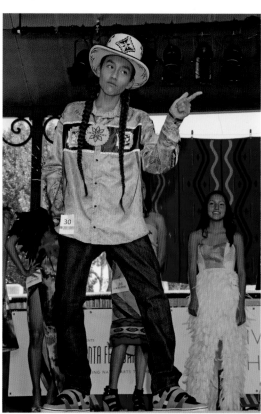

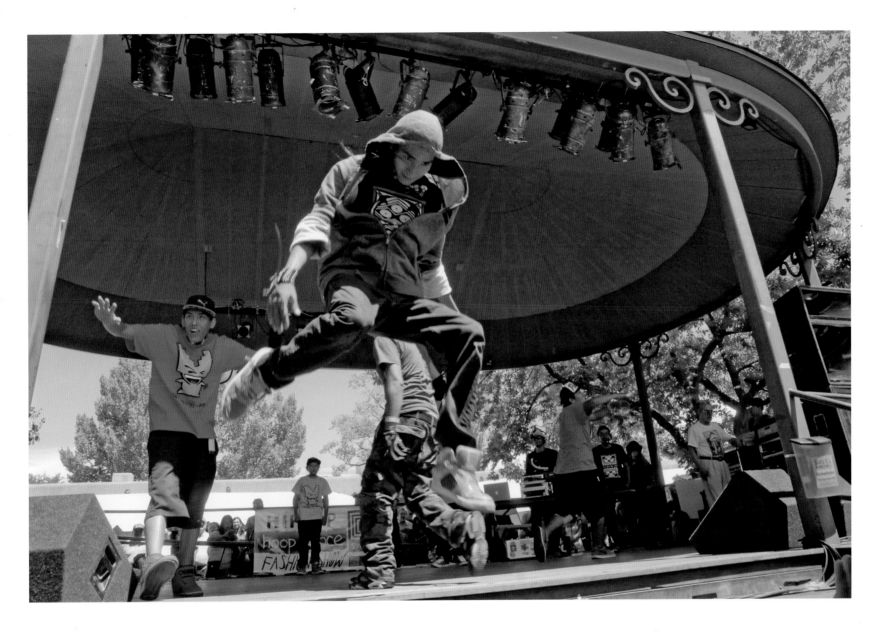

OPPOSITE PAGE, TOP, CLOCKWISE

Longtime Native American Clothing Contest emcee and chairwoman JERI AH-BE-HILL (Kiowa–Comanche) comments on traditional Kiowa clothing and jewelry created by VANESSA MOPOPE-JENNINGS (Kiowa–Apache–Gila River Pima). Jennings is an NEA National Heritage Fellow and an NEA Living National Treasure.

PHILIP ONE SUN BREAD (Comanche–Kiowa–Blackfeet) models contemporary designs of PENNY SINGER (Diné) in the Native American Clothing Contest. The "contemporary" category grows more popular every year, and some of its designers are developing international reputations.

A bored NAVAJO CLOTHING CONTESTANT is pacified in the same manner as modern children everywhere.

WAKEAH JHANE (Comanche–Blackfeet) models ORLANDO DUGI'S (Diné) "Desert Heat" evening wear. The outfit features a hand-painted silk gown and a goose-feather cape accented with silver-and-gold beadwork. Dugi grew up on the very traditional rural Navajo Reservation.

Break-dancer and six-time world champion hoop dancer NAKOTAH LARANCE (Tewa–Diné–Hopi–Assiniboine) leaps into the audience during a hip-hop fashion show promoting the T-shirt designs of EHREN KEE NATAH (Diné–Kewa Pueblo–Cherokee). The first-time event brought the jam-packed plaza audience to its feet. Indian Market strives to be both traditional and responsive to the vision of its very modern younger generation.

73

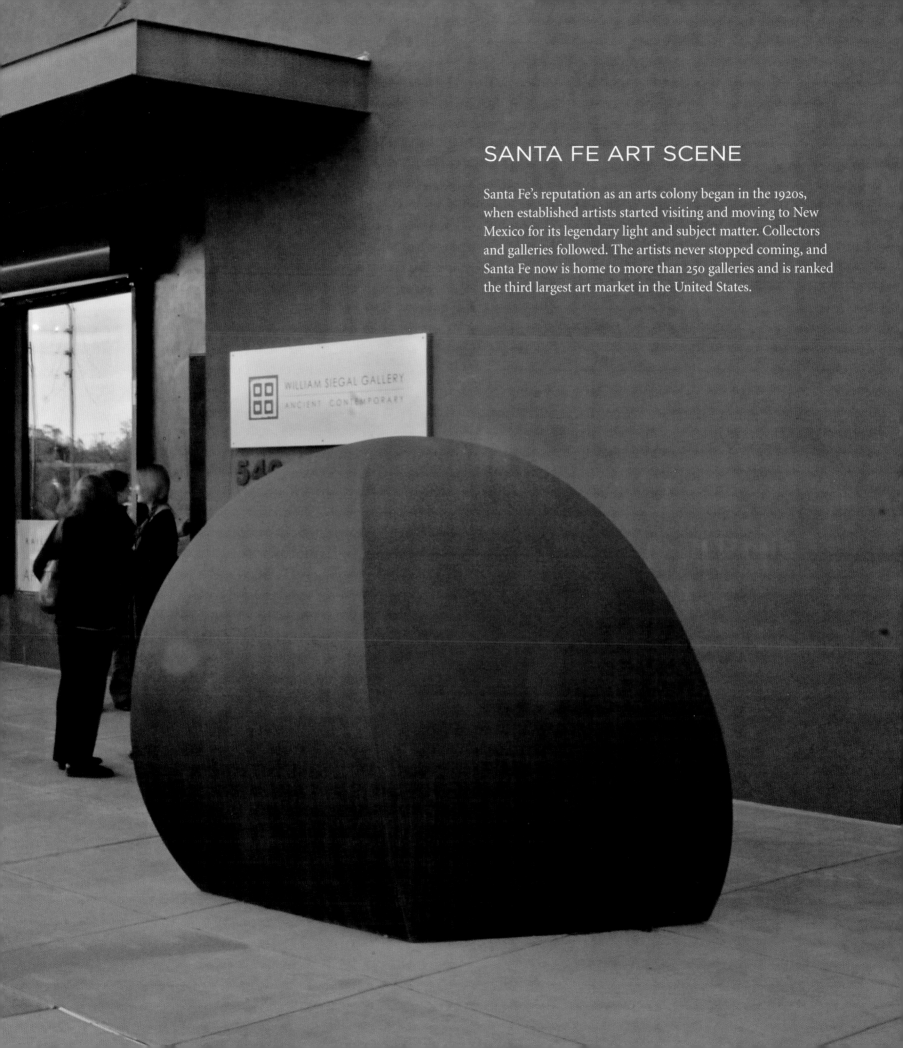

SANTA FE ART SCENE

Santa Fe's reputation as an arts colony began in the 1920s, when established artists started visiting and moving to New Mexico for its legendary light and subject matter. Collectors and galleries followed. The artists never stopped coming, and Santa Fe now is home to more than 250 galleries and is ranked the third largest art market in the United States.

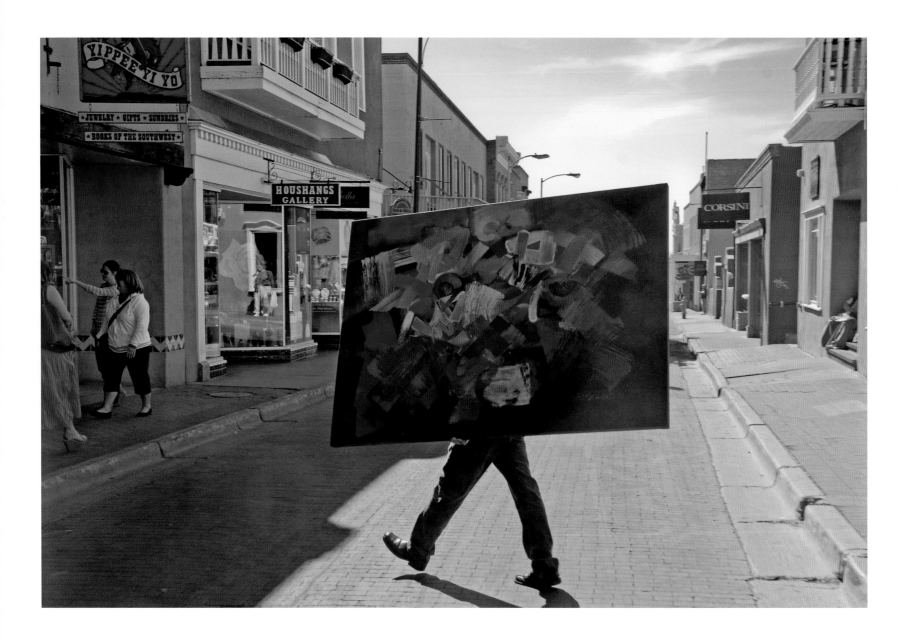

An abstract painting crosses
WEST SAN FRANCISCO STREET
on its way to a plaza-area gallery.

PREVIOUS SPREAD
THE RAILYARD ARTS DISTRICT
features world-class galleries in
modern warehouse-style buldings.
The contemporary art space SITE
Santa Fe anchors the district.

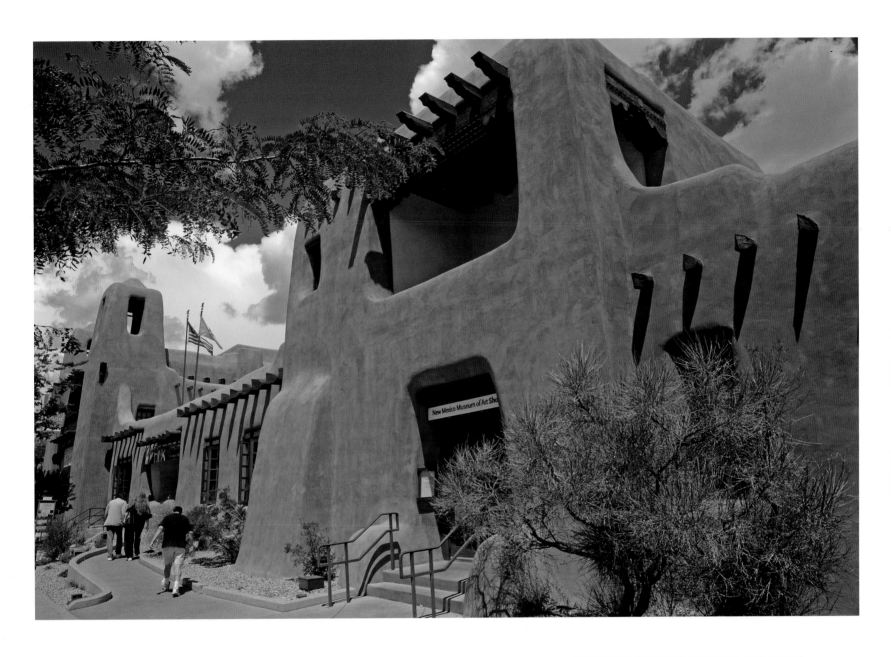

THE NEW MEXICO MUSEUM OF ART played
a major role in promoting Southwest art
and in attracting and supporting artists who
would make Santa Fe an important art colony
in the early 1900s. Built in 1917, the massive
adobe structure established Pueblo Revival as
Santa Fe's dominant architectural style.

Once a humble farming community on the edge of town, CANYON ROAD today is the center of Santa Fe's lively art scene.

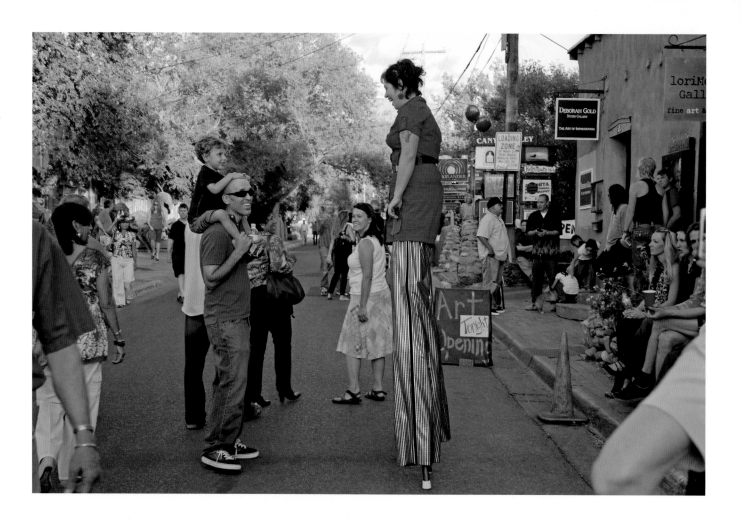

Summer crowds stroll CANYON ROAD during a Friday evening art walk.

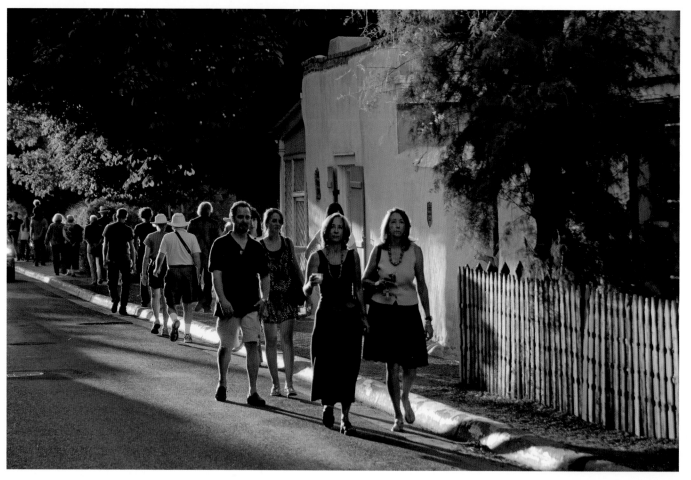

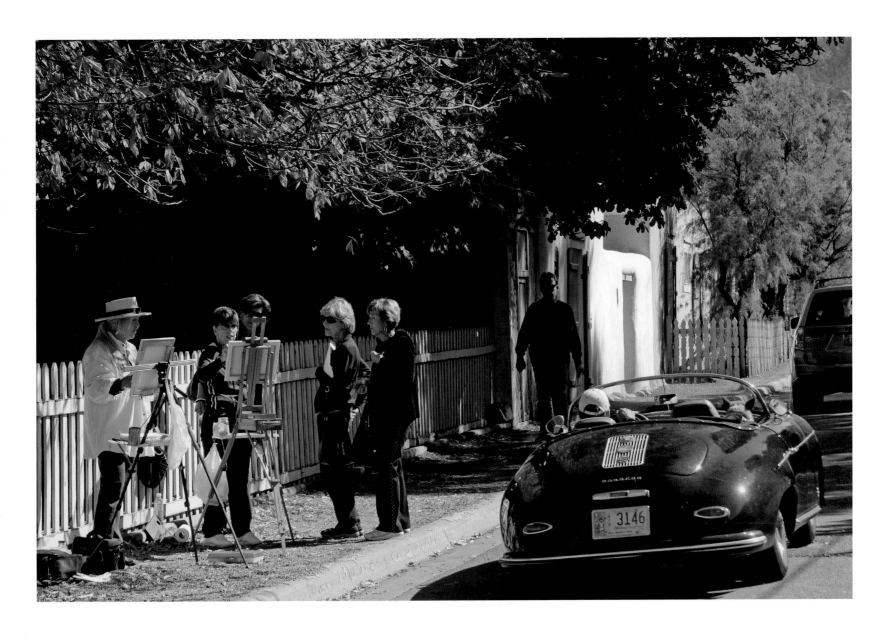

PLEIN AIR PAINTERS are an almost
everyday sight along Canyon Road.

Specializing in Antique American Indian arts, MICHAEL SMITH GALLERY occupies an adobe farmhouse built in the 1700s. The Canyon Road area features more than 100 art galleries and restaurants along a half-mile stretch of mostly single-story adobe buildings.

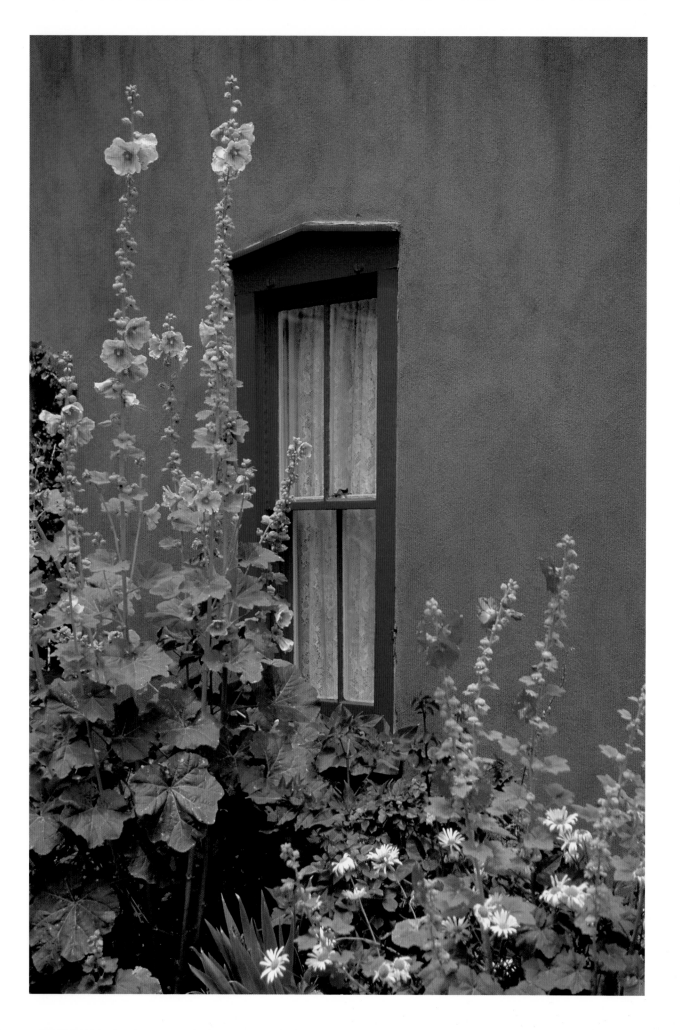

HOLLYHOCKS rise above a Territorial-style window near Canyon Road.

An UPPER CANYON ROAD
courtyard borrows the
arched doorway and tile roof
designs of Old Mexico.

FOLLOWING SPREAD
A modern PUEBLO
REVIVAL–STYLE HOME sits
tucked away on a quiet east-
side cul-de-sac.

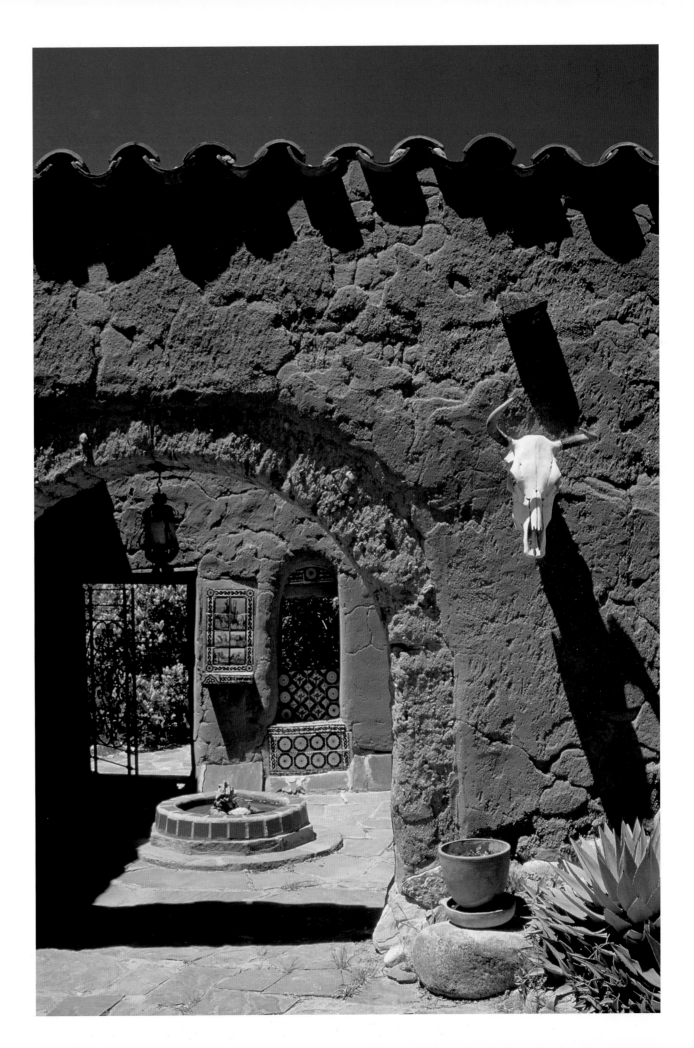

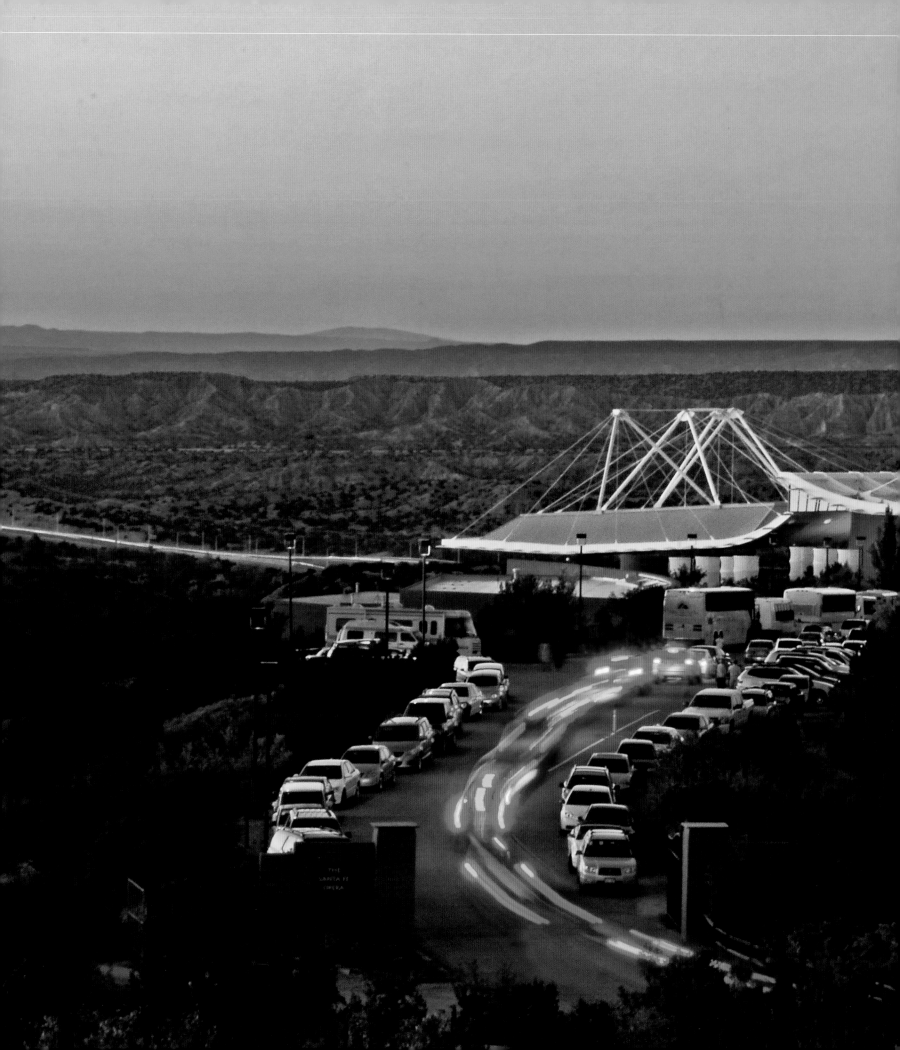

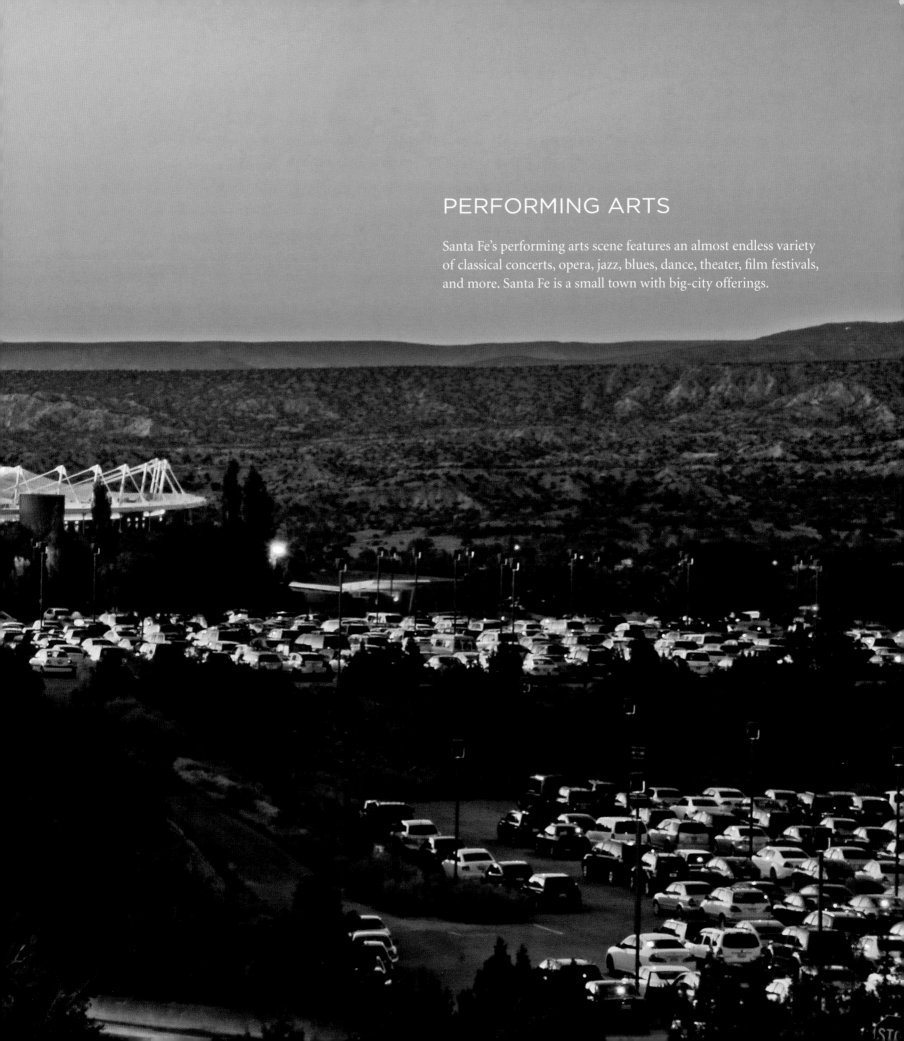

PERFORMING ARTS

Santa Fe's performing arts scene features an almost endless variety of classical concerts, opera, jazz, blues, dance, theater, film festivals, and more. Santa Fe is a small town with big-city offerings.

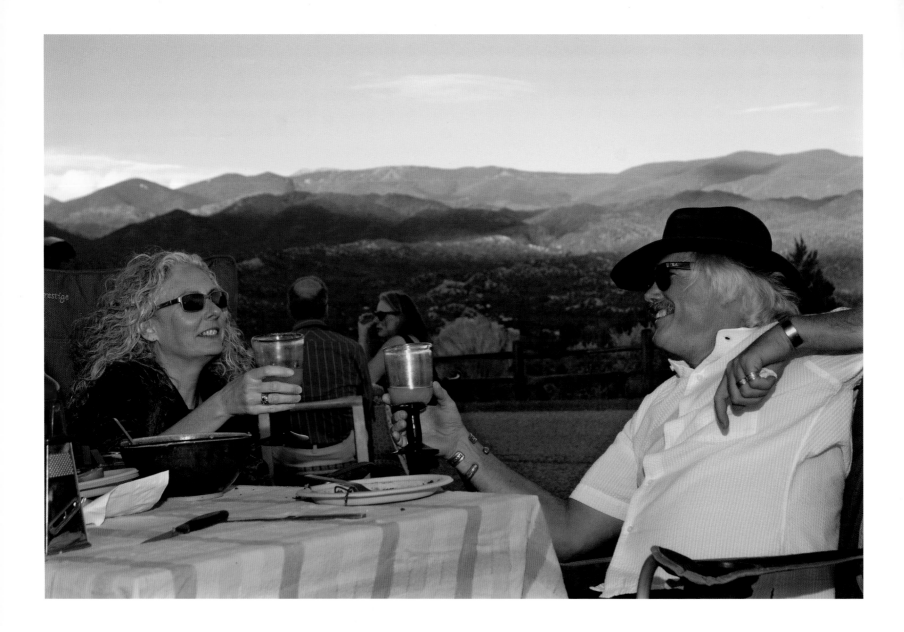

Mary Anne Redding and Roger Atkins TAILGATE
before the premier of *Oscar* at the Santa Fe Opera.

PREVIOUS SPREAD
Cars arrive at the Santa Fe Opera for its sold-out
production of *The Magic Flute*. Built atop a mesa
with spectacular views of the Jémez and Sangre
de Cristo mountains, the open-air opera began
its first season in 1957 and is now a world-class
institution. July and August events include classic
and contemporary operas, world premieres, and
apprentice and community outreach programs.

OPPOSITE, TOP
THE SANTA FE CHAMBER MUSIC FESTIVAL is a
six-week series of classical concerts presented in
St. Francis Auditorium and the Lensic Performing
Arts Center. The music festival, founded in 1972,
dovetails with opera season.

OPPOSITE, BOTTOM
SANTA FE PLAYHOUSE is the oldest community theater
west of the Mississippi. Its year-round performances
showcase local actors in a variety of plays and musicals,
including the always sold-out Fiesta Melodrama spoofing
Santa Fe's local culture and politics.

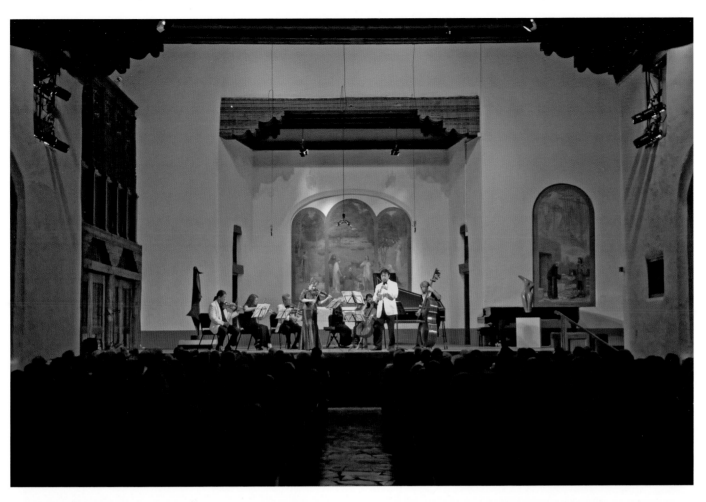

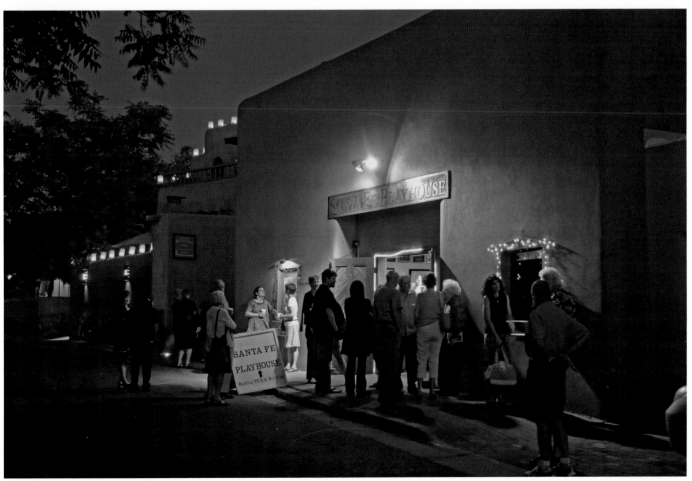

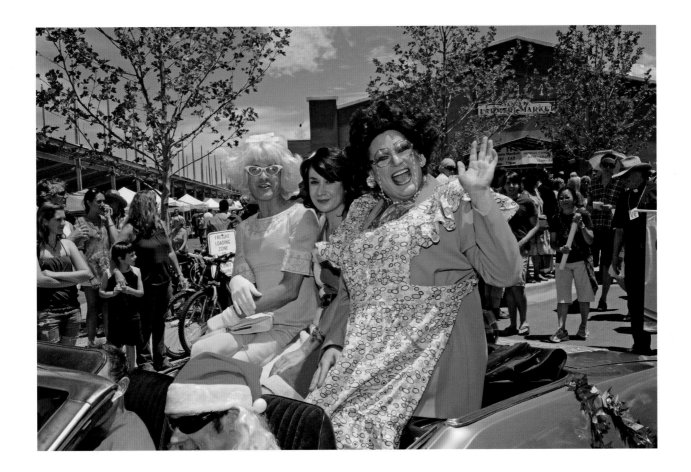

The GAY PRIDE FESTIVAL in June includes a big parade, dances, concerts, plays, and many special events. The town has long been home to a vibrant and well-established gay and lesbian community that contributes greatly to the cultural richness of the area.

ABOVE
Santa Fe Playhouse A TUNA CHRISTMAS cast members Landon Starnes, Belle Gurule, and Darron Dunbar ride as royalty in the Gay Pride Parade.

OPPOSITE
Composer JANICE SIMMONS marches in the annual Gay Pride Parade at the Railyard.

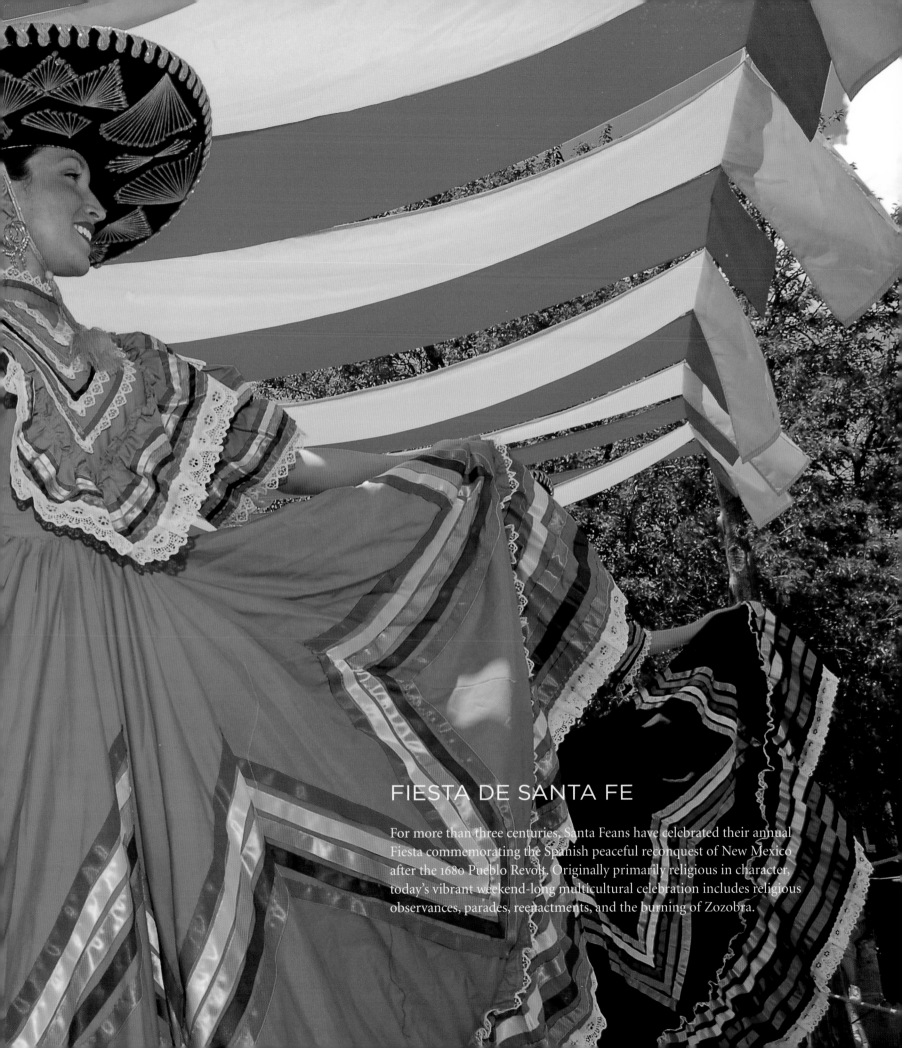

FIESTA DE SANTA FE

For more than three centuries, Santa Feans have celebrated their annual Fiesta commemorating the Spanish peaceful reconquest of New Mexico after the 1680 Pueblo Revolt. Originally primarily religious in character, today's vibrant weekend-long multicultural celebration includes religious observances, parades, reenactments, and the burning of Zozobra.

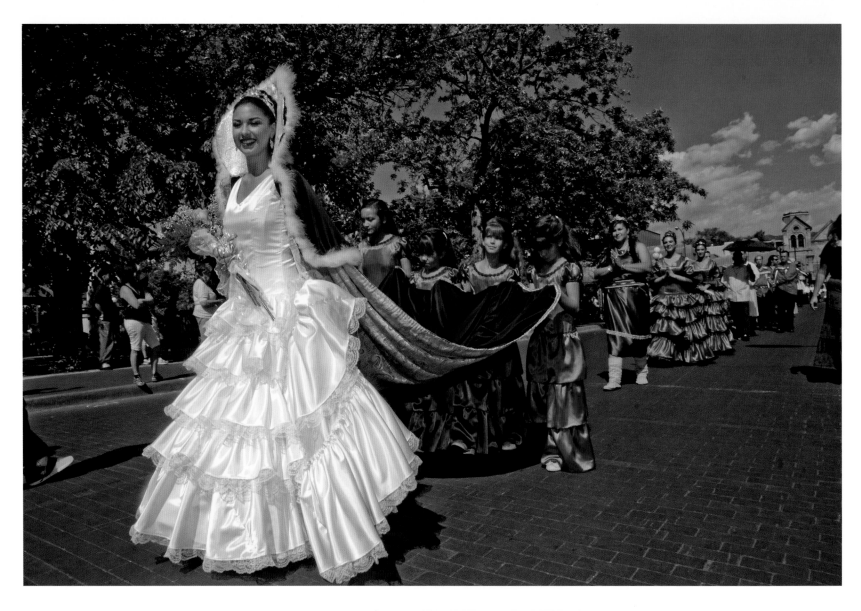

La Conquistadora procession is the only event of its kind in the world. La Conquistadora is the oldest statue of the Virgin Mary in the United States and a symbol of the 1692 Spanish return to New Mexico after their expulsion in the 1680 Pueblo Revolt. Every year the statue is carried from the Cathedral Basilica to Rosario Chapel and returned the following Sunday in a grand Old World–style procession featuring the costumed Fiesta Court, the archbishop, priests, children scattering rose petals, and hundreds of church members.

ABOVE
Fiesta queen KRISTY OJINAGA Y BORREGO—La Reina 2013—parades through the plaza amid pageantry.

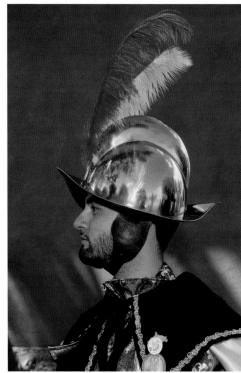

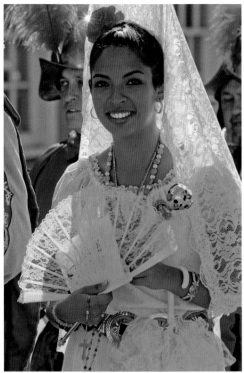

The statue that became LA CONQUISTADORA arrived in Santa Fe from Spain in 1624. Men who carry her in processions are called the Caballeros of De Vargas.

PREVIOUS SPREAD
MAJESTIC FOLKLORICO dancers bring bold color and beauty to Fiesta.

OPPOSITE
JASON LUCERO, the pageant's 2013 Don Diego de Vargas, readies at Rosario Chapel for the procession to the cathedral.

JENAE MONIQUE CISNEROS Y ROYBAL—La Reina 2012—is dressed casually for the return trip from Rosario Chapel to the cathedral.

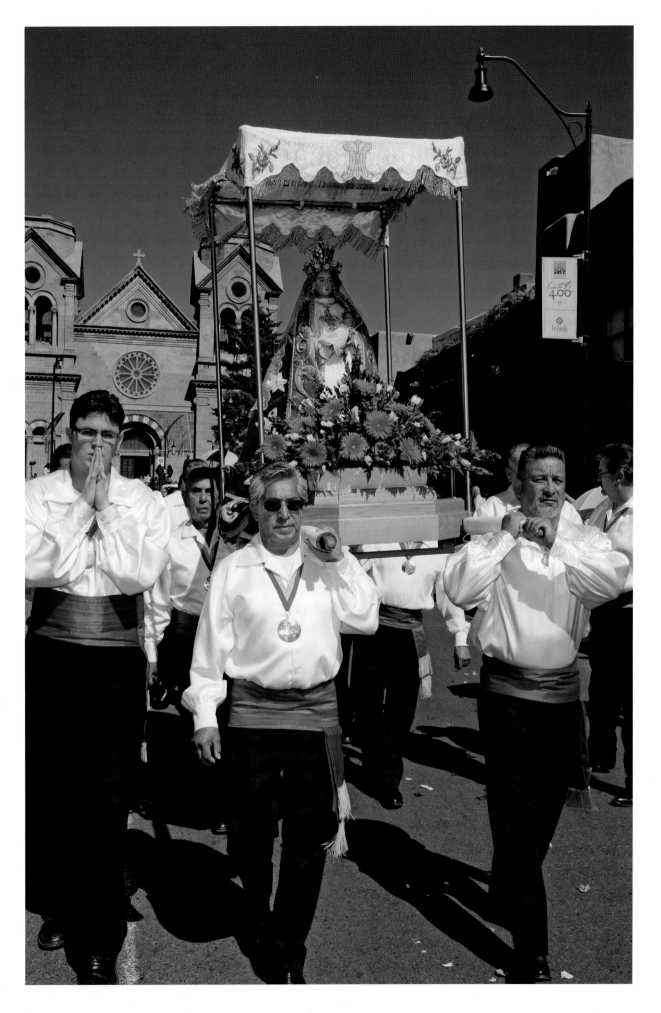

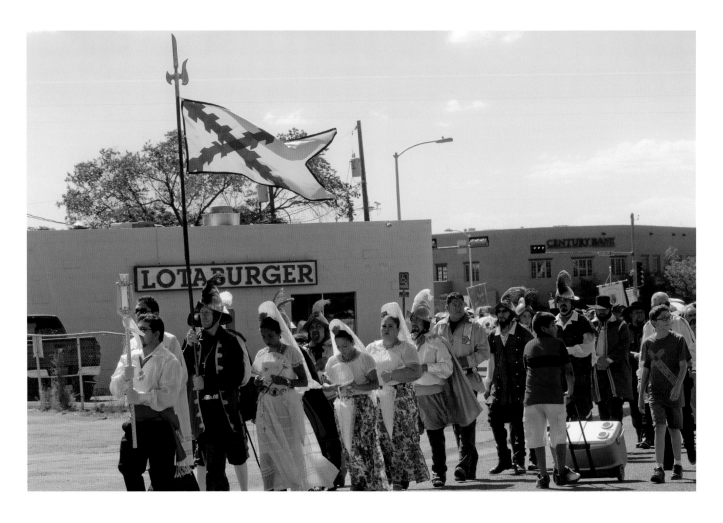

LA CONQUISTADORA PROCESSION
marches past a time-honored New Mexico
landmark.

OPPOSITE
La Conquistadora is returned to her
chapel in the CATHEDRAL BASILICA.

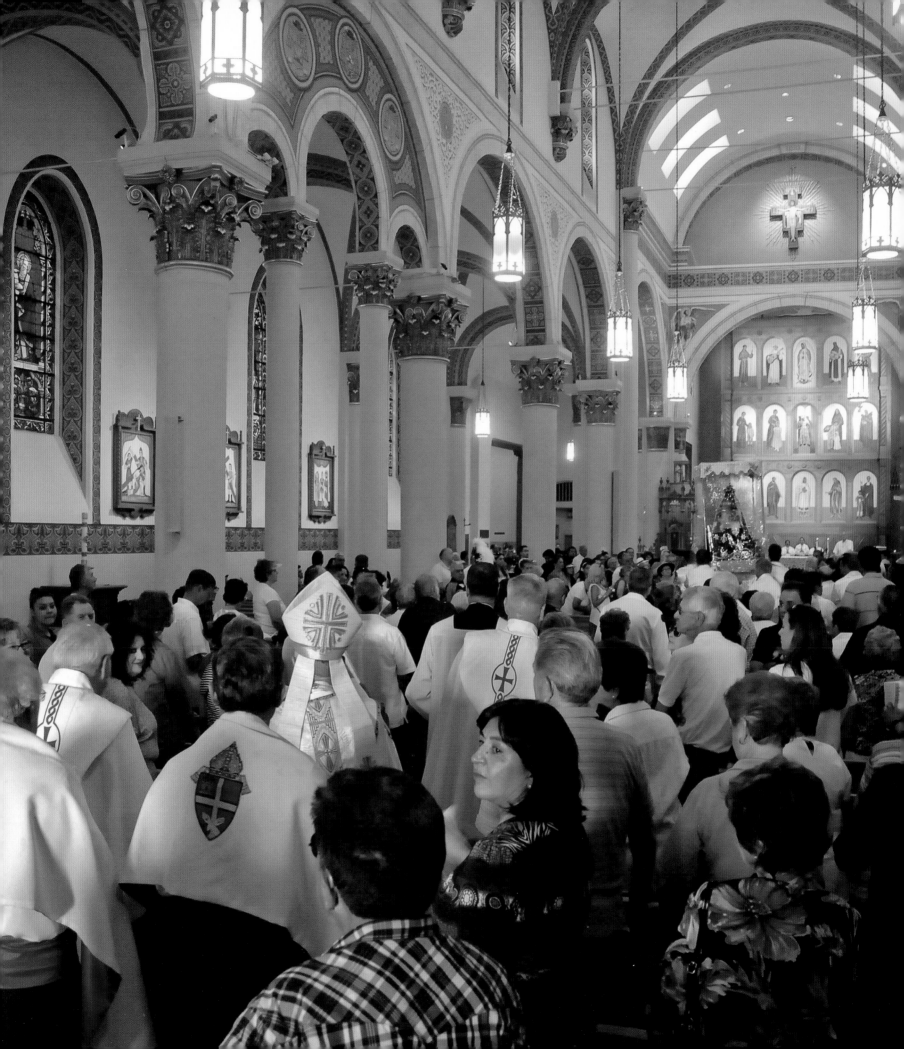

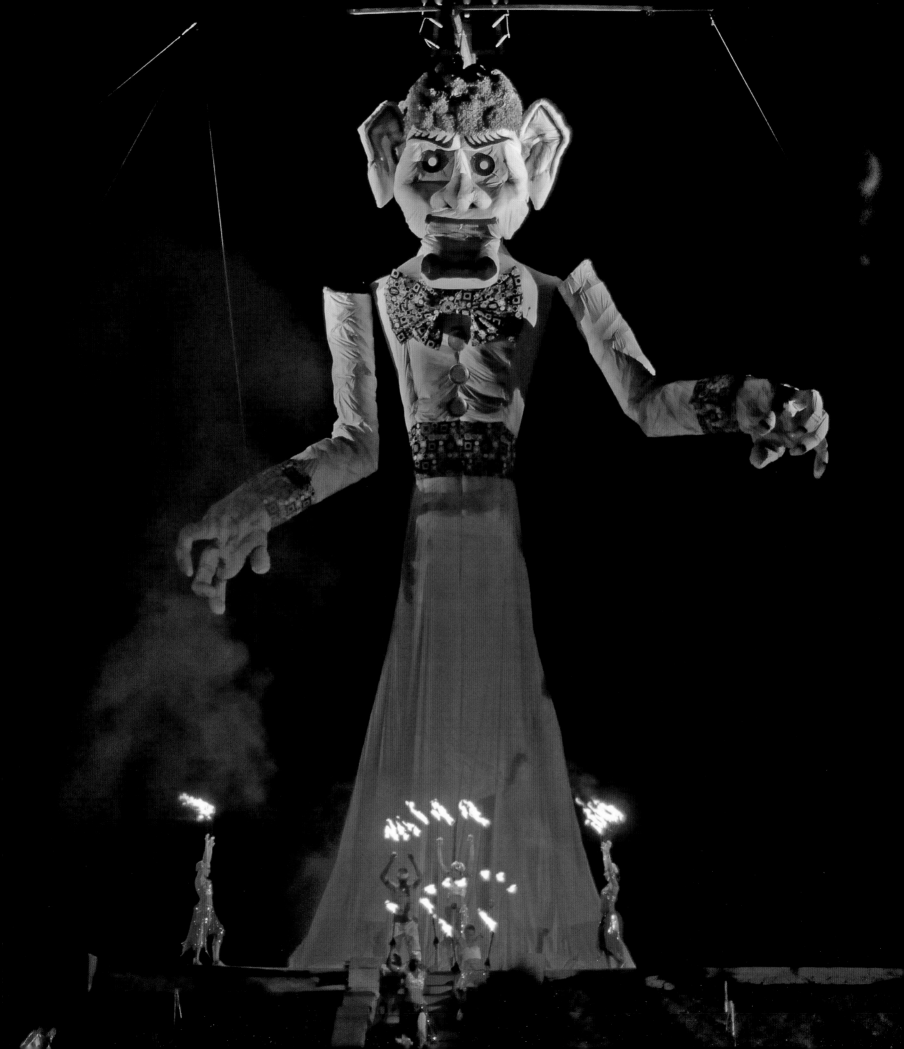

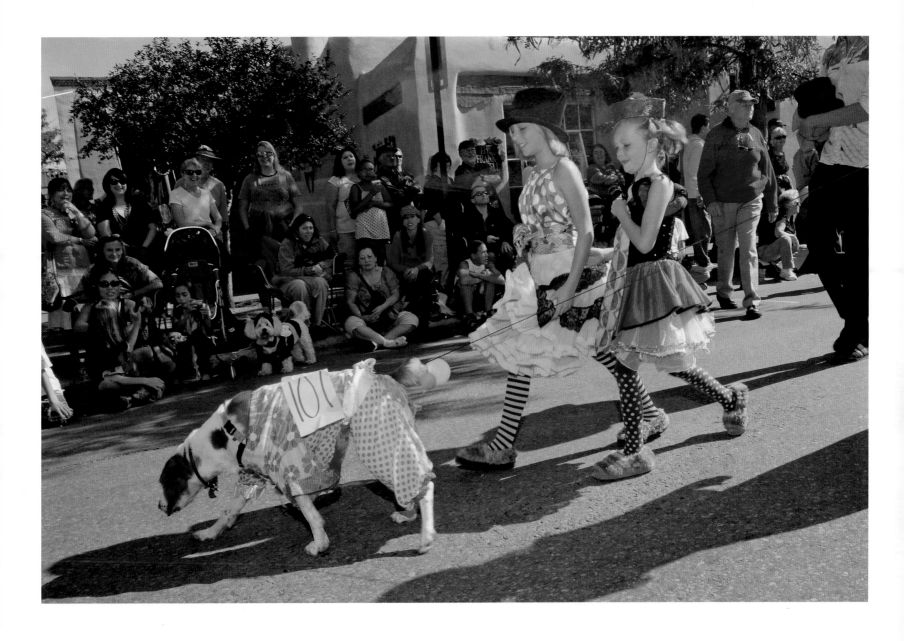

Saturday morning's DESFILE DE LOS NIÑOS (CHILDREN'S PET PARADE) is one of Fiesta's most popular family events.

Fiesta opens with the ritual burning of ZOZOBRA, a 50-foot-tall puppet stuffed with overdue bills and other bad news. The pagan-like tradition began in 1924 as a mostly Anglo artist reaction to the religious flavor of Fiesta. Today, thousands gather at Fort Marcy Park north of the plaza to chant "Burn him!" as Zozobra groans and writhes, engulfed in flames and fireworks.

Baile Español dancer AMOR TORRES expresses second thoughts about her Las Chiapanecas dance costume.

OPPOSITE
MARIACHI musicians perform during Fiesta.

FOLLOWING SPREAD
The CANDLELIGHT PROCESSION to the Cross of the Martyrs is a solemn event honoring twenty-one priests killed during the 1680 Pueblo Revolt. The procession officially ends Fiesta and is one of Santa Fe's most serene and lovely events.

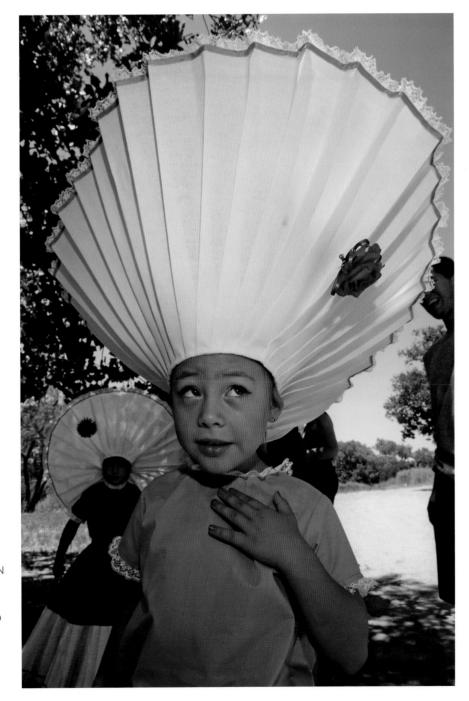

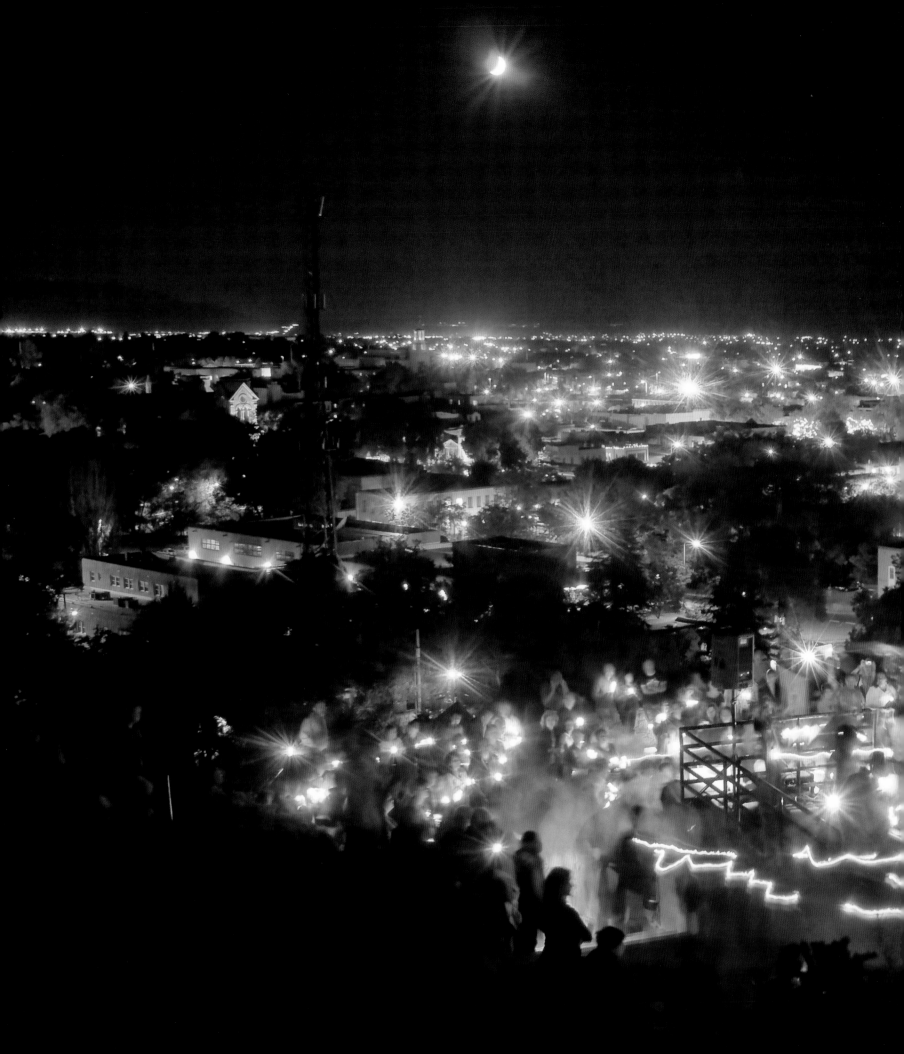

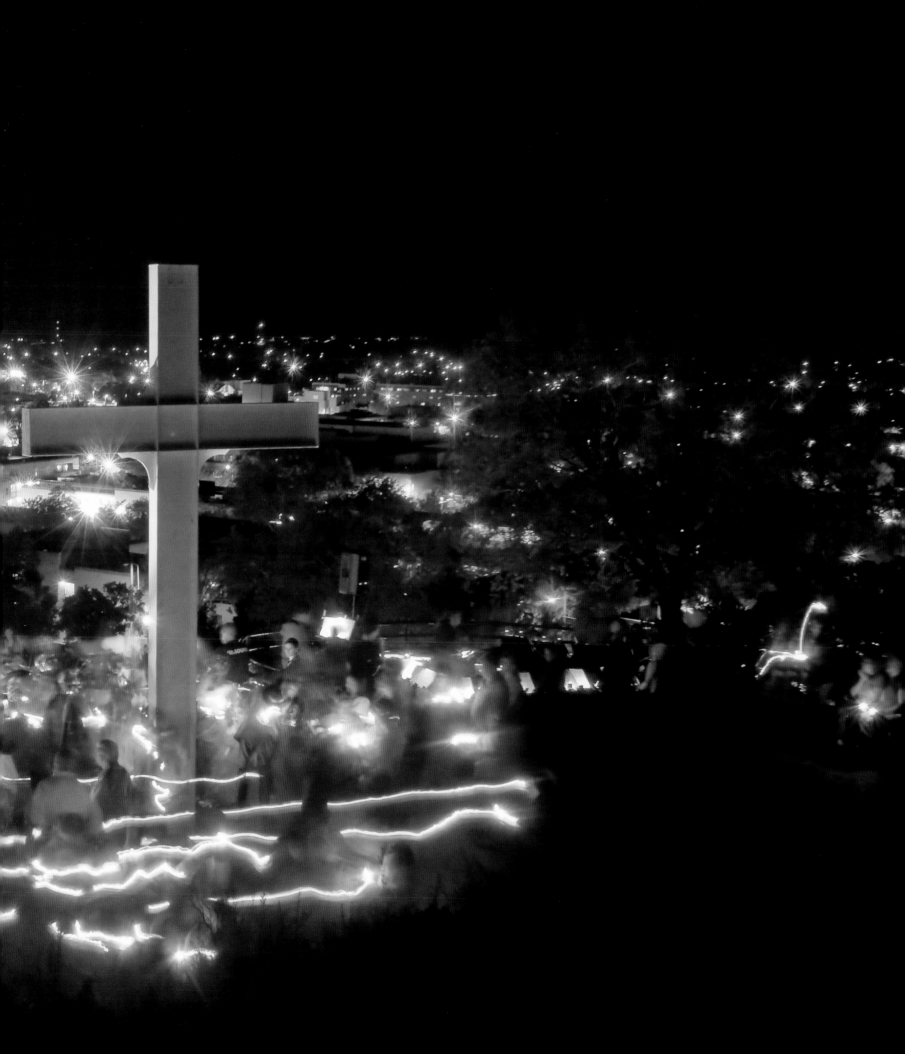

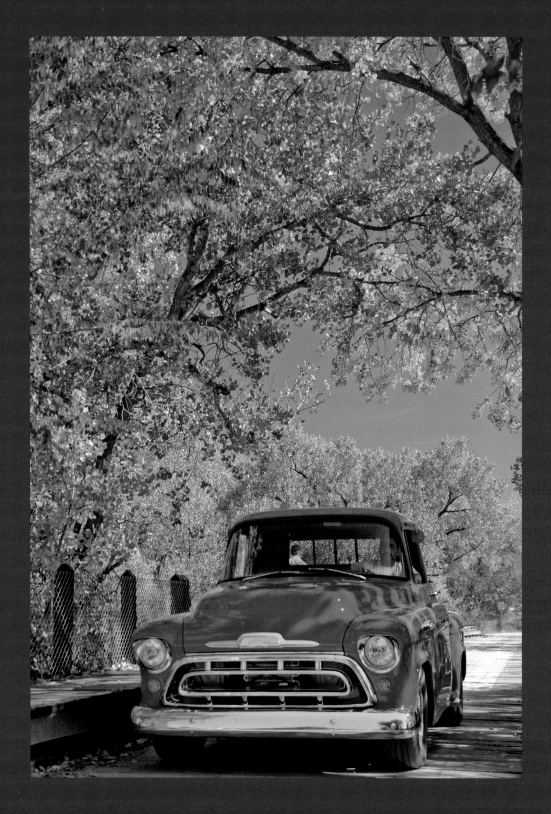

A classic '57 Chevy pickup crosses a single-lane
bridge in the small town of GALISTEO south of
Santa Fe.

AUTUMN

A deep blue shadow falls
On the face of the mountain—
What great bird's wing
Has dropped a feather?
—Alice Corbin Henderson

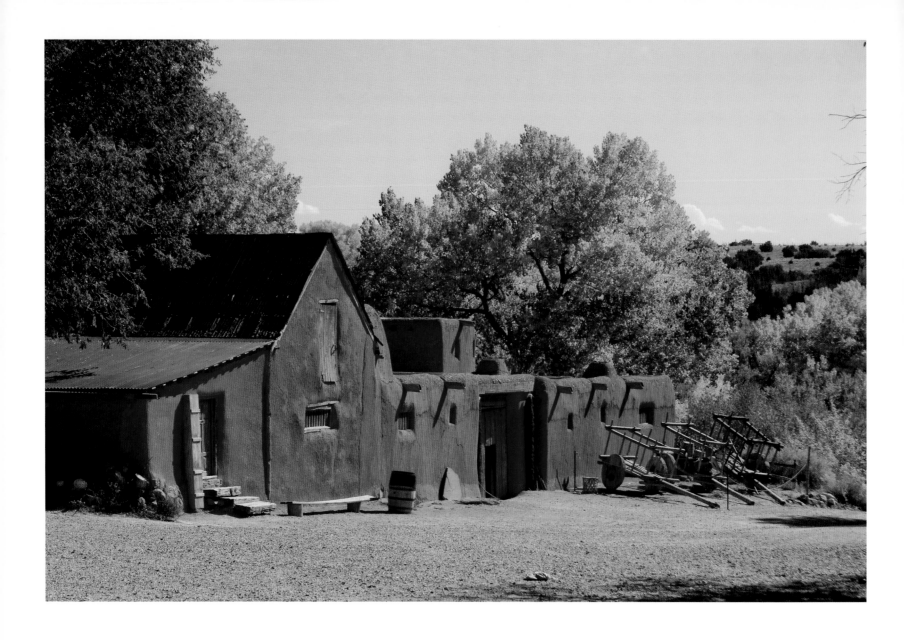

EL RANCHO DE LAS GOLONDRINAS (Ranch of the Swallows) is a Spanish colonial living history museum located at an old Camino Real rest area south of Santa Fe. The museum features historic buildings from the 1700s and 1800s and hosts numerous cultural events and reenactments.

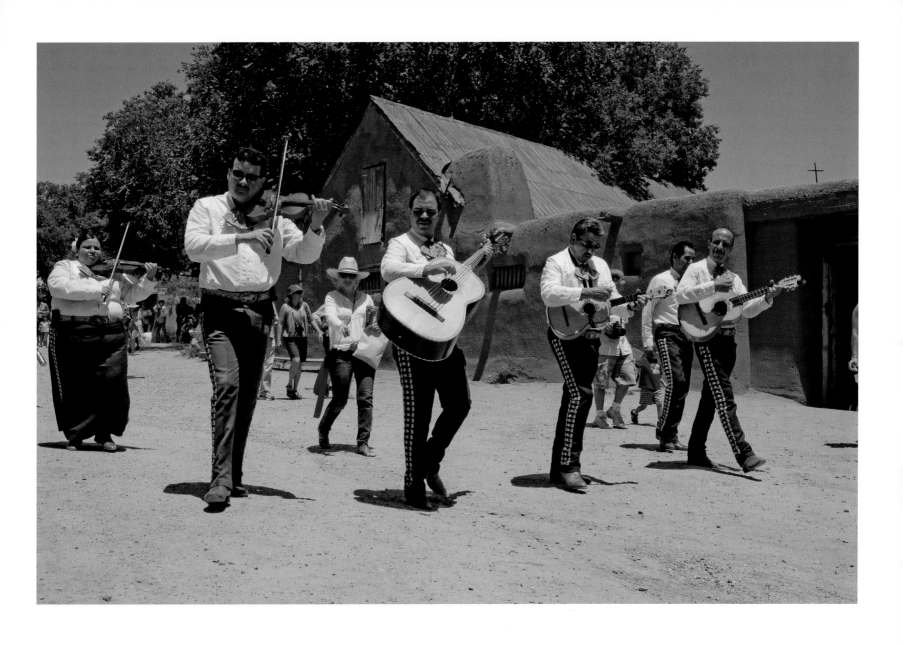

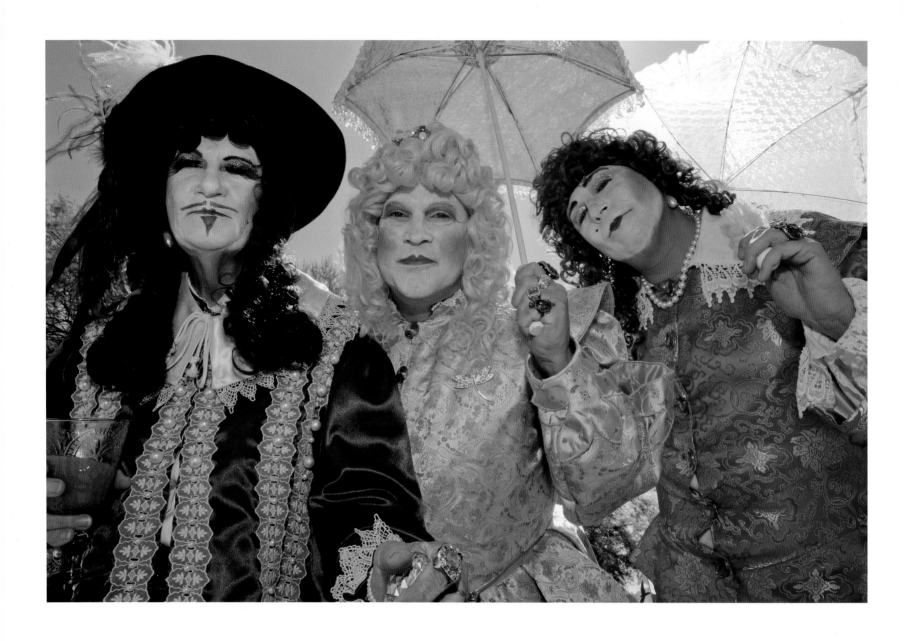

In September El Rancho's popular SANTA FE
RENAISSANCE FAIR celebrates King Arthur–era
themes with jousting knights, jesters, and costumed
royalty.

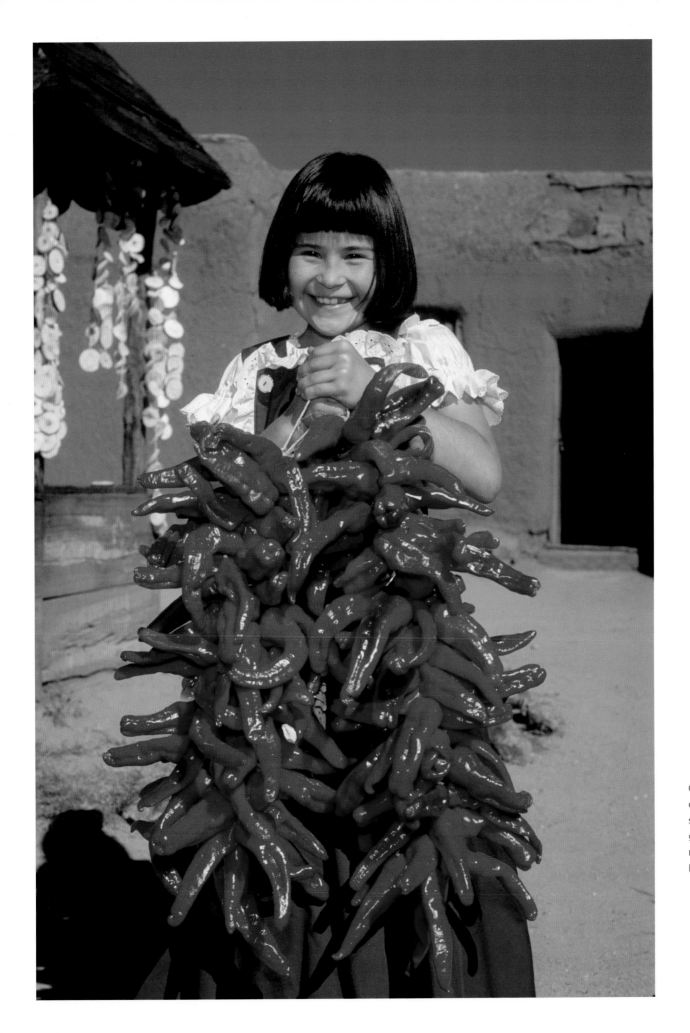

CRYSTELLA GONZALES carries chile ristras strung by her mother and grandmother during the museum's popular Harvest Festival in October.

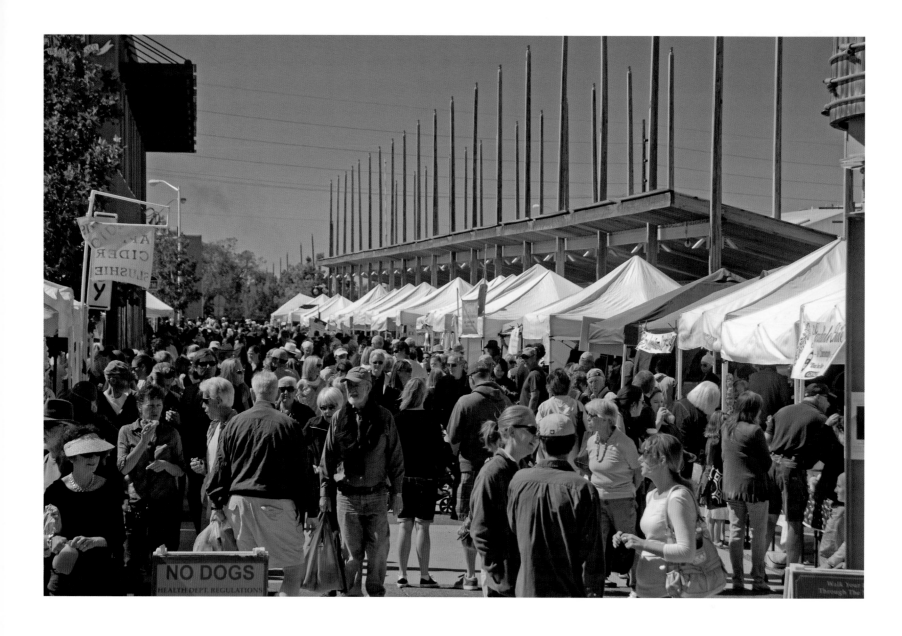

Santa Fe's top-ranked FARMERS
MARKET draws huge crowds of
locals to the Railyard on Saturday
and Tuesday mornings.

OPPOSITE, CLOCKWISE, TOP

MATT ROMERO roasts an assortment of peppers grown on
his Alcalde and Dixon farms. Smelling roasting chile peppers
may be the most intoxicating experience of late summer and
autumn in Santa Fe.

Chimayó farmer TERESA MARTINEZ shares a treat with a
new friend. More than 150 vendors sell their produce at the
Farmers Market. Everything is locally grown.

GREEN CHILE PEPPERS fresh from the fields of Rio Grande
Valley farms await roasting. Chile—red and green—is the
essential ingredient of New Mexico cooking.

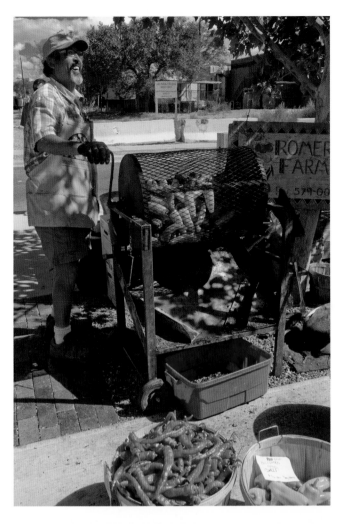

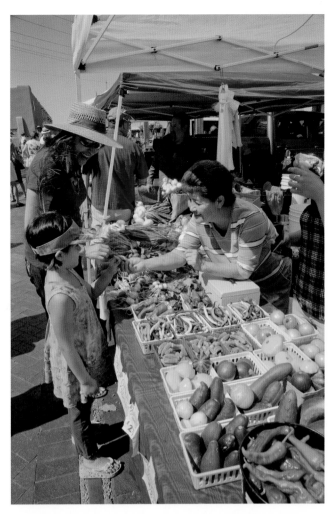

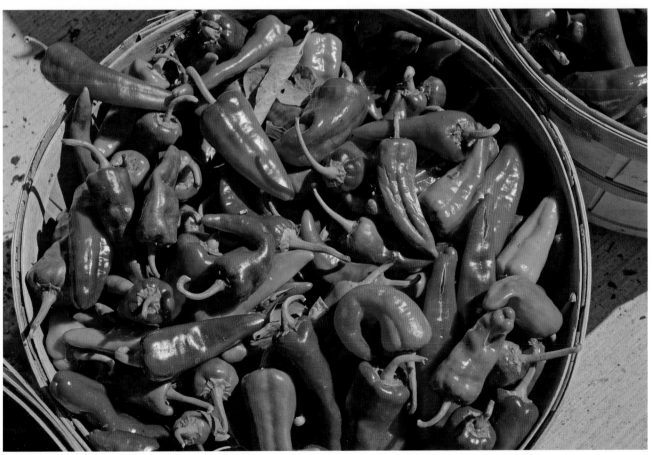

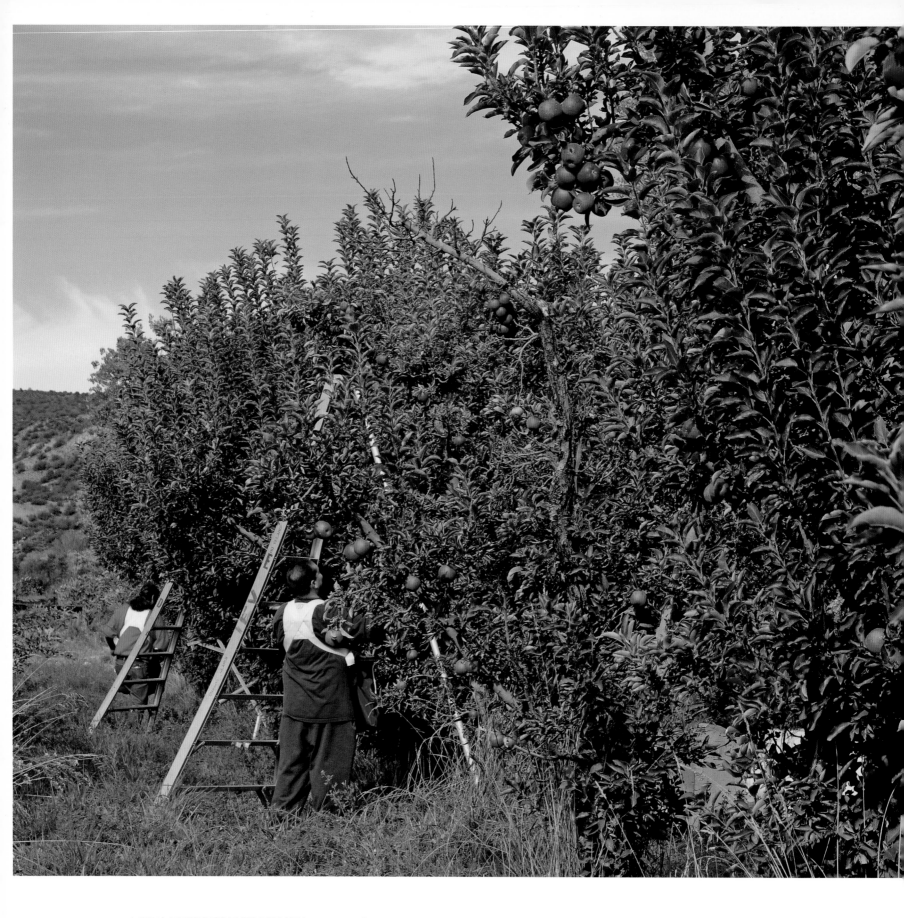

LOCAL WORKERS PICK APPLES in a generations-old Velarde family orchard in the upper Rio Grande Valley. The town of Velarde is named for the family.

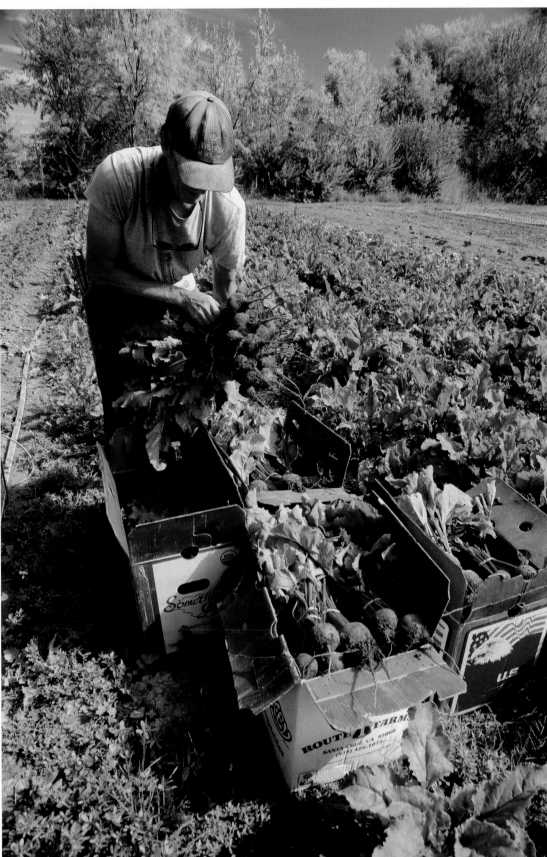

GARY GUNDERSEN of Mr. G's Organic Produce
harvests beets on his certified-organic farm in Jacona.

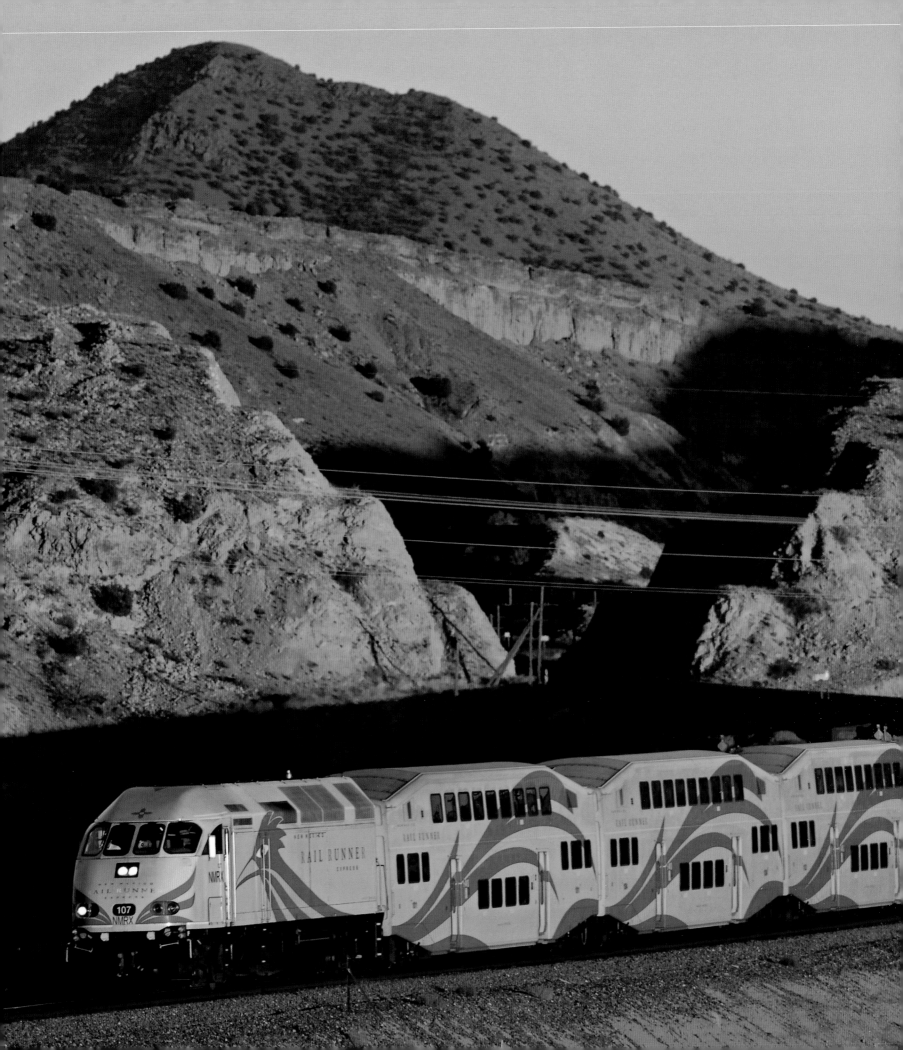

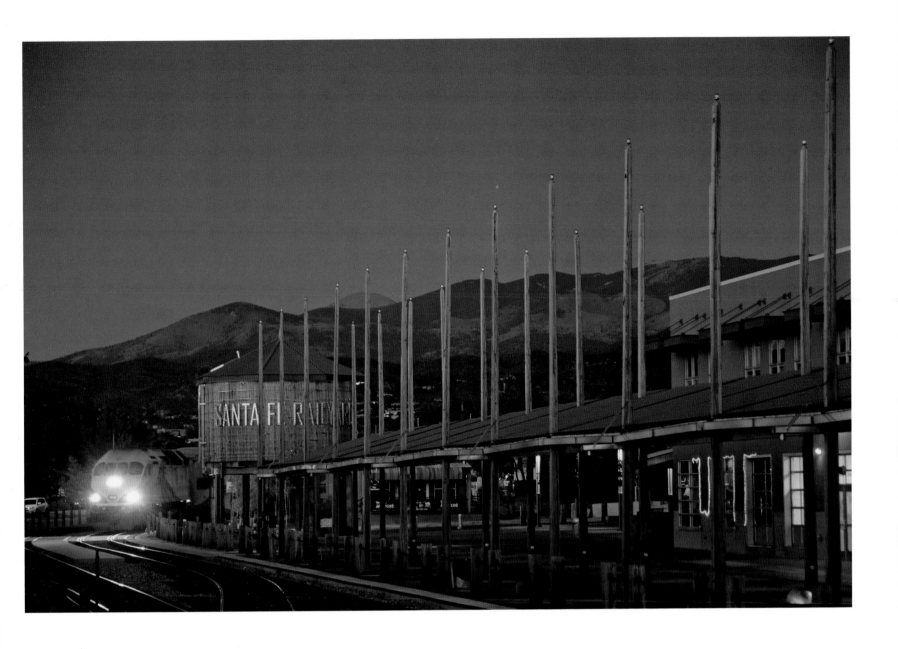

THE RAIL RUNNER EXPRESS is a commuter train connecting Santa Fe with
Albuquerque, Belen, and points between. The Santa Fe extension began service in
December 2008. Its route navigates rugged canyons and skirts along the edges of the
Kewa, San Felipe, Santa Ana, and Sandia pueblos. Beautiful murals that can be seen
only from the train decorate the backs of old warehouses in Albuquerque.

FOLLOWING SPREAD
GOLDEN CHAMISA and PURPLE ASTER are early signs of autumn.

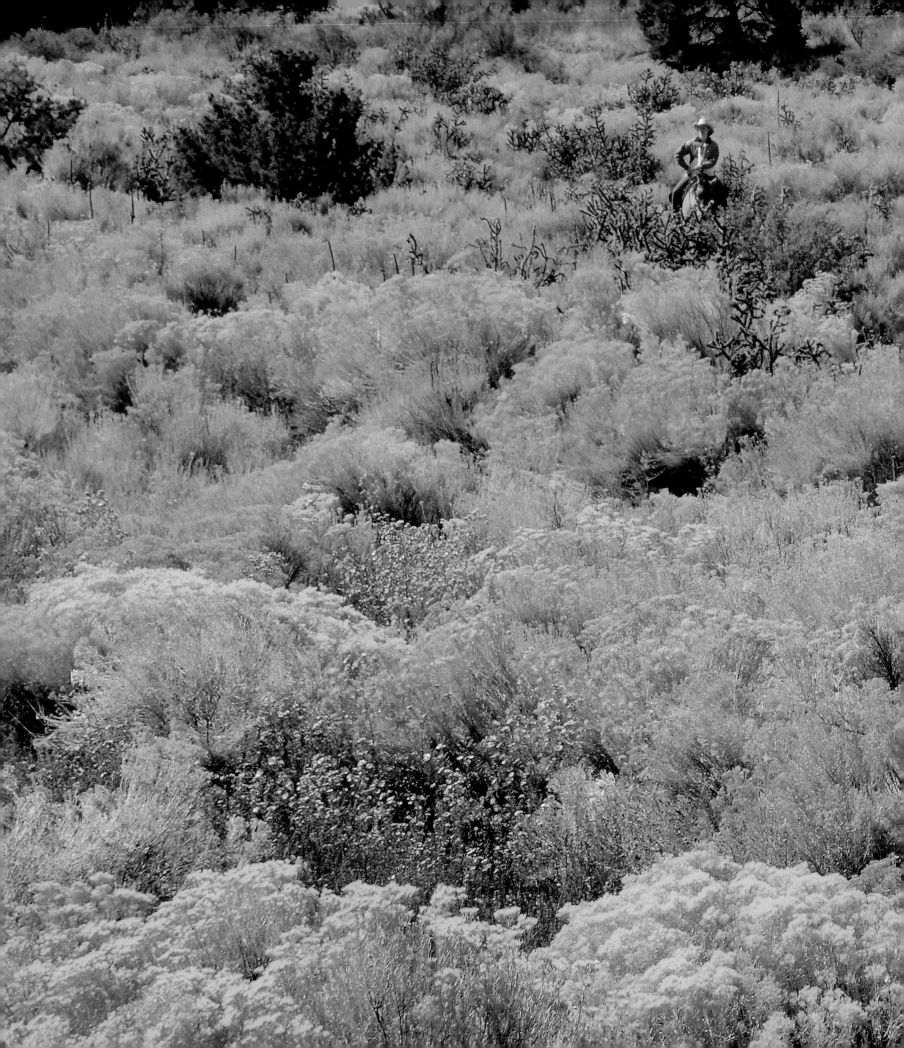

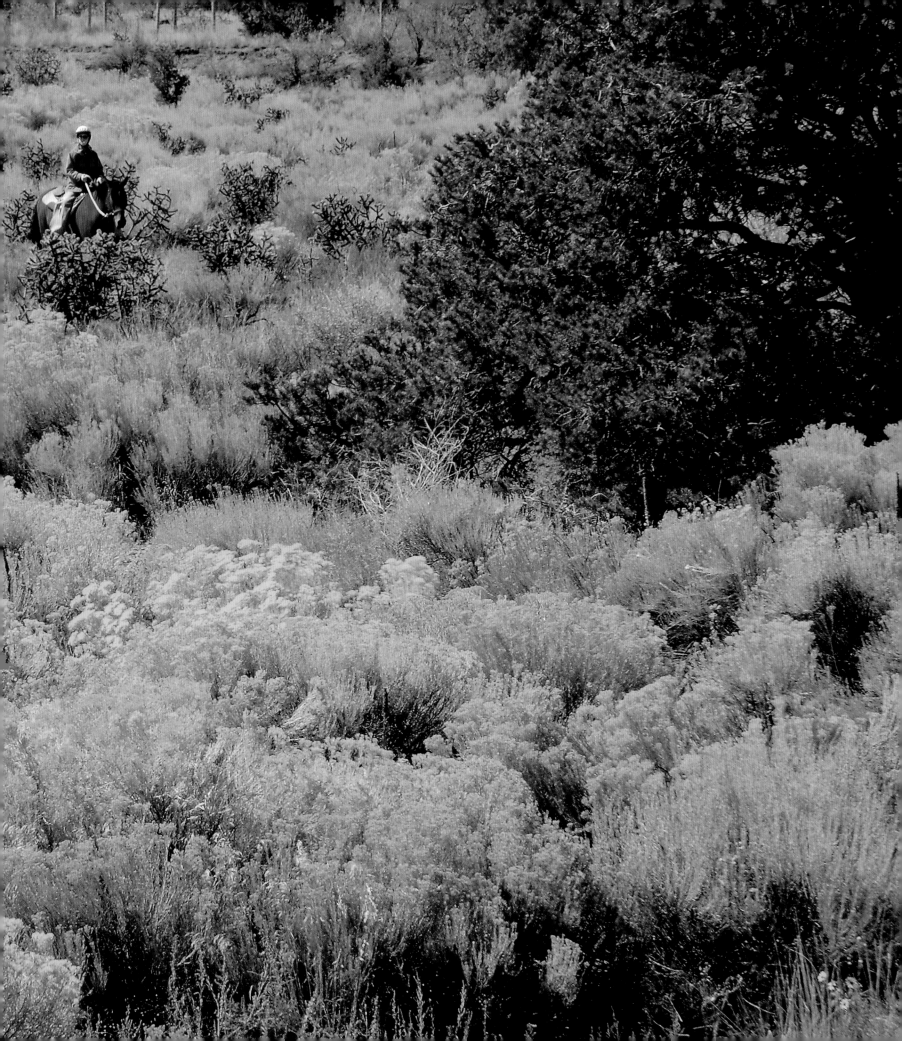

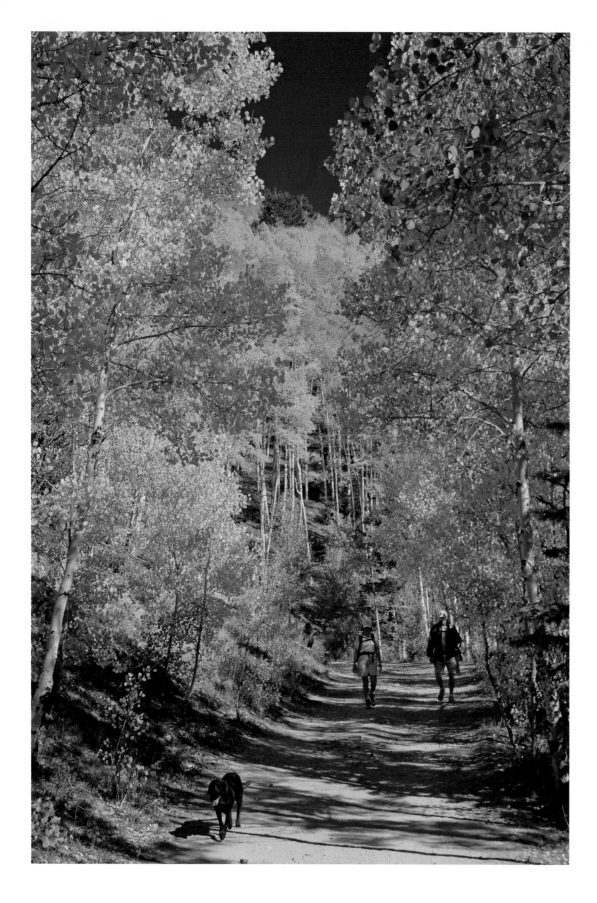

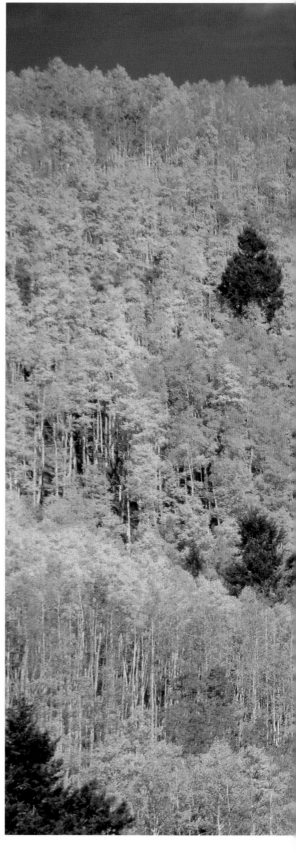

Hikers flock to the ASPEN VISTA TRAIL near Ski Santa Fe.

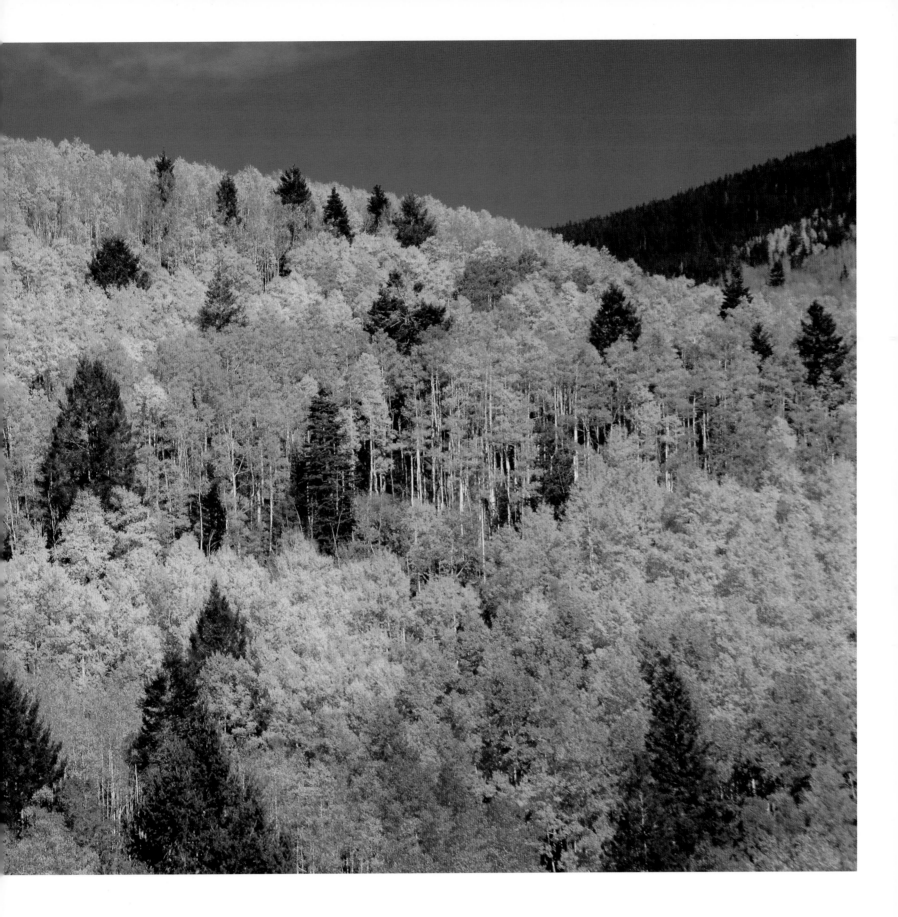

BRILLIANT FALL COLORS paint the mountainsides in October.

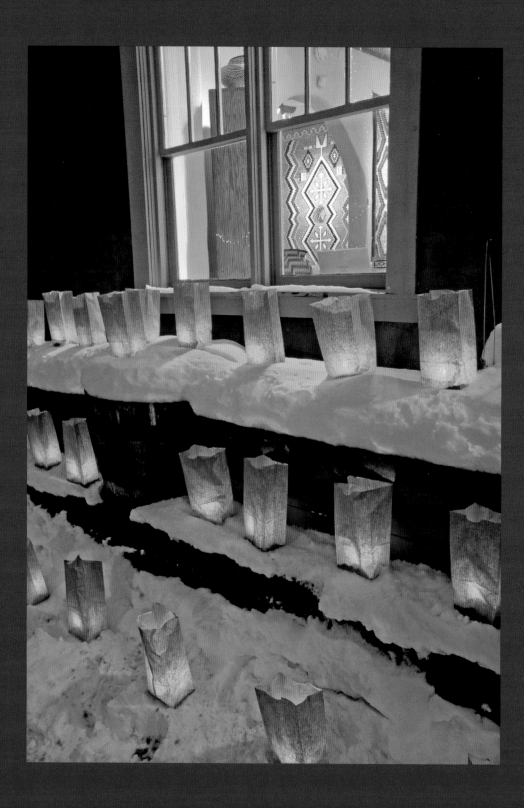

Rows of glowing FAROLITOS—paper bags with lit candles—decorate a Canyon Road gallery on Christmas Eve. The bonfires built for warmth are called LUMINARIAS.

WINTER

I saw it first in December, 1940,

the high plateau among the red and purple mountains . . . ,

the tawny earth dotted with . . .

small dark pines so it looked like a leopard skin. . . .

I was unprepared in every way, unprepared for the air itself

—May Sarton

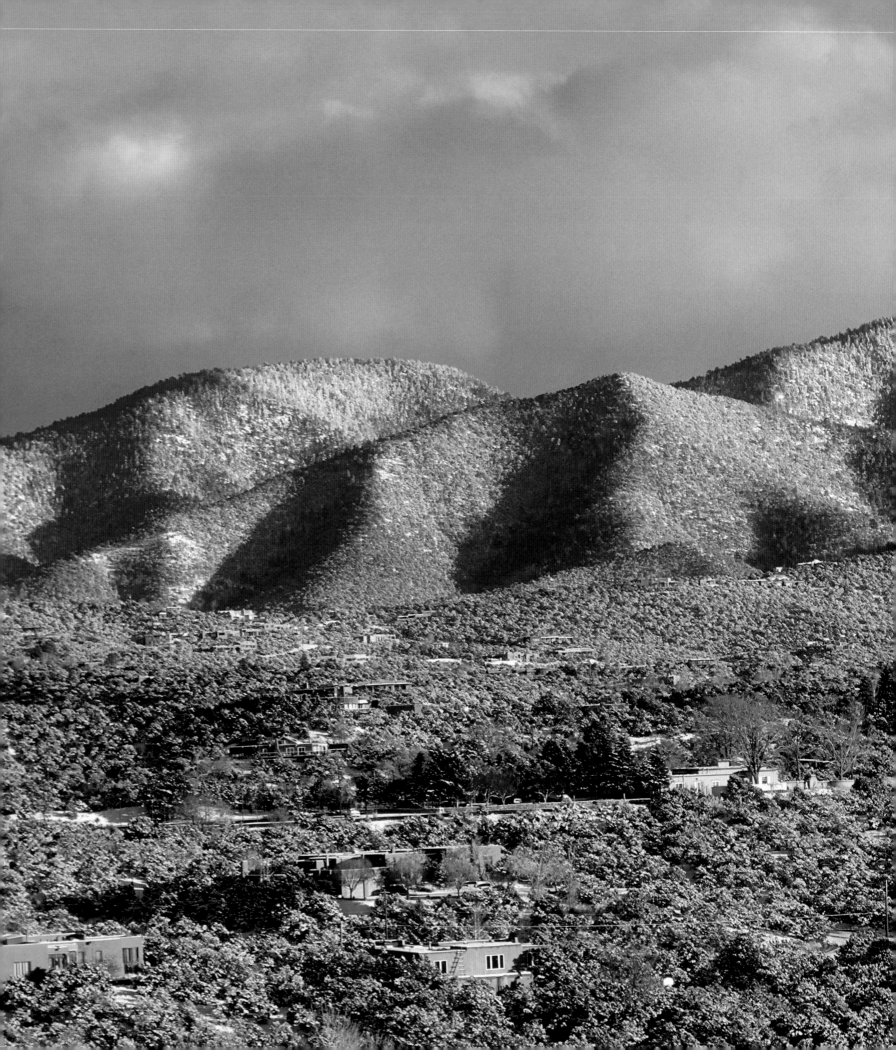

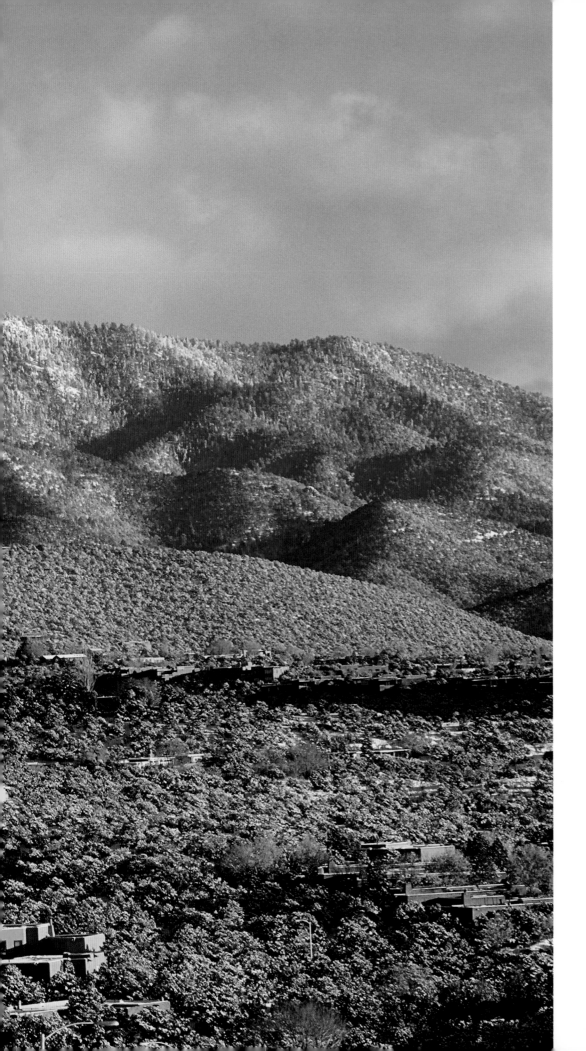

An early snowfall blankets Santa Fe's
northeast neighborhoods and FOOTHILLS
of the Sangre de Cristo Mountains.

FOLLOWING SPREADS
A FULL MOON RISES above snow-covered
mountains at sunset.

123

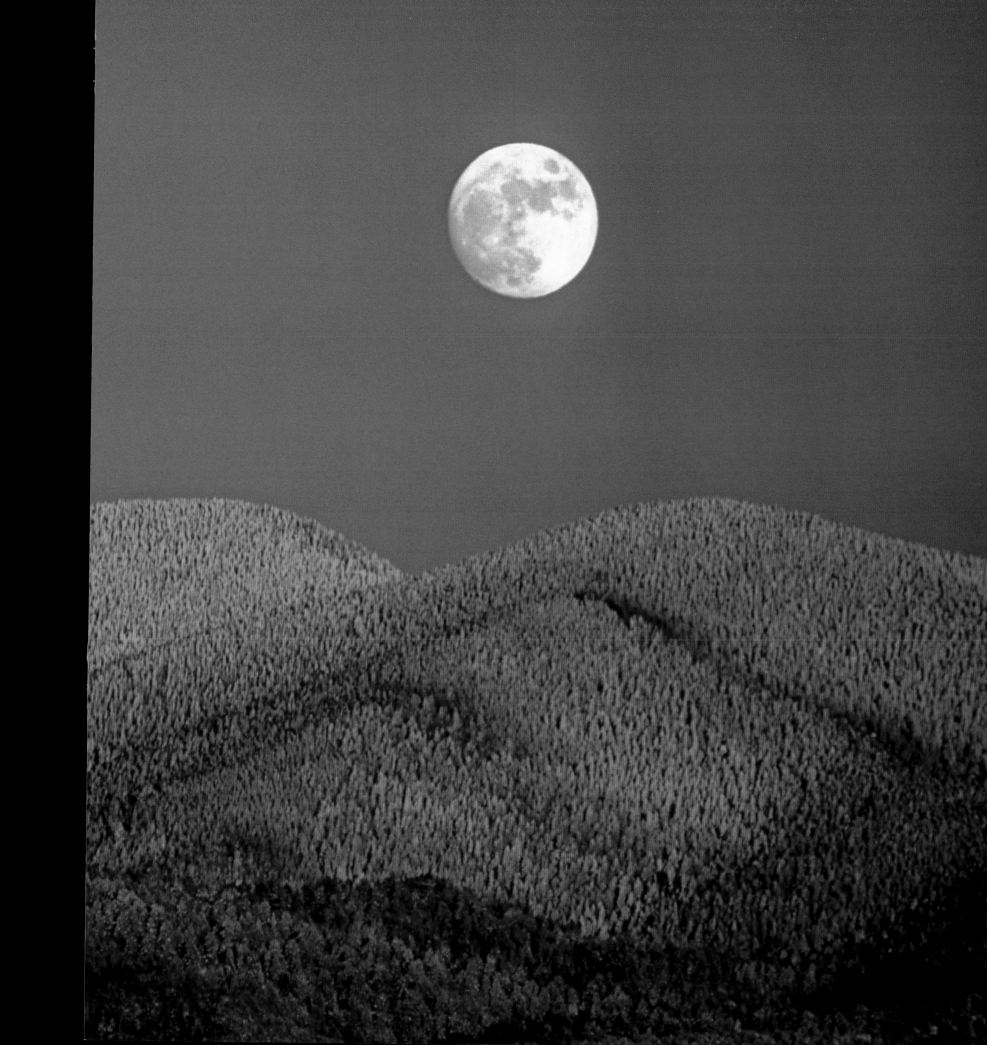

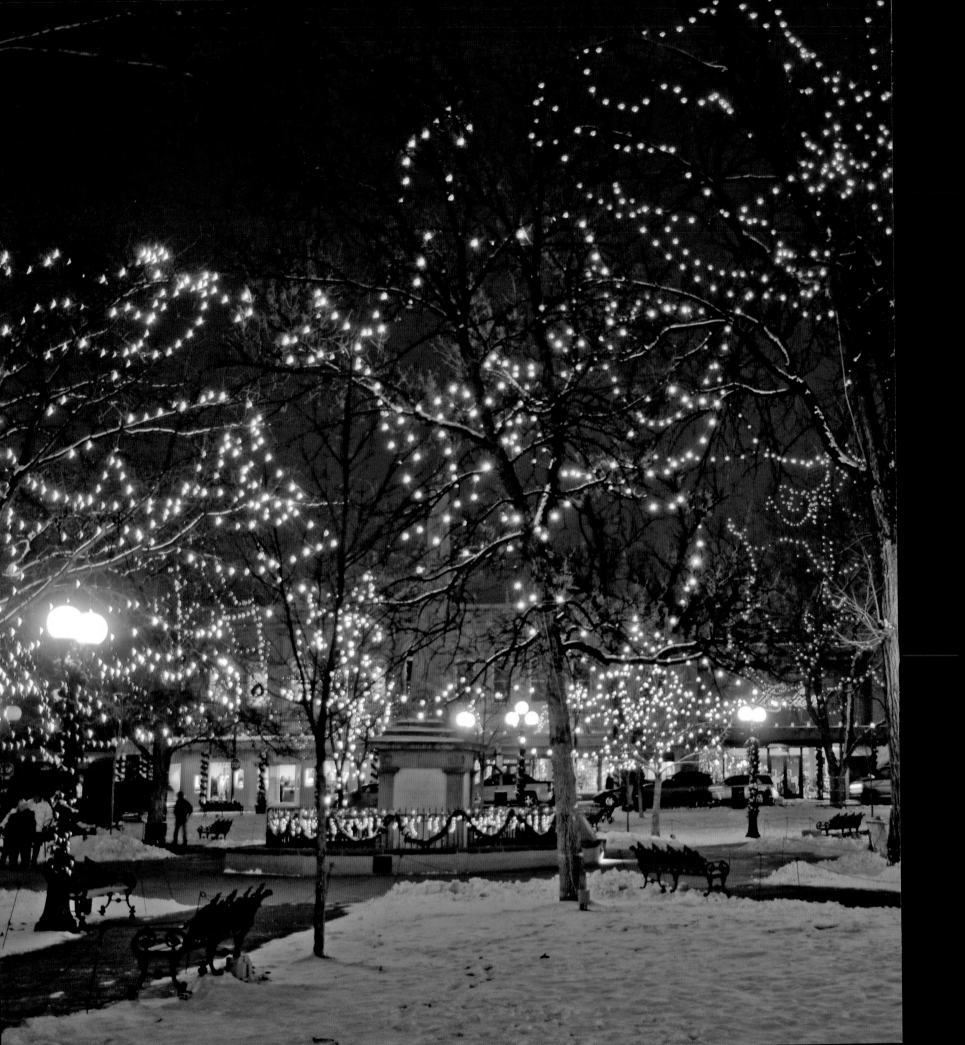

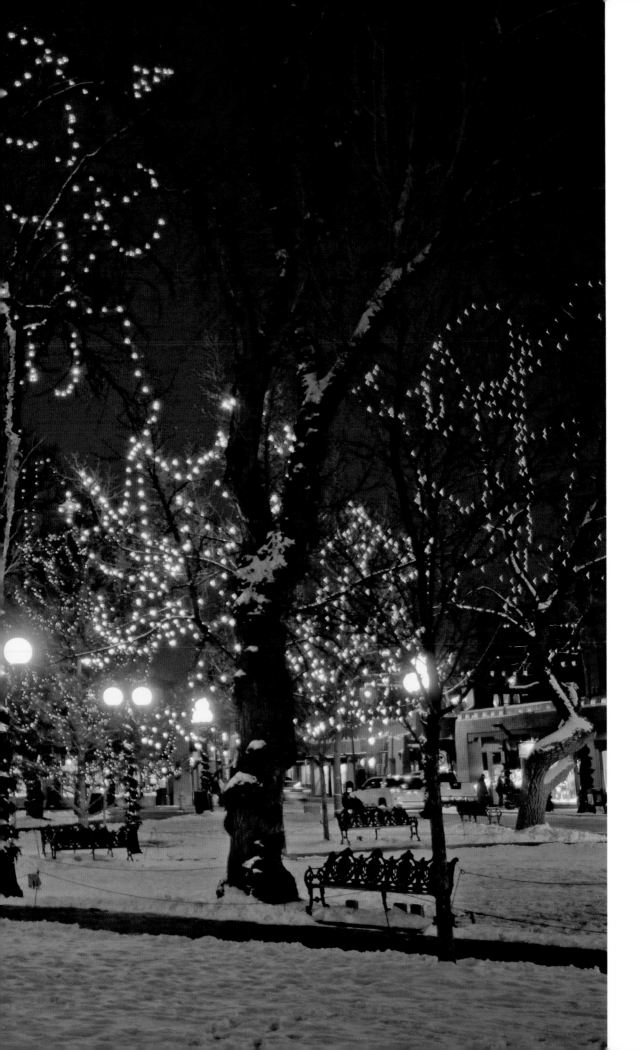

CHRISTMAS LIGHTS
brighten the plaza at dusk.

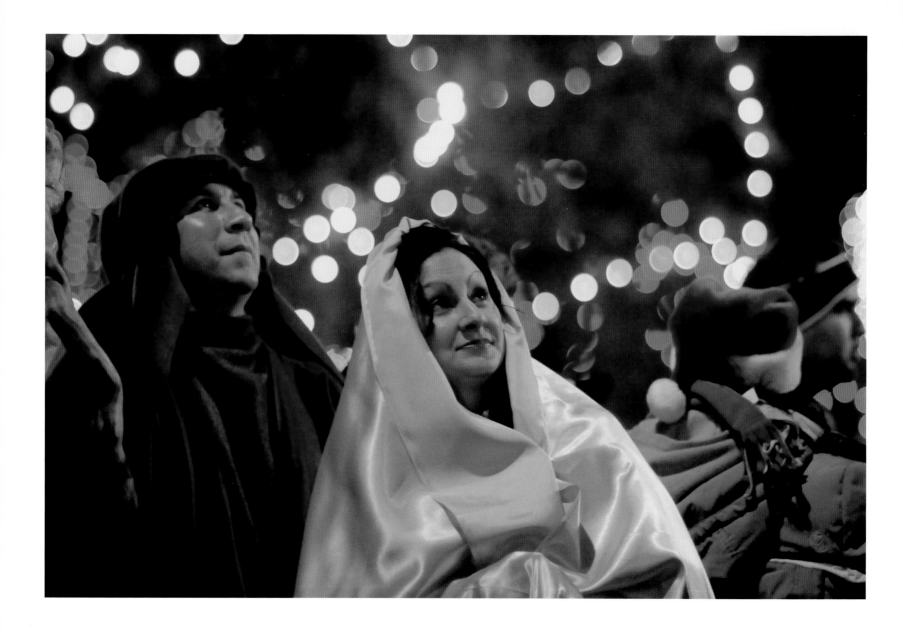

Sylvia Montoya and Ted Ortiz play MARY AND
JOSEPH in the La Posadas event on the plaza,
a popular folk reenactment of Mary and Joseph
searching for shelter in Bethlehem.

OPPOSITE
The CATHEDRAL and PLAZA area bustles with
holiday shoppers.

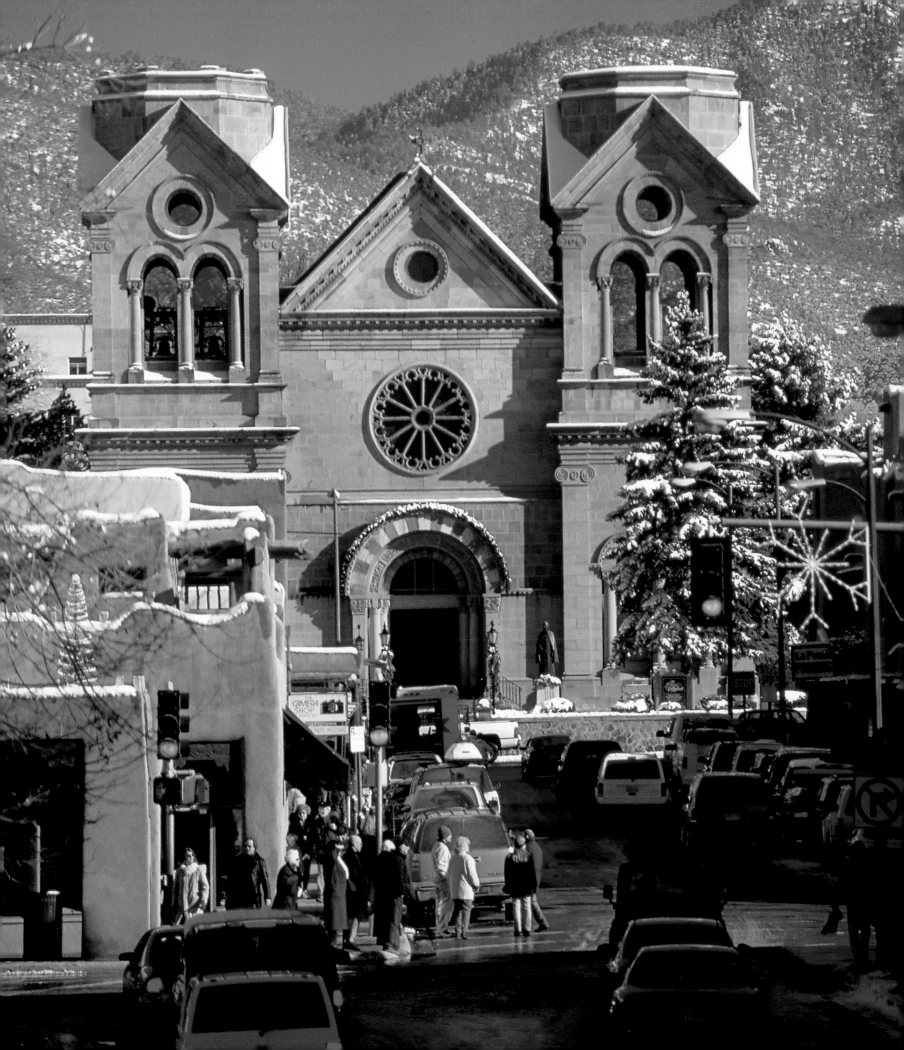

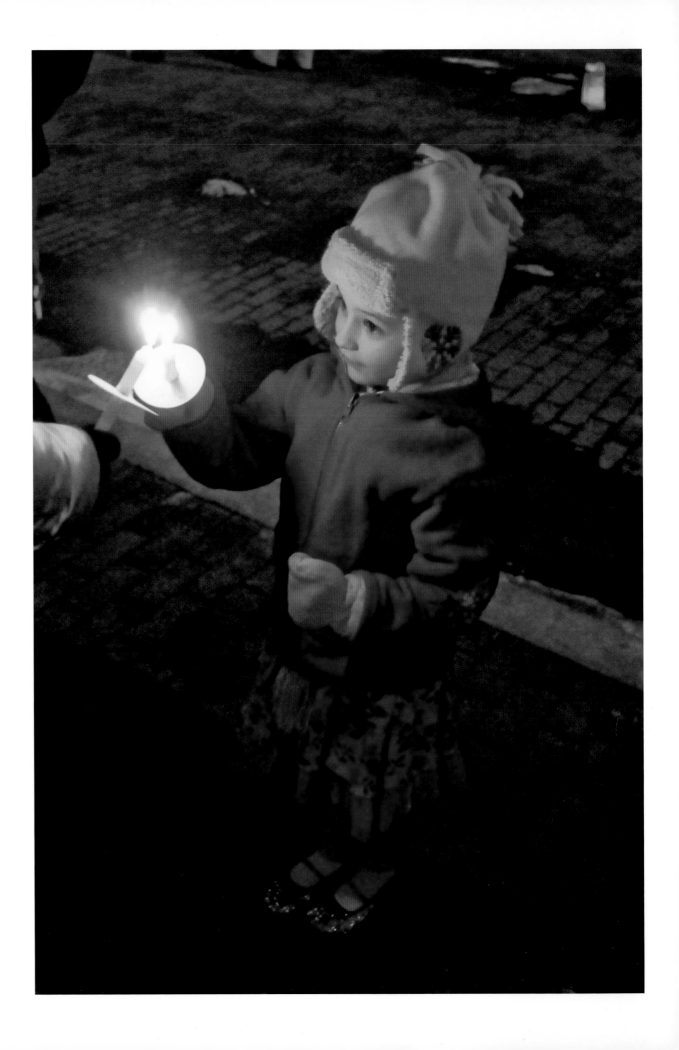

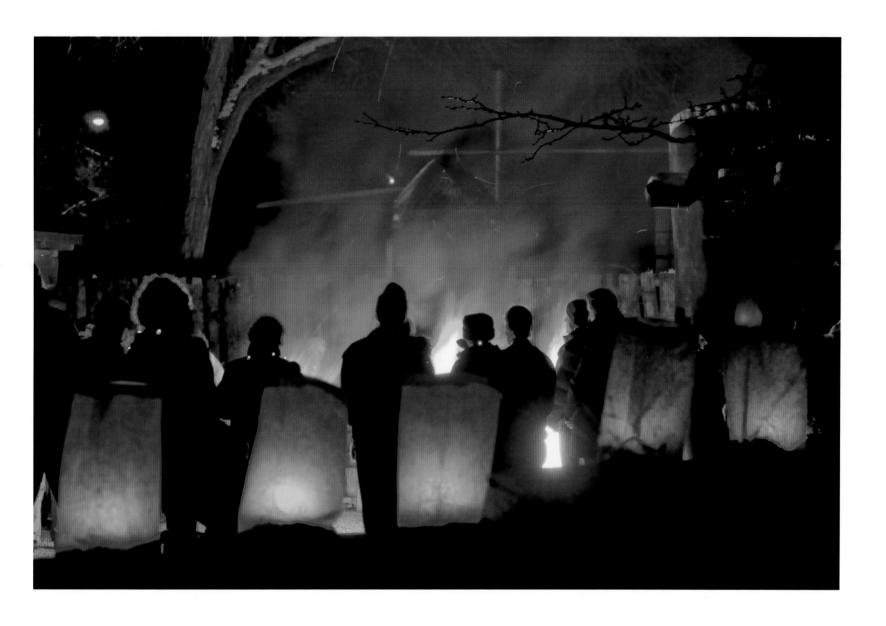

The CANYON ROAD neighborhood on Christmas
Eve brings thousands of revelers to the historic
east side to celebrate the holiday spirit.

OPPOSITE
A young Santa Fean participates in the annual
LAS POSADAS.

FOLLOWING SPREAD
Farolitos illuminate a historic home on ACEQUIA
MADRE.

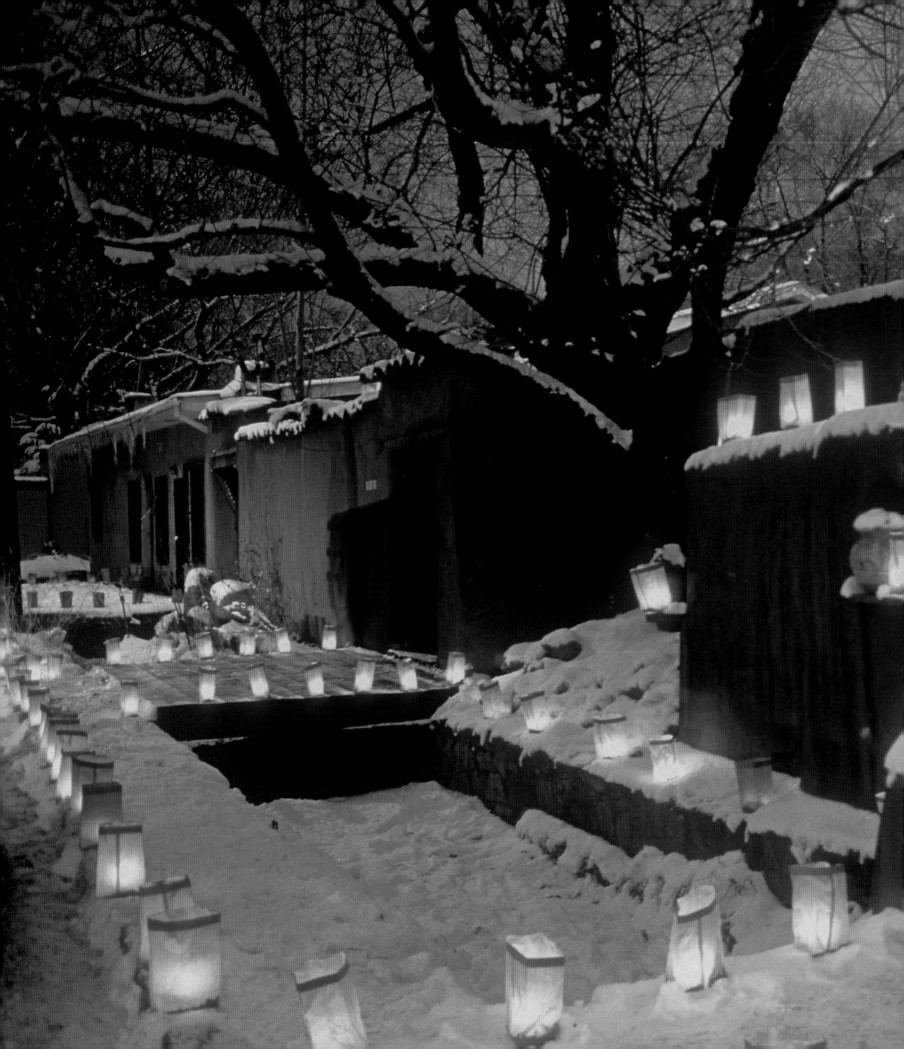

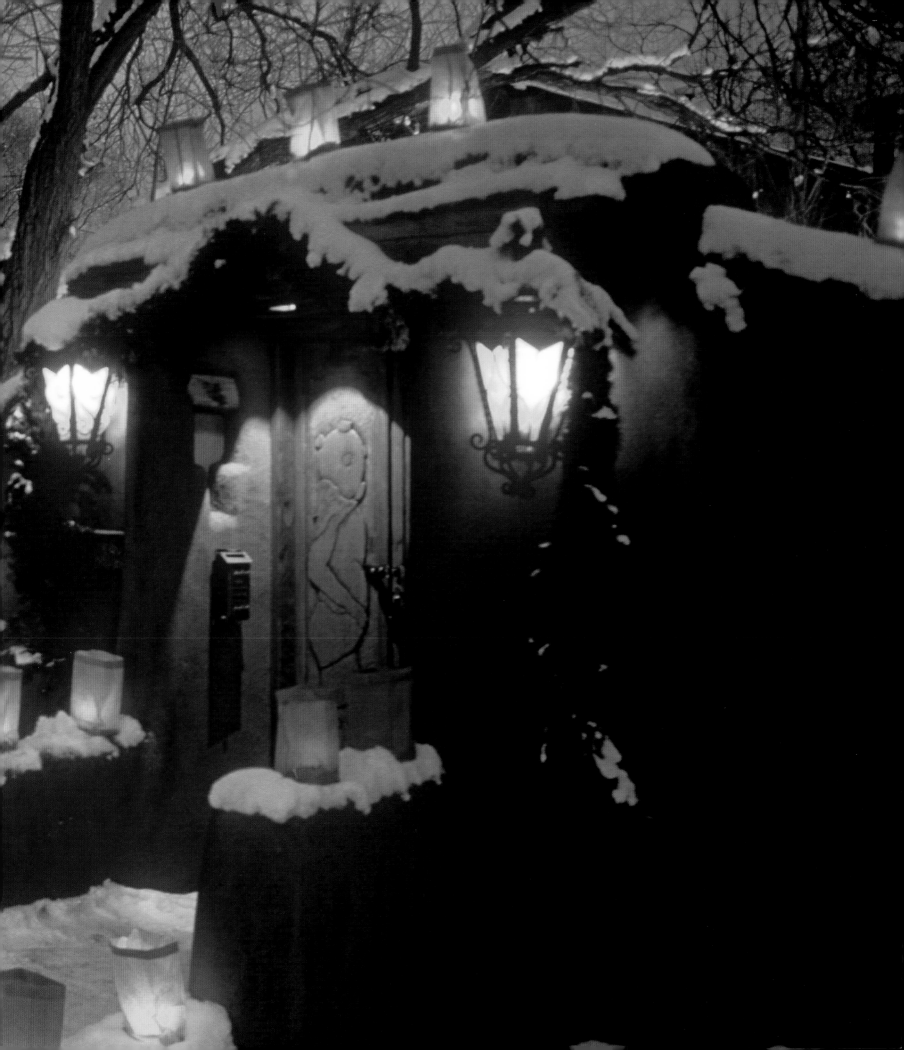

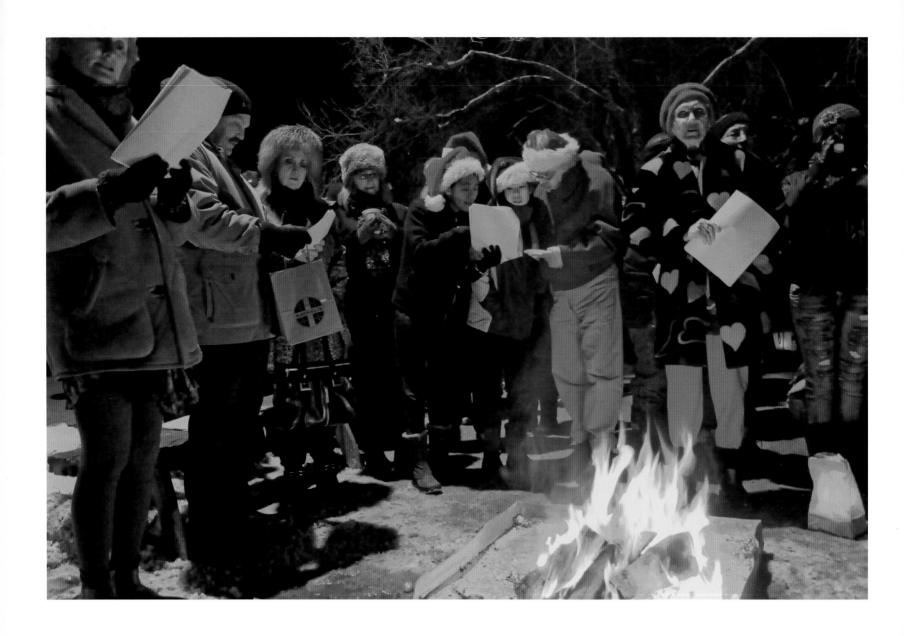

Carolers gather AROUND A LUMINARIA along
Canyon Road.

OPPOSITE
EL SANTUARIO DE
CHIMAYÓ north of Santa
Fe shines bright on
Christmas evening.

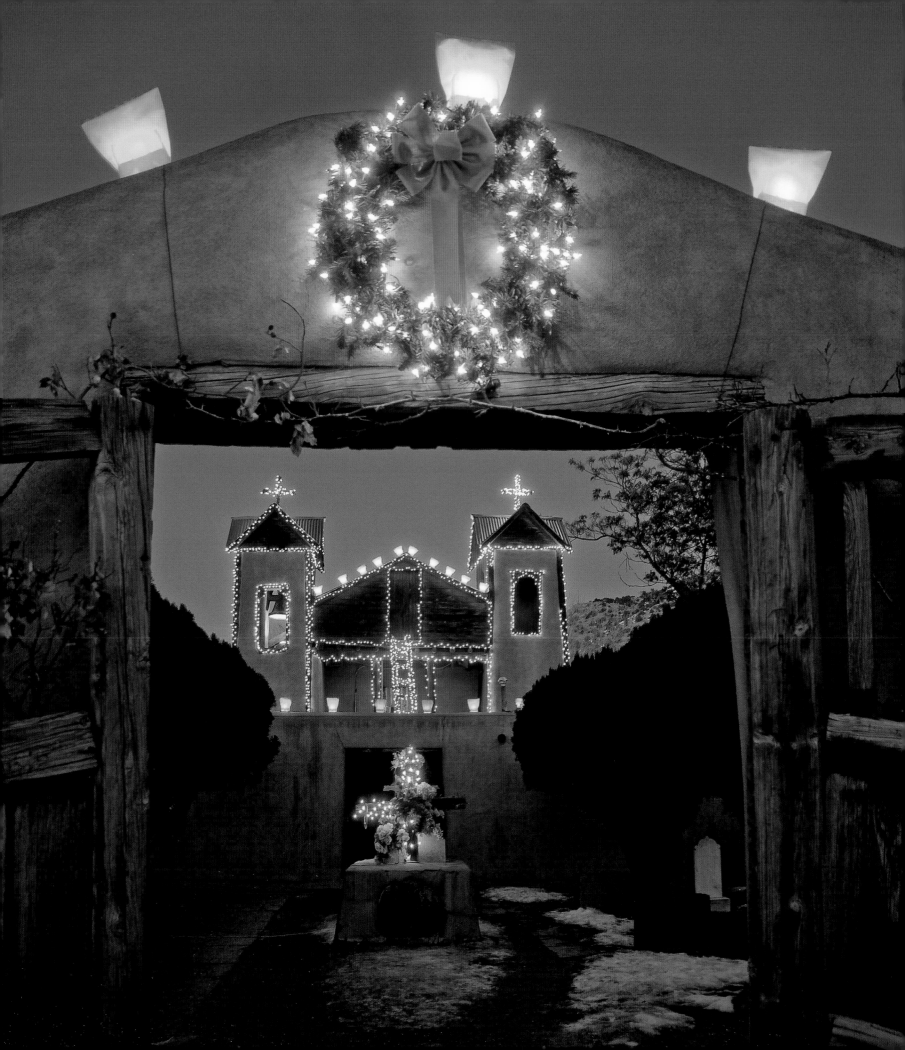

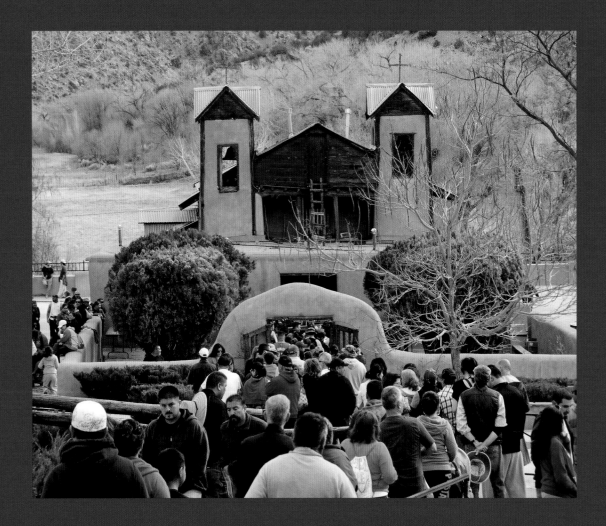

Known for its miraculous healing dirt, EL SANTUARIO
DE CHIMAYÓ is the most visited Catholic pilgrimage
destination in the United States. Thousands of faithful
Christians walk to Chimayó every Good Friday. Some
pilgrims walk only a few miles; others walk hundreds.
Some bear heavy crosses, and others talk and text on
cell phones.

SPRING

"... the water is clear as crystal and filled with cress."

—Santa Fe Weekly Gazette, April 28, 1855

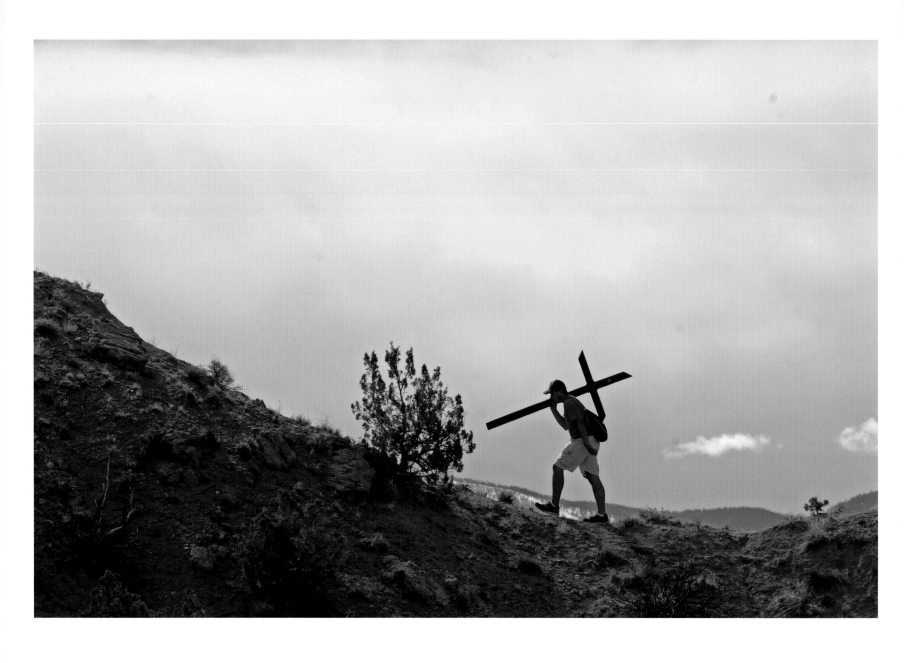

A GOOD FRIDAY PILGRIM visits a hilltop shrine
on his journey.

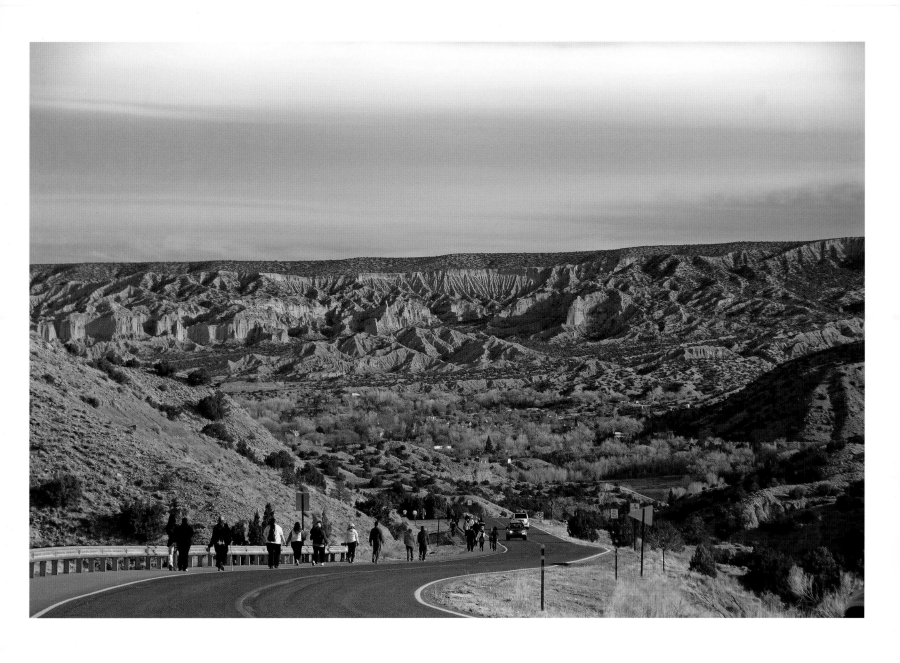

PILGRIMS DESCEND into the Chimayó Valley
during early morning.

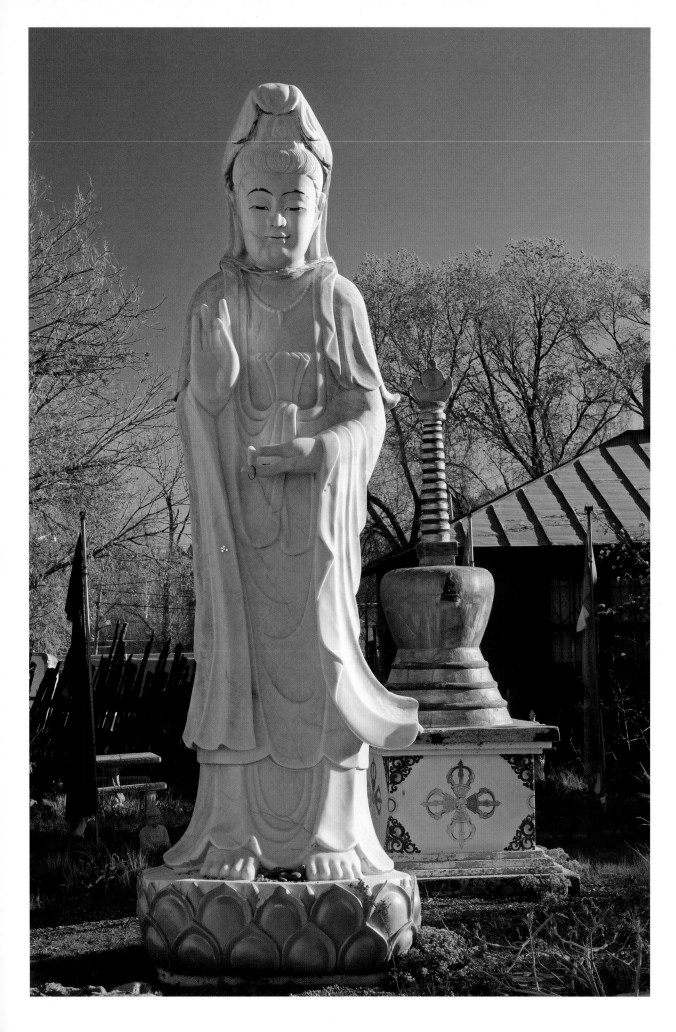

PROJECT TIBET features a Buddha garden and gallery of Tibetan art. Santa Fe has long been a melting pot of cultures and religions. Historically Catholic, the town is also home to many Buddhists, Hindus, Muslims, and a variety of New Age practitioners. Tibetan Buddhism maintains a strong presence, and several teaching centers and a stupa serve the community.

OPPOSITE
BUDDHIST PRAYER FLAGS fly outside the Tibetan Association of Santa Fe, an organization dedicated to the preservation of Tibetan culture. Santa Fe has welcomed many immigrant families through the Tibetan Resettlement Project.

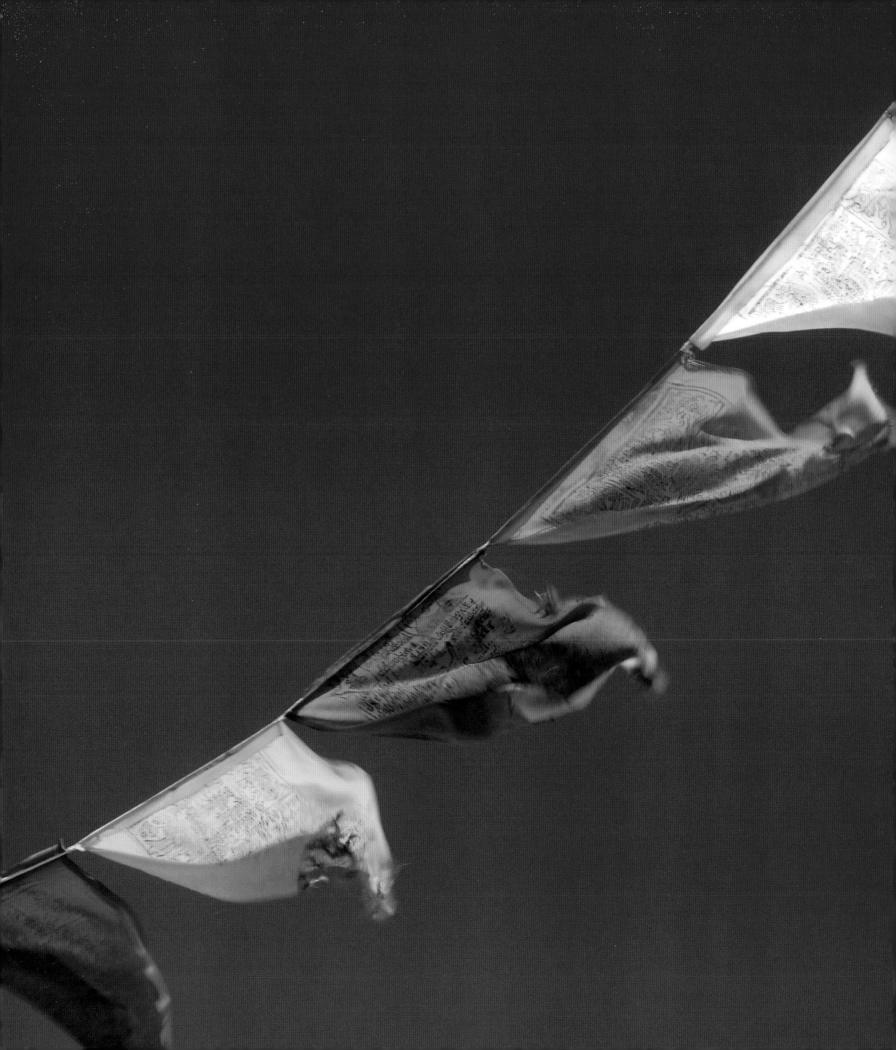

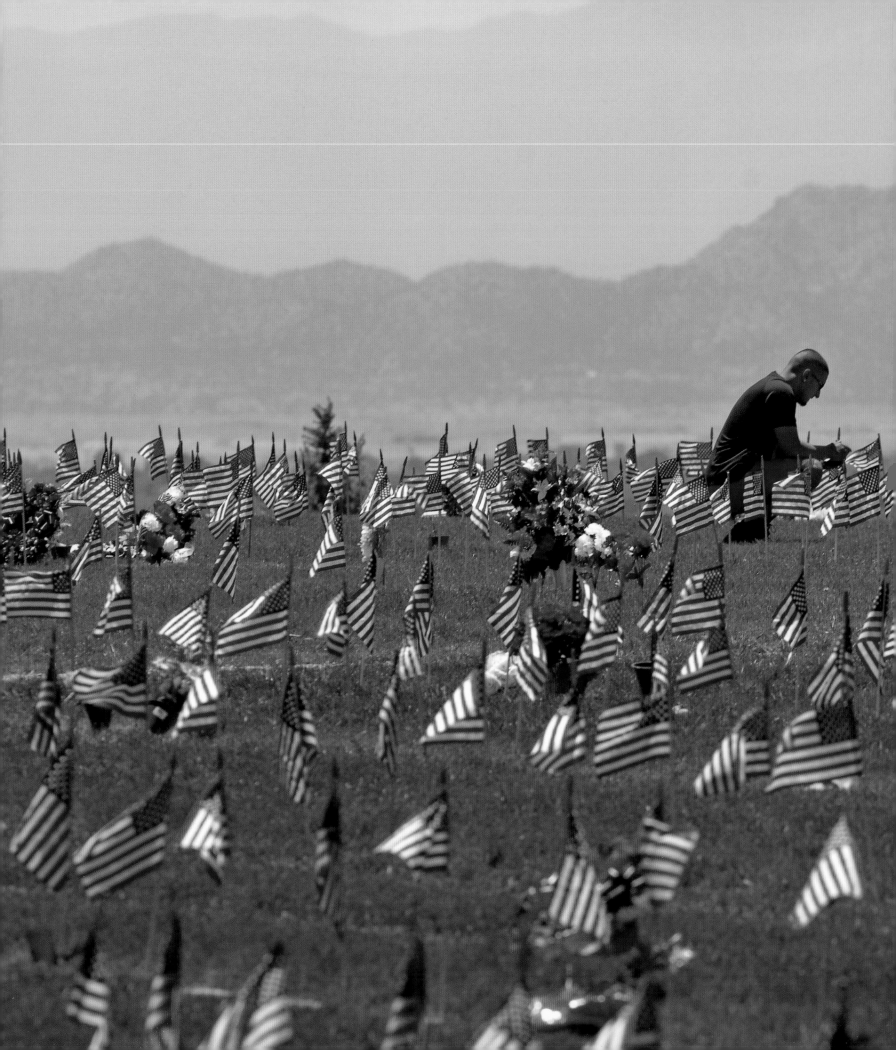

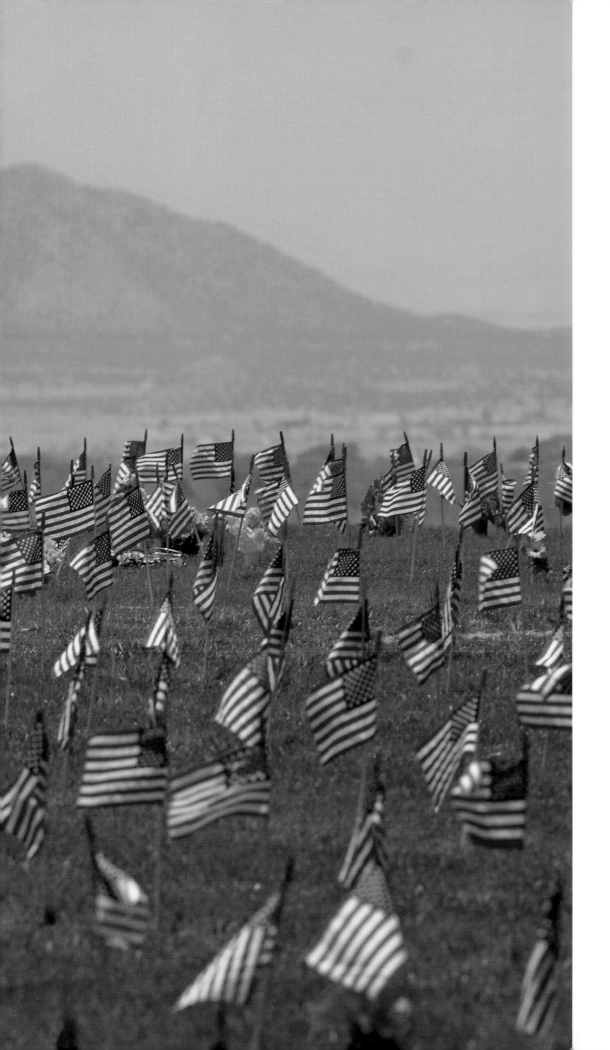

A Memorial Day visitor pauses at a gravesite in SANTA FE NATIONAL CEMETERY. The large and immaculately maintained military cemetery was established at the end of the Civil War.

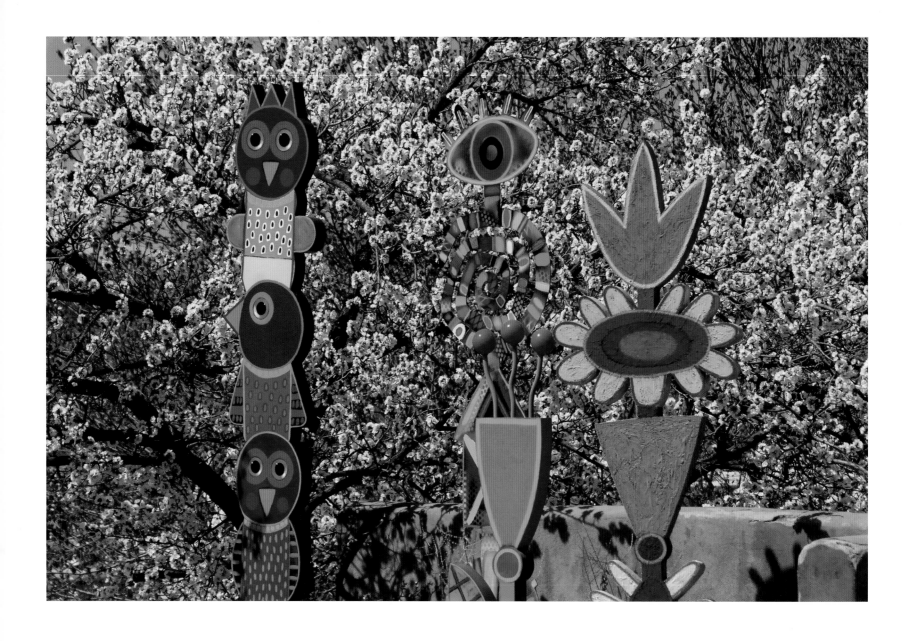

TERRELL POWELL'S whimsical totem sculptures stand outside a Canyon Road gallery.

OPPOSITE
Spring waters flow through the 400-year-old ACÉQUIA MADRE (mother ditch) in Santa Fe's eastside. Flowing once a week during growing season, the acéquia delivers irrigation water from the Santa Fe River to the historic neighborhood's gardens and trees.

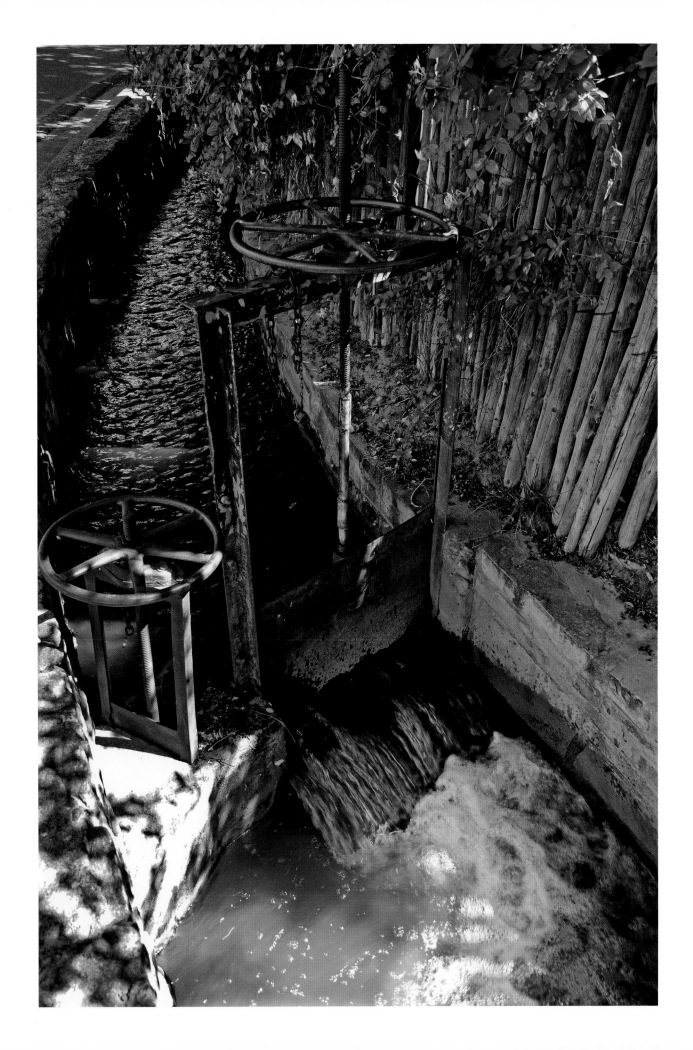

LILACS BLOOM above an antique carved gate along Camino del Monte Sol.

CRABAPPLES are among
Santa Fe's most vibrant spring
performers.

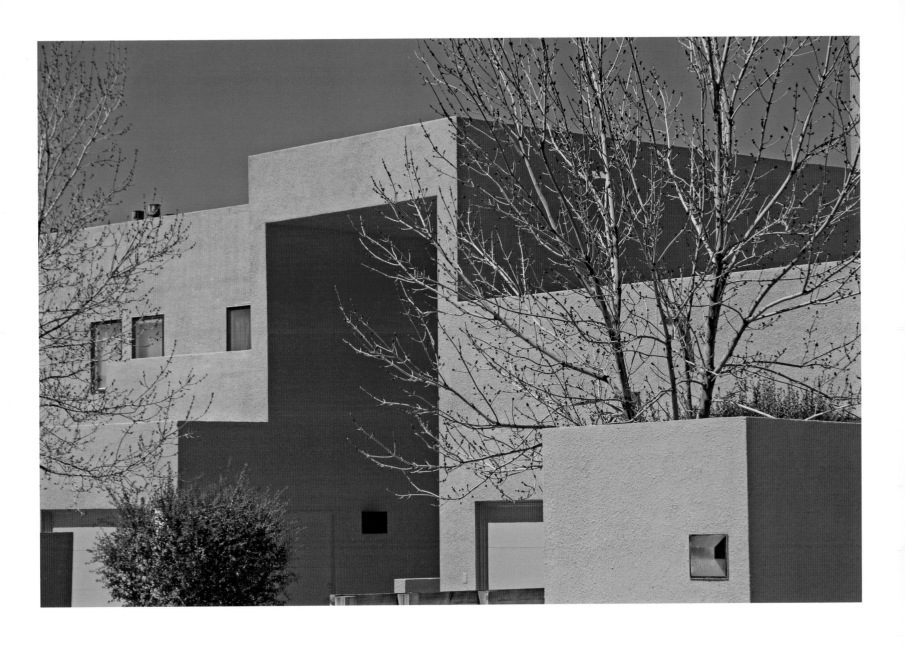

The Zocalo residential community
at the northern edge of town was
designed by world-renowned
architect RICARDO LEGORRETA.

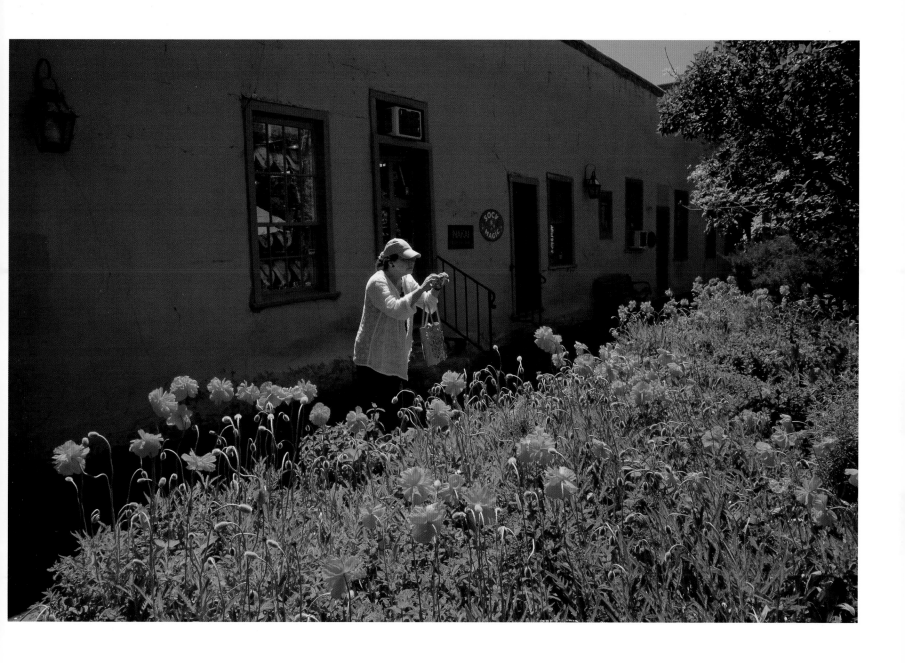

POPPIES BLAZE BRIGHT inside the Territorial-style
Sena Plaza courtyard.

OPPOSITE
Redbud trees paint the SENA PLAZA COURTYARD
with deep pinks in May.

CHERRY BLOSSOMS herald spring's arrival at the John Gaw Meem–designed National Park Service office compound on Old Santa Fe Trail.

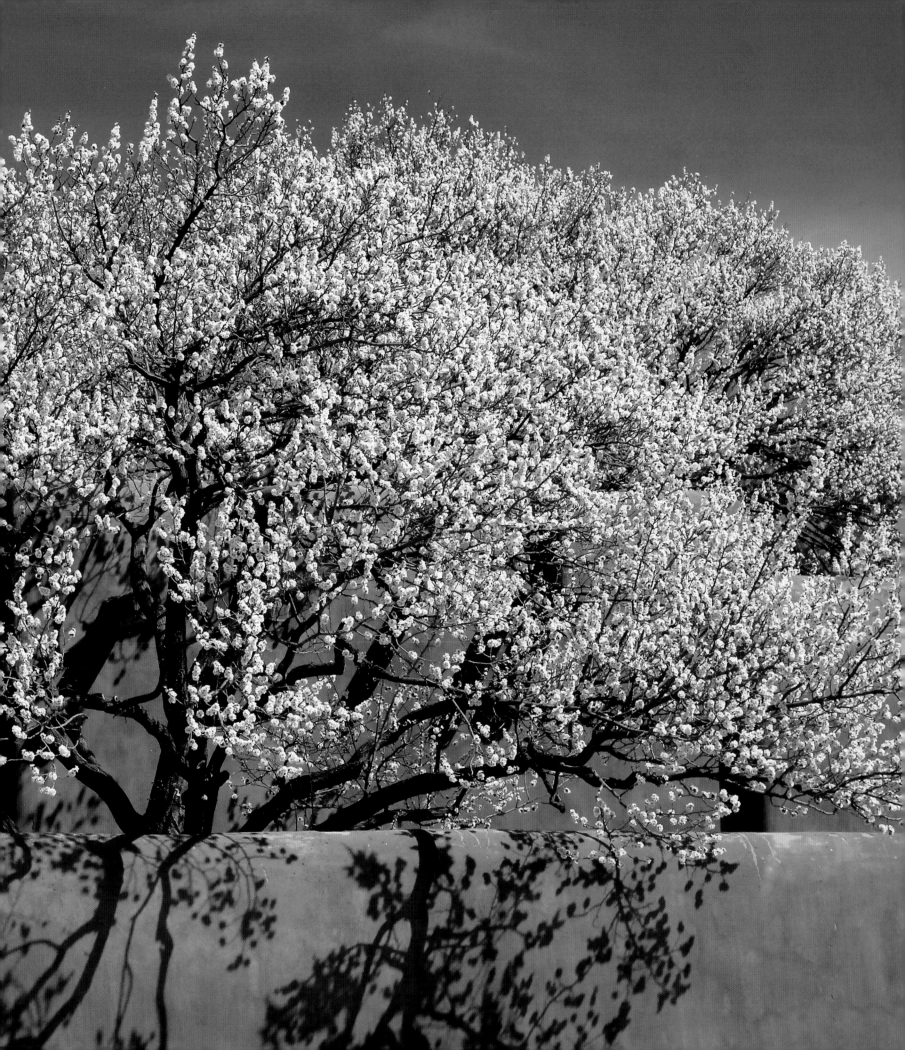

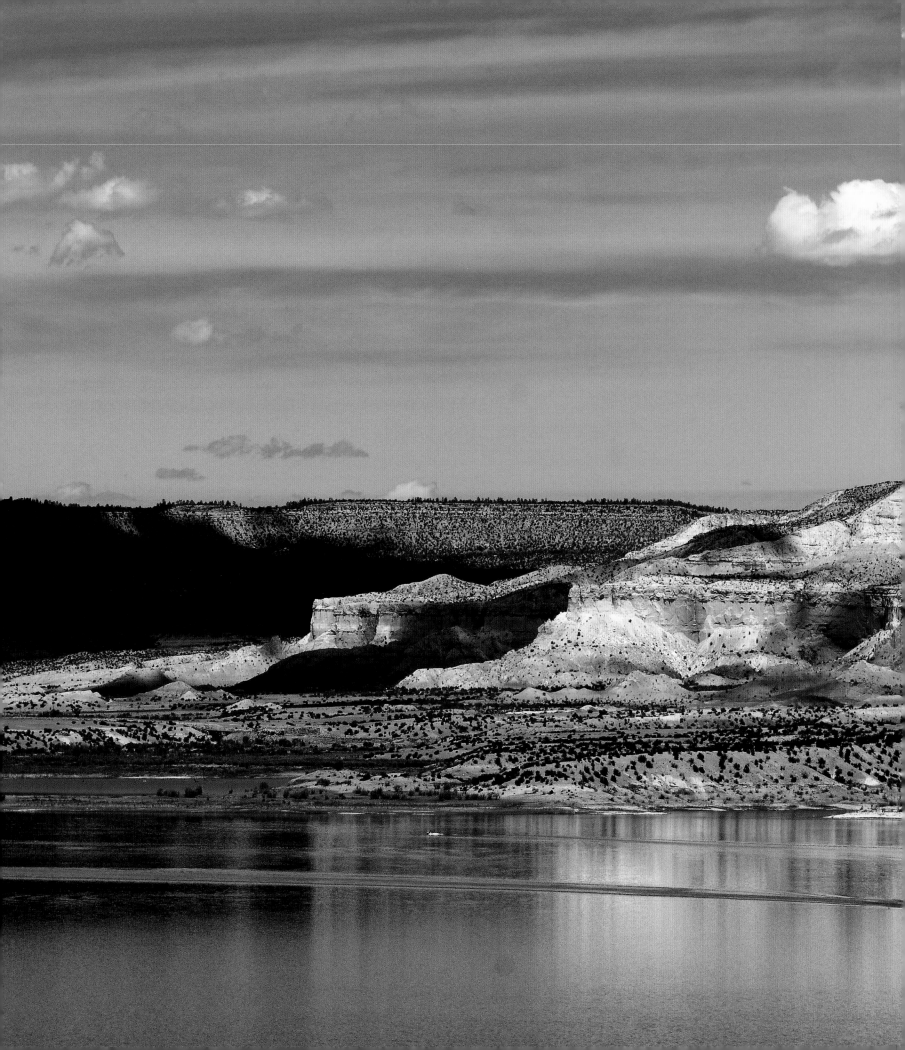

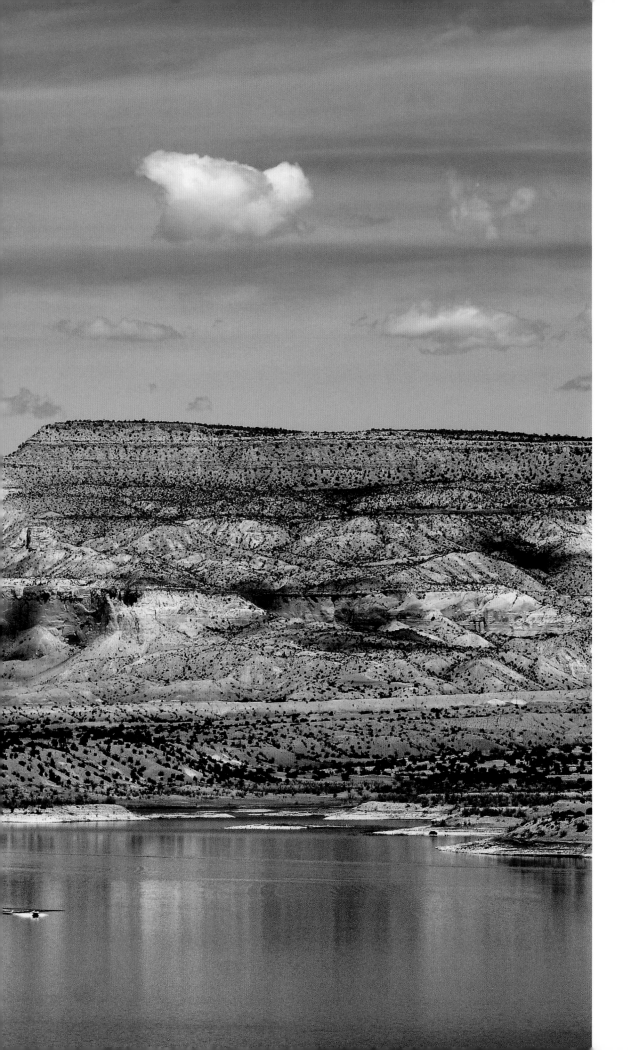

OUT OF TOWN

Santa Fe is surrounded with some of the most breathtaking landscape on earth. An hour's drive from town in any direction delivers one to an astonishingly diverse range of scenery, from steep mountains and canyons to vast open plains.

Boats skim across ABIQUIU LAKE near Ghost Ranch. Abiquiu, an hour's drive north of Santa Fe, was Georgia O'Keeffe's former home and was pictured in many of her paintings. The rugged Chama River Valley has also been a home for Utes, Navajos, Apaches, and, since the 1700s, Hispanic *genízaros*.

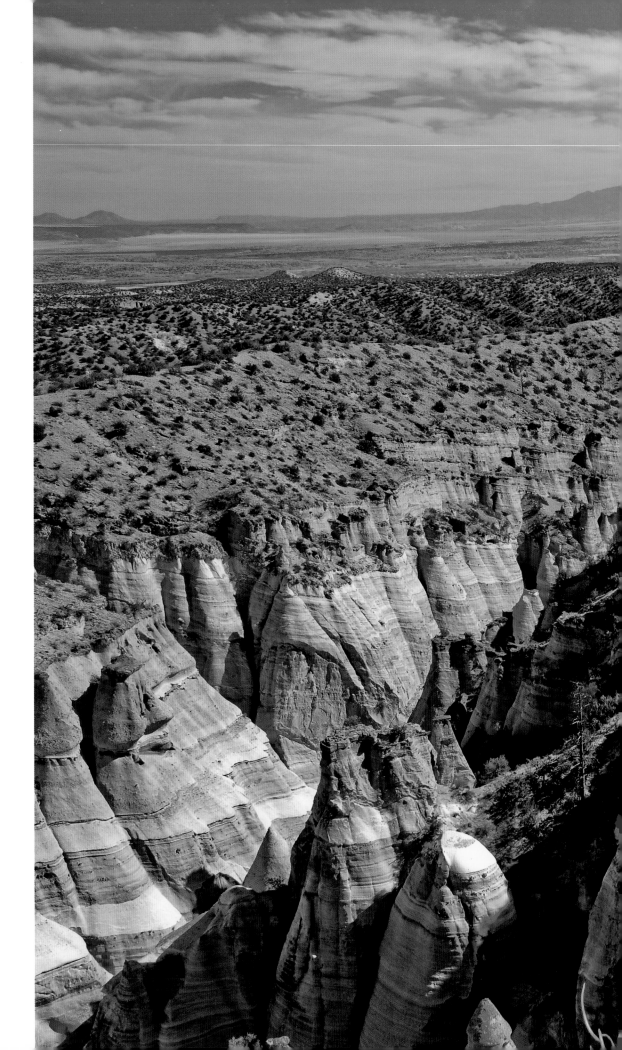

The Kasha-Katuwe TENT ROCKS NATIONAL MONUMENT near Cochiti Pueblo is a favorite hiking destination.

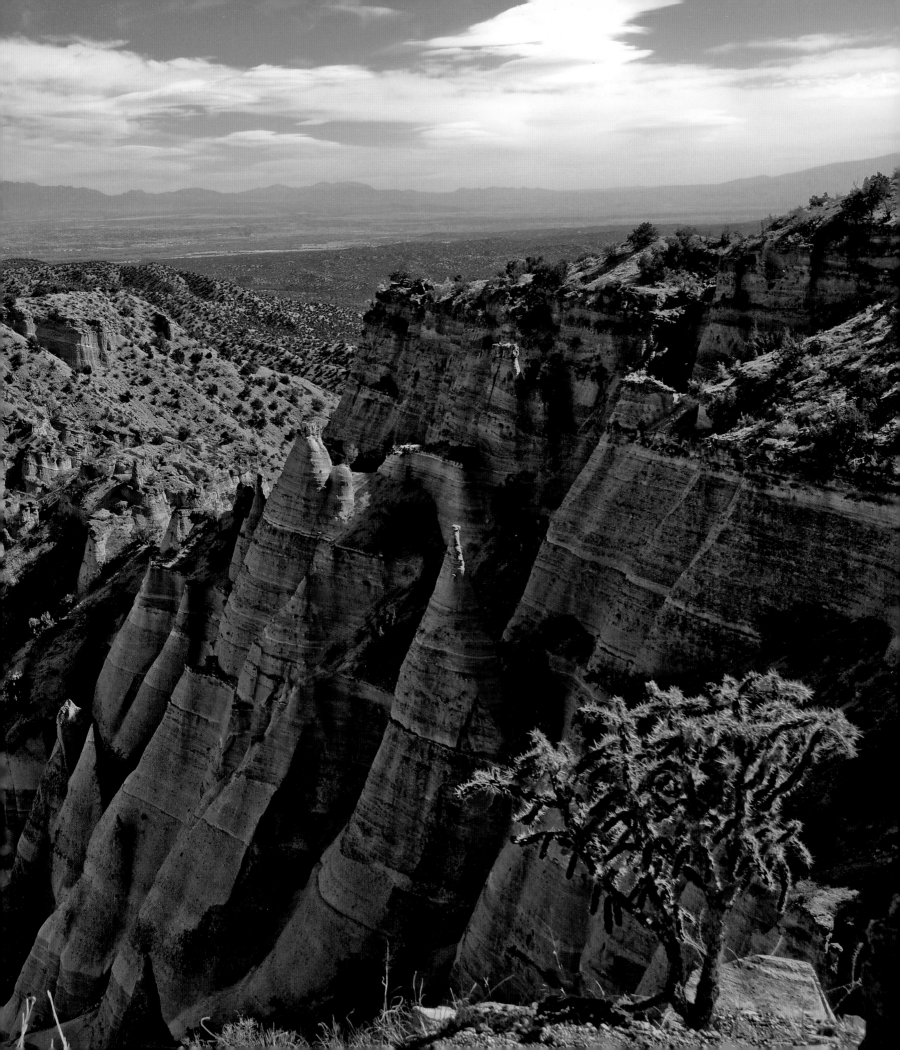

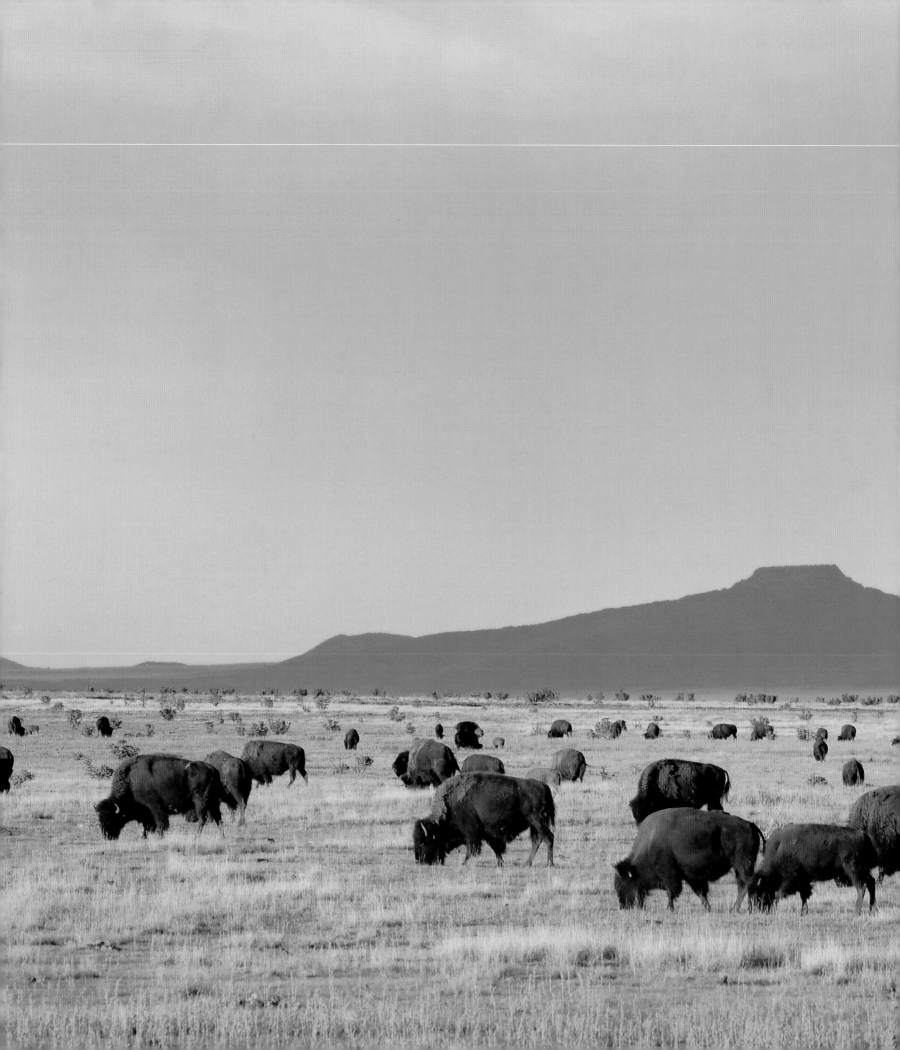

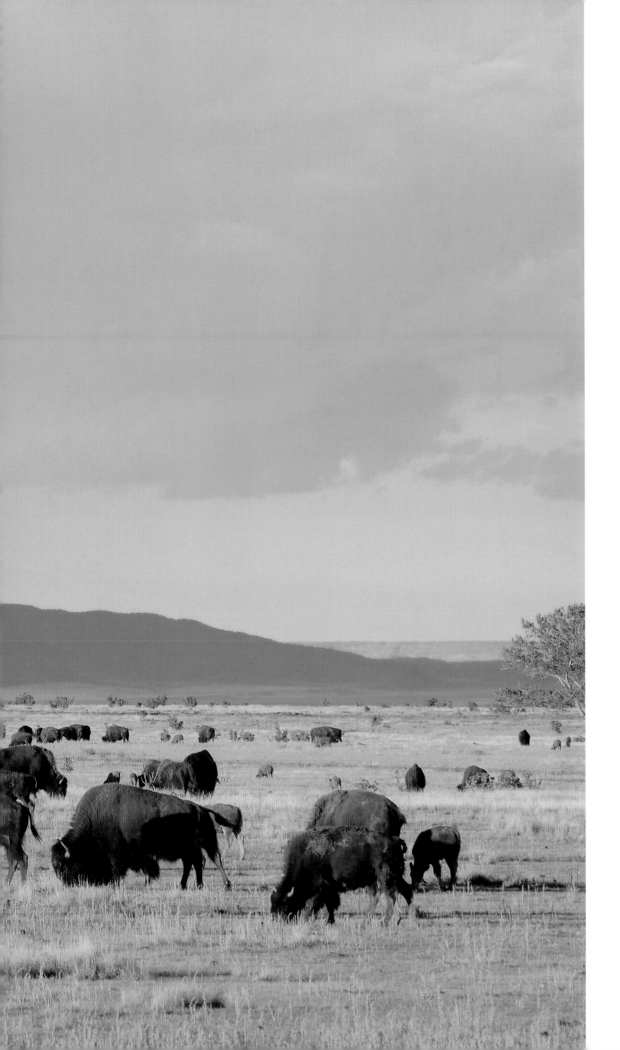

A buffalo herd grazes VERMEJO PARK RANCH NEAR CIMARRON. Millions of buffalo once roamed the vast plains of eastern New Mexico, followed by legions of hunters.

FOLLOWING SPREAD
A remuda of WORKING RANCH HORSES gallops through a wide pasture on the 160,000-acre Agua Verde Ranch south of Santa Fe. New Mexico is rich with authentic working cowboy communities, and huge ranches blanket the state.

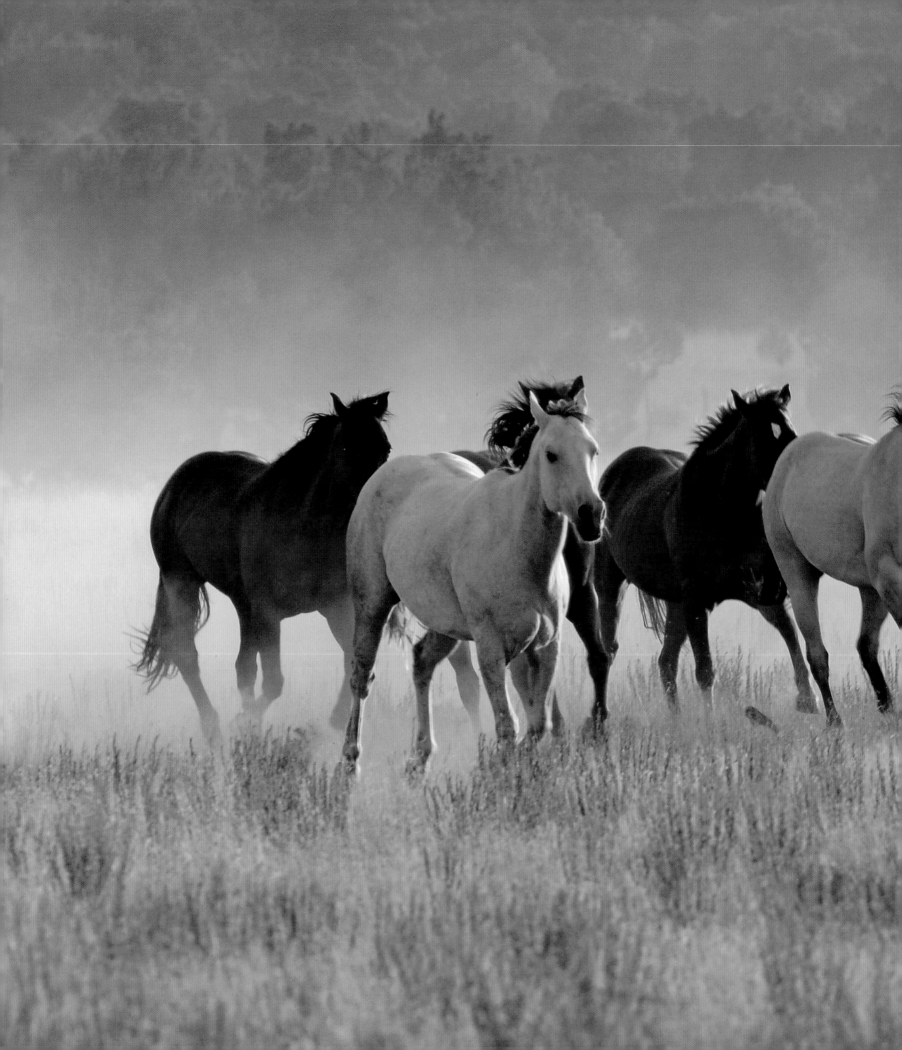

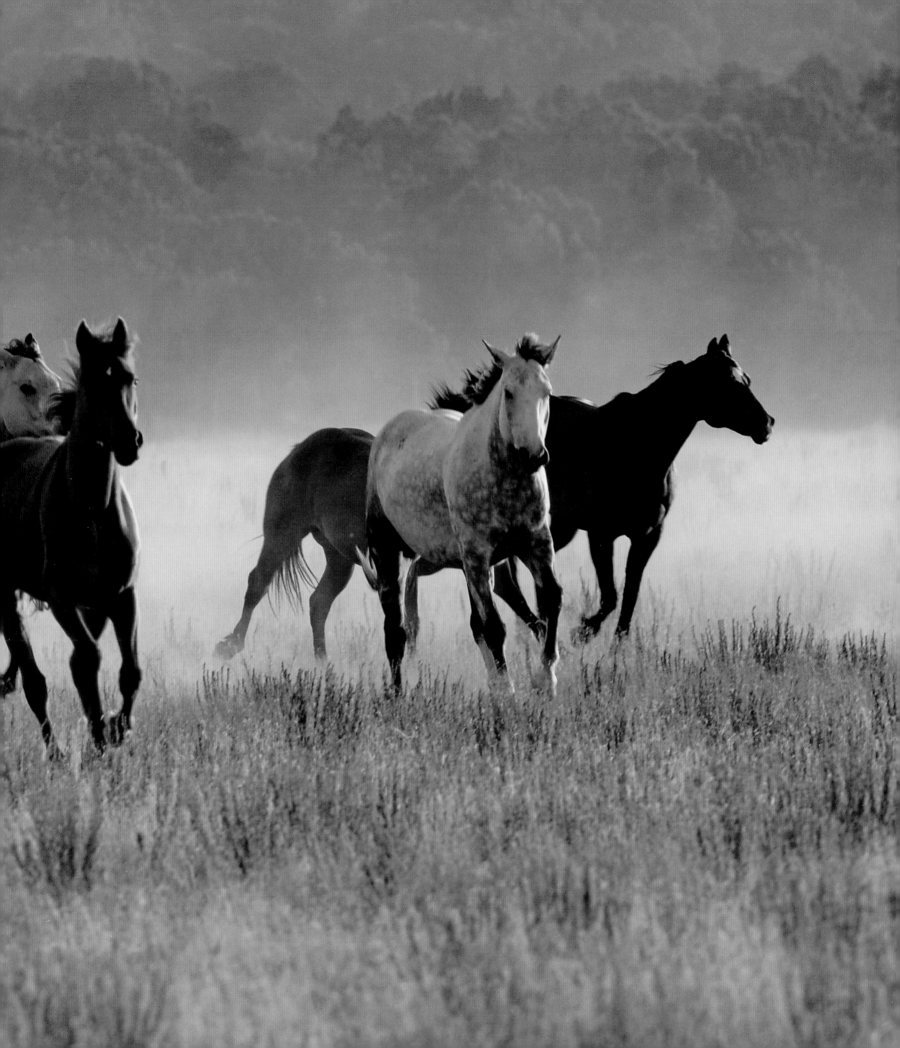

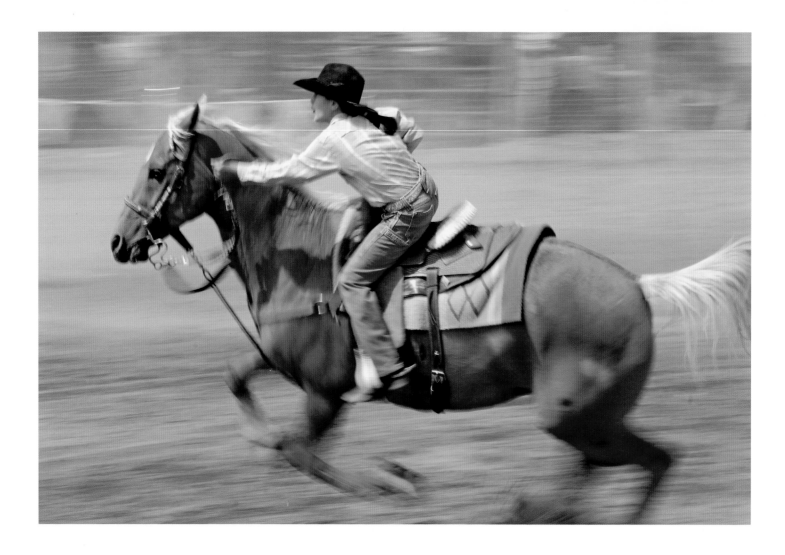

A YOUNG BARREL RACER speeds to the finish line at Rodeo de Galisteo. Local cowboy Rudy Sena created the rodeo in 1972. Its old-time country rodeo flavor attracts fans from both urban Santa Fe and rural New Mexico. Many Hollywood movies are shot in the surrounding Galisteo Basin.

OPPOSITE
Fourteen-year-old bull rider TATE STRATTON strides back to the bucking chutes after a winning ride. Beginning in early spring and lasting into fall, hundreds of rodeos of every kind are held in arenas across New Mexico. Rodeo is the social network connecting the rural West.

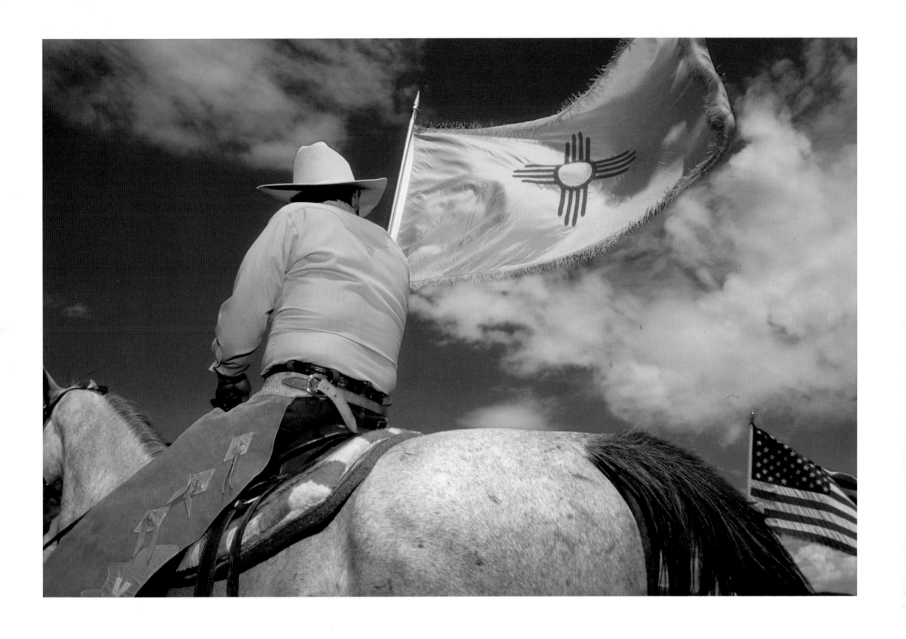

A Valencia County SHERIFF'S POSSE
RIDER flies the New Mexico state
flag at a rodeo parade in Magdalena.

May Sarton's 1972 article "The Leopard Land: Haniel and Alice Long's Santa Fe," from *Santa Fe and Taos: The Writers Era* (Ancient City Press, 1982)
D. H. Lawrence's 1931 essay "New Mexico," from *Telling New Mexico: A New History* (Museum of New Mexico Press, 2009)
Alice Corbin's 1920 poem "Desert Drift," from *Red Earth: Poems of New Mexico* (Museum of New Mexico Press, 2003)

Project editor: Mary Wachs
Design and production: David Skolkin
Composition: Set in Gotham Book and Minion
Manufactured in China

Library of Congress Cataloging-in-Publication Data
Peach, Gene.
Santa Fe / by Gene Peach ; introduction by Christine Mather.
pages cm
ISBN 978-0-89013-589-1 (clothbound : alk. paper)
1. Santa Fe (N.M.)—Pictorial works. 2. Santa Fe (N.M.)—Description and travel. I. Title.
F804.S243P43 2014
978.9'56—dc23
2013045112

Museum of New Mexico Press
PO Box 2087
Santa Fe, New Mexico 87504
mnmpress.org

PAGE 8
The southernmost tip of the ROCKY
MOUNTAIN RANGE rises above
US 285 near Eldorado subdivision
southeast of town.